The Tangierman's Lament

Earl Swift

The Tangier-man's Lament

and Other Tales of Virginia

University of Virginia Press | Charlottesville and London

University of Virginia Press
© 2007 by Earl Swift
Printed in the United States of America on acid-free paper
First published 2007

9 8 7 6 5 4 3 2 1

LIBRARY OF CONGRESS CATALOGING-IN-PUBLICATION DATA
Swift, Earl, 1958–
 The Tangierman's lament, and other tales of Virginia / Earl Swift.
 p. cm.
 Includes bibliographical references.
 ISBN-13: 978-0-8139-2622-3 (cloth : alk. paper)
 1. Virginia—History—Anecdotes. 2. Virginia—Social life and customs—
Anecdotes. 3. Virginia—Biography—Anecdotes. 4. Virginia—History, Local—
Anecdotes. I. Title.
F226.6.S94 2007
975.5—dc22

 2007007630

For my mom

Contents

viii *Contents*

Introduction

The Appalachians are slump-shouldered and low by alpine standards, dwarfed by the Rockies, mere hills next to the raw and knife-edged heights of the Andes or Alaska Range. Used to be, it's said, that these Virginia mountains towered highest of any on earth; they've dwindled to their present size simply because they've had the time to—being, as they are, among the oldest mountains around.

Over the eons, their bones have been worn to sand by wind and rain, swept downhill into passing rivers, and carried hundreds of miles to the Atlantic. So nourished, the coastal plain has grown to two thousand feet thick; when I leave my house I thus walk and drive on those ancient peaks. Every foot of stature the highlands have lost has brought a deposit of sediment downstream, a small square of dry land, a new and higher coastline.

Somewhere in there is a hint to what I love about Virginia and telling its stories. I wasn't born here; I am not descended from anyone who ever made a home here; I can't say that any of my ancestors so much as vis-

ited. Nor can I claim that my arrival fulfilled some longstanding desire; I was a newspaperman, a wanderer, and after three winters in Alaska merely sought a sunny coast on which to thaw—and so, in the spring of 1987, found my way to Norfolk.

With each foray from the office in pursuit of the news, I encountered evidence that the past lived all around—in the worn brick of the buildings that surrounded me, and riverbanks studded with ancient shark teeth, and place-names that harkened to tribes long vanished. Stories were arrayed vertically as well as horizontally; more than anyplace I'd ever lived, I sensed that I was walking ground trod by generations passed. Human experience, like the coast's geology, was layered deep.

It might have taken years to calibrate my senses to Virginia's nuanced charms. Happily, my work accelerated that process. In short order I hiked across the state, canoed its longest river from start to finish, climbed its highest peak and belly-crawled in its deepest cave. I slept in half of its counties. I stood vigil up top of a lighthouse, camped on desert islands, shared a summer's night with millions of crawling cicada nymphs.

I paddled a great circle around the Chesapeake Bay. At an abandoned coal pier in Newport News, I spent a year's worth of weekends spelunking the innards of a derelict ocean liner. I walked the halls of the Pentagon, Jeff Davis's presidential mansion, and a railroad tunnel through the heart of the Blue Ridge.

I spent long, breezy winter's days on the Eastern Shore, meditating on the rustle of spartina grass, and sipped campsite coffee while admiring the misty cool of blue-gray dawns over the Shenandoah. I noticed the shadows of clouds racing across Southside peanut fields.

I went native. Twenty years on, I call myself a Virginian and view the time before my arrival as a separate and far less fortunate life. And I've experienced enough of the state to know that I know practically nothing. Virginia's breadth, in topography alone, defies intimacy with the whole.

So the collection that follows is by no means a comprehensive portrait; it's an album of snapshots. The two longest pieces—"Out of Nowhere" and "When the Rain Came"—are about disasters, the former detailing the experiences of a handful of soldiers and sailors at the Pentagon on September 11, 2001, the latter those of a half-dozen families in central Virginia during a freak rainstorm in 1969, one of the most destructive such events in American history.

The title piece is set on Tangier Island, a low lump of mud and marsh grass in the middle of the Chesapeake Bay—among the most eccentric

small towns in the East, and one almost surely doomed to undergo terrible change.

Hardly representative, these stories, of life in Virginia on most days. The familiar's absent, as well, in the profiles I've included: In place of George Washington, Thomas Jefferson, and the other usual suspects, you'll meet a man who devoted his life to writing simply awful novels set in Norfolk; the suburban drummer for a famed heavy-metal rock band; a mysterious swami living in the Blue Ridge.

Most of the historical pieces detail small events forgotten by pretty much everybody. Ever heard of Rye Cove? Most modern maps don't even include it, but it was the epicenter of another disaster that achieved immortality in song . . . immortality, at least, to those who've heard the song.

It's probably wise to view this sampling as a chronicle of specific moments, as witnessed from particular and narrow angles, arranged not by subject or type of story but to provide an easy transit from beginning to end (I've resisted the temptation to lump all the disasters together, for instance; best to offer some relief in between).

Some might find in it an insight or two into the entire state and its people at the turn of the twenty-first century, in the same way that describing the circumference of a circle suggests something of its interior. I'd like to think that'll be the case—that by defining the boundaries of Virginia experience, I've helped you better understand it. I'm not counting on it, though. You shouldn't, either.

If there's any theme that binds most of these stories, beyond the geographical, it's impermanence—our struggle, as a species, to leave a mark, to combat the overwhelming forces of nature and time that conspire to erase us. It's a theme that's interested me since my arrival in Norfolk.

Because even here, in a place so mindful of its past, nothing lasts but our stories.

Not even mountains.

The Immortal Dismalites

Deep, deep, deep in the Great Dismal Swamp, we paused to gather our wits.

The sky was low, its light weak, and we sat in a dusky gloom. The only sounds were our panting and the steady plink of rain on the prison of flesh-hungry brier around us. "I think," George Ramsey said as he fiddled with his global positioning receiver, "that we're getting just a little taste of what Byrd's people went through."

"Probably so," said Bill Trout, who sat beside me on a fallen tree, chewing a cookie. "Only they carried all that heavy surveying equipment. Imagine that."

I shook my head, too spent to imagine any such thing. We had battled the Dismal for hours, hacking at its clinging vines with machete, carving through its barbed tangles with bolt cutter, sweating and cursing and straining for every step in the name of "Byrd's people"—the men who,

275 years before, laid down the dividing line between Virginia and North Carolina.

We were honoring the anniversary of Colonel William Byrd II's 1728 expedition by re-creating its most audacious chapter: the traverse of a vast blank on maps of the day, reputed home to monsters and muck and frightful death—a place that even now is secretive and seldom visited. Equipped with hubris and twenty-first-century gear, we'd followed the footsteps of the "Immortal Dismalites" into the swamp's thorny gut—and had managed a pace that threatened to trap us there as dusk approached.

George looked up from his GPS. "We're 1.27 miles from the car," he said—just a tenth of a mile closer than we'd been twenty minutes before. "We're making progress," he added, trying to stay positive. "We're headed in the right direction."

Were we? I opened my compass, turned to align its needle, and found west in an unexpected place. "No, that can't be," George said.

"West should be that way," Bill agreed, pointing to what the compass said was the southeast.

"We came from over there," George said, pointing the other way.

"I know," I said. "But this thing says *that's* west."

My companions stared at me. We were soaked and cut up and cold. We were low on food and water. Next to Colonel Byrd's Immortal Dismalites, we suddenly seemed very mortal indeed.

Those who know of Byrd likely recall him as the man who laid out Richmond and built Westover, a great mansion on the lower James River. But his most enduring contribution might be a pair of first-person "histories" recounting his role as a Virginia commissioner on the Dividing Line Expedition, through which the Crown hoped to settle a colonial beef.

The better of the travelogues, "The Secret History of the Line," is a catty, often hilarious portrait of Carolinians as dim-witted white trash, and Byrd's fellow Virginians as fiends for the flesh of every wife or daughter they encountered. It's also a telling study of just how wild the borderlands remained 121 years after Jamestown, especially that stretch of country Byrd labeled "this dreadful swamp, which nobody before ever had either the courage or curiosity to pass."

In Byrd's eyes, it was a hell where "no beast or bird or even reptile can live." It was a hotbed for "agues and other distempers occasioned by the noxious vapors that rise perpetually from that vast extent of mire and nasti-

ness." It was "overgrown with tall reeds interwoven with large briers, in which the men were frequently entangled," and littered with fallen trees "bristling out with sharp snags, so that passage in many places is difficult and dangerous."

He related all this secondhand, because he didn't cross the Great Dismal himself: Byrd left that to his surveyors and nine woodsmen eager for the privilege of going where no man had gone before. The colonel viewed them the way we might astronauts, and was sure they'd be forever celebrated as heroes.

He was wrong about that, and other things: The swamp teemed with black bear, whitetail deer, otters, catfish, and snakes, and whatever vapors it pumped out weren't particularly foul. Then again, he got the "briers" part exactly right.

I had been warned. Lloyd Culp, the manager of the Great Dismal Swamp National Wildlife Refuge, a man who loves the place, had told me about his backcountry searches for lost hunters. "Not an experience I've enjoyed," he said. "After I've spent a day in the woods here, I've been pretty passionate about not going back in."

I'd heard stories of ace outdoorsmen who'd been bewildered by its depths, and of runaway slaves who hid in them for years, and of city folk who ventured in and never came out. I knew this was no ordinary woods. But the Dismalites beckoned as the anniversary of their journey approached. How many people had crossed the swamp in all the years since? I found no testimony that anyone had; books abounded on the swamp, but none recounted a post-1728 beeline through its middle.

So I'd called Bill Trout of Richmond, a retired scientist, respected historian, and eager student of the Dividing Line. I knew he'd be game for a hike: He'd suggested the trip to me years before. I called Trout's friend and swamp expert, George Ramsey of Suffolk, and invited him, too. "It'll be a difficult walk," he allowed, "but it's something I've always wanted to do."

We met one morning in late March at the refuge headquarters, where Culp saw us off with a worried inspection of the sky. "When it's overcast like this," he'd said, "it's really easy to get turned around out there." We'd assured Culp that he had no need to fret. After all, we were packing two GPS receivers, a modern compass, good maps. The swamp was much changed from the remote, goopy pocosin of the eighteenth century; our outing would cross mostly dry woodlands hemmed on all sides by suburbs

and farms. Besides, we'd never be more than a couple of miles from the car. How difficult could it be?

Byrd was not nearly so cocky. The fifty-three-year-old land baron, lawyer, and naturalist worried that the swamp and its "foul damps" were impassable. Even so, on March 7, 1728, the colonel set off from present-day Corova Beach with two other Virginia commissioners, three surveyors, and fifteen men, along with a like-sized party from Carolina. The group surveyed a line across Currituck Sound and Knotts Island and the foot of today's Virginia Beach, hounded a passel of local women, and before long found itself at the threshold of terra incognita.

Byrd proposed to replace some of his already tired team with fresh workers, but "they begged they might not be relieved, believing they should gain immortal honor by going through the Dismal." The men drew lots, and when one lost out, he offered a winner, George Hamilton, "a crown to go in his room"—which Hamilton "would not listen to for ten times the money."

Their membership decided, the Dismalites set off on March 14. Byrd accompanied them beyond the mire's edge into a sea of twelve-foot reeds, over ground that squished and quaked underfoot. It took them three hours to cover a half mile. Their leader turned back at that point and waited in Carolina for the team's reappearance.

Two days later the rain came, which Byrd wrote "put us in some pain for our friends." The next day, Byrd ordered guns fired and drums beaten "to try if we could be answered out of the desert," but heard only echoes. On the fifth day, worried now, he dispatched men along the swamp's western frontier—then, as now, the Dismal ended abruptly at the Suffolk Scarp, a thirty-foot rise marking an ancient beach—but to no avail.

The forest was silent still on March 21, the eighth day, when Byrd knew the Dismalites would exhaust their rations.

In the colonel's time the swamp spread far beyond U.S. 17, its eastern boundary today, and miles deeper into Gates, Camden, and Pasquotank counties in North Carolina. Just the same, it remains a massive preserve. The national wildlife refuge, which incorporates only a portion, is two and a half times the size of Norfolk.

From the air it appears seamless. In truth it's a quilt split by ditches and

canals dug long ago to drain the place or to float felled timber to its edges. One such waterway, the Washington Ditch, dates to 1763 and was named for the future president who helped build it.

Now, as we drove eastward into the swamp on a rutted, puddled track, we stared down into another ditch, the Corapeake, its water stained the color of strong tea. Beyond it, dense cane and bundled vine rose ten feet high, broken here and there by stands of red maple and thickets of pond pine ankle-deep in black water. A couple hundred yards through those obstacles, parallel to the ditch and its companion road, lay the state line—the modern state line, laid down in 1887. The border that Byrd's people surveyed lay another 515 feet north of that.

Whitetail deer bolted before us. Turkey buzzards wheeled overhead. A lazy drizzle fell. And miles deep in the Great Dismal, beyond the reach of cell phones, we turned onto a road alongside a north-south ditch, the Laurel, and locked up the car.

Here was the plan: We would hike a mile and a half eastward to the swamp's edge at the Dismal Swamp Canal, which runs alongside U.S. 17. We'd follow it north to Byrd's line. Then we'd strike a course through the woods back to the Laurel, move the car to another ditch road a mile farther west, and repeat the process. With diligence, we'd be able to cover several miles on the first day, and take up the remainder the next.

Except that the hike east, to the beginning of our journey, wasn't what we expected. At its intersection with the Laurel, the Corapeake Ditch Road reverted to jungle so wild and thick that it seemed nothing could ever have passed there. It threw up tall grass, then stiff cane, then ever-denser saplings. Then came the greenbrier. Laurel-leaf greenbrier, to be specific. *Smilax laurifolia*. Nature's barbed wire.

It is a vine of spindly, almost delicate constitution, which makes its true nature all the more diabolical. Its limbs carelessly knot with their neighbors. Each is toothed with dozens of barbs a quarter-inch long and sharp enough to slice even the hardiest canvas, and curved like a viper's fangs so that a victim has to reverse course to pull free. Fifty yards of clear walking we got, before we hit the greenbrier. At about the time it drew first blood, the drizzle turned to steady rain.

Let the record show that we were stalwart, even as the *Smilax* encircled our ankles and grabbed our shoulders and slapped, ripping, across our mouths, that we bulled through it and hacked at it and snipped windows through its weave calmly, and without complaint. But man, did it hurt.

"Byrd wrote about the briers, so this is no surprise," Bill observed. "Of course, the Dismalites never had to walk east before they walked west, so we're one up on them."

The sky darkened. The temperature slowly fell. The rain intensified. When we reached the road's end, we paused for a few minutes to eat sandwiches and swig water, then pondered our next problem: To head north to Byrd's line, we'd have to cross the Corapeake Ditch.

We backtracked to a pair of trees that had fallen across the twenty-foot waterway, George and Bill brazenly striding across the slick trunks, me inching across on my center of gravity. On the far bank lay a seemingly impenetrable chaos of brier and toppled trees. "OK, colonel," George said, "we'll follow you." I pulled out my compass and found north.

A technical note is necessary here on the business of orienteering. Most places, one draws a compass bead on a distant landmark—a boulder or tree, a notch in a far-off ridge, whatever—and simply walks to it; having done so, he takes another compass reading, finds a new landmark, makes for it, and in this manner crosses the landscape with some reliable sense of his place in it.

Such is not true in the Great Dismal. Scrub interrupts the view so that only the crowns of the trees are visible. Those crowns are vexingly similar. And one cannot walk in a straight line: Where the briers are not, great heaps of tree trunk lay, sometimes chest-high. A journey of fifty yards north might require a detour of twenty yards east, followed by ten northeast, then a correction to the northwest interrupted by yet another jog eastward. Direction becomes increasingly difficult to gauge, particularly in the absence of sun and shadow.

It was a jagged route that we traveled the several hundred yards to Byrd's line. When we reached it, George's GPS informed us that we were 1.6 miles from the car. Half the afternoon was gone. The rain was falling hard. We turned west.

In retrospect, I wish that before embarking on the trip I'd read Byrd's second diary, "History of the Dividing Line betwixt Virginia and North Carolina Run in the Year of Our Lord 1728," for it provides far more detail than the jauntier "Secret History" on exactly what happened to the Immortal Dismalites.

On their second day in, finding "reeds and briers more firmly interwoven than they did the day before" and trees "laid prostrate, to the great

encumbrance of the way," they pushed just over a mile. On the next, a mile and a half. Rain on the third killed any progress at all. It went like that until they ran out of food, by which time they'd covered only ten miles. Fearing starvation, they abandoned the survey and made a dawn-to-dusk sprint for firm ground, but managed only four miles on terrain "so dirty and perplexed."

So it was as we retraced their hike. We began walking the Line within earshot of traffic on U.S. 17. Half an hour later, we could still hear it. The ground was more uneven than ever, the treefalls more abundant. Animal burrows abounded, some roofed in leaves and twigs through which we crashed knee-deep. Every westward step required a machete stroke and two steps to the north or south. Every thicket of *Smilax* presaged another twice its size.

My companions took it all in good humor. While I cussed under my breath at every brier in my path, Bill wished aloud for some sign of the Dismalites' passage—eighteenth-century liquor bottles, maybe, or the remnants of a campfire. But the struggle and the cold took their toll, and our energy was sapped further when the GPS informed us that after an hour's hard work, we were only three-tenths of a mile closer to the car. George announced that his legs were cramping.

It wasn't long after that that I took the counterintuitive compass bearing. Seeking some explanation for the instrument's behavior, I recalled the presence of a weak magnetic anomaly at Lake Drummond, the round lake—some say meteor crater—a little more than two miles away. "Maybe it's that anomaly," I suggested.

"Maybe," George said, not bothering to mask the doubt in his voice.

"Or maybe," I muttered, "I'm just a lousy navigator." This earned no debate, so I set a course true to the compass. A few minutes later, we came to the edge of a water-filled ditch. Unfortunately, no ditch was supposed to lie between us and the car.

You might turn an uncharitable thought at this point—might say, "I'm never going hiking with those guys," which I can't fault, or "This is like one of those tragic Jon Krakauer books," which it almost is, or "What a bunch of greenhorns," which I wish were accurate. We three have solid credentials, however. I hike often, and only rarely get lost. Bill Trout has paddled and mapped hundreds of miles of Virginia rivers, and has done it for years; he's sixty-five. George Ramsey, at seventy-two, is as competent a woodsman as you'll meet.

No, this was not the misadventure of novices. It occurred to me as I

stared at the ditch, utterly mystified as to how we'd arrived there, that this was the sort of fix that befalls only people who supposedly know what they're doing.

"Uh-oh," George said, coming up behind me. "What's this?"

"A ditch," I replied. "I think we're a little off-course."

"If this is the Corapeake, we're way off-course," he said. "We've come several hundred yards south when we should have been going west."

"Are we sure it's the Corapeake?" Bill asked. An excellent question.

"I don't see how it could be anything but."

George pulled off his boots and wrung out his socks. I looked at my watch. I'd promised Lloyd Culp we'd be out of the refuge by afternoon's end, and the appointed time was now thirty minutes away. We were still 1.2 miles from the car. At this rate, there was a very real possibility that Culp would call out a search for us, or that we'd spend the night in the swamp, or both—unless we, like the Dismalites, abandoned the Line.

So we headed west along the canal, looking for a place to cross back over. We passed one log too skinny to support our weight. Another only stretched two-thirds of the way across. A third made a high, scary arc over the water. Just as I resigned myself to swimming, we came on a large tree that had fallen across, with a smaller trunk dangling six feet above it. I tested the big log as George put his weight on the smaller, so that it dipped low enough for me to grab for balance, then inched my way across. George and Bill followed. Both made it safely.

It was the day's one triumph. More than an hour later we burst from the brush, soaked and sore and shivering, and piled into the car. I turned up the heat, and for a minute we sat in exhausted silence, listening to the blower. George yanked a banana from his knapsack. "Potassium," he murmured. "It might help get my legs to work again."

"So," Bill said, "do you still want to come back out tomorrow, to try to finish this?"

"No," I answered.

"I think we sort of got the idea," George agreed.

No sooner had we turned back onto the Corapeake Ditch Road, pointed west, than we saw headlights ahead. Lloyd Culp had sent one of his wardens to find us. He insisted on following us out of the refuge.

I consoled myself with the knowledge that Byrd had dispersed lieutenants to look for his overdue party, too, but the comparison only went so far. Late on their ninth day incommunicado, the Immortal Dismalites staggered from the swamp near present-day Desert Road in Suffolk. The

colonel gave them a few days' rest, then sent them back. On the fourth day of this second foray, they completed running the Line through the Great Dismal.

They did it without GPS, Gore-Tex or bolt cutters, while lugging brass transits and oak tripods and salt pork. Yet their achievement, however impressive, is remembered by few. The cedar posts and blazes they used to mark the Line are long-vanished. The border was adjusted southward 159 years later, dimming their significance. No historical marker stands on the swamp's western fringe. Even their names have vanished: Historians can't identify all the nine woodsmen who made the trip. The Immortal Dismalites, sad to say, have not been.

But on the basis of the *Smilax* alone, I'm here to tell you, they should be. And I know two other people who say the same.

The
Unexpected
Artist

It was reading that got him into it. Eugene Abbott was in the army, bouncing around the Pacific — Honolulu, Okinawa, Saipan — and reading everything he could get his hands on. W. Somerset Maugham. James Joyce's *Ulysses. For Whom the Bell Tolls.* Faulkner.

Somewhere in the pages of those great books, in the company of those great writers, Abbott detected an invitation, saw his life's path laid plain before him. He decided to be a great writer himself. It was a career to which he'd devote his energy for more than a half century, that would hammer his ego and cost him a fortune and drive him to question his sanity. That eventually would see him celebrated as an artist in ways, and for work, he didn't foresee.

But back then, Eugene Abbott simply believed he had a duty to mankind. So he bought the first of six typewriters he'd wear out, and embarked on a gritty tale of call girls and their customers at a brothel in Honolulu. He was still working on it when he came home from the army and moved

in with his aunt in Norfolk. She came across the story while he was out one day in 1948. When he returned, she had an ultimatum: "If you're going to write stuff like that, get out of my house."

She was the first of many literary critics. "My war had started," says Abbott. "Roosevelt's war was small, compared with mine."

He moved into a boardinghouse and, while pulling day shifts as a clerk at the Naval Supply Center, set to work on the first novel he'd complete, an autobiographical saga titled "Reflections." Full of hope and confidence, he bundled up its carefully typed pages and headed for New York. "I took it to publishers," he says. "I went back several times, and they told me something different every time — 'You didn't do this.' 'You didn't do that.' 'You didn't develop your characters enough.' 'You didn't have a romantic ending.'

"Everything I did was wrong. Read my lips: Everything I did was wrong. It was an absolute failure. How can we put it another way? We can't."

Undaunted, he tackled a second novel, "The Fiery Furnace," a saga of love and war, courage and cowardice, sex and more sex. He took it to New York. Again, publishers sent him packing. One literary agent told him it "wasn't a story at all, but a mere recitation of some events, without conflict or love interest." So he took it home and rewrote it, doubling its size. Then, after reading Norman Mailer's *The Naked and the Dead,* he rewrote it again.

Over the next thirty years he rewrote "The Fiery Furnace" four more times, refining the narrative, painstakingly assembling each new manuscript keystroke by keystroke on the manual typewriter in his boardinghouse room. He went without a car, a permanent home, a bank balance, spending his money on postage, and copying, and envelopes, and agent's fees.

And women. He spent a lot of money on women, which is what inspired his third novel, "The Last Time: A Tale of Old Ocean View."

"Gilbert," said Kenny Week, as he sat uneasily in Gilbert's comfortable armchair, located in Gilbert's bedroom, a room that Gilbert loved to dub, "The Pilot House," because of its bay of three large windows facing his familiar world of Warren Crescent, "I've really gotta hot number for ya this trip; her name's Carol, and she speaks 'Fluid' French, not tha language, either." (From the opening of "The Last Time")

The manuscript's 309 double-spaced pages related the sad tale of Gilbert Savage, a cynical misogynist who falls for a Norfolk prostitute, realizes she feels nothing for him, and betrays her to the police. "The main character was a complete degenerate," Abbott says, lip curled with disgust. He pauses. "It was me, of course. It was I. I was Gilbert Savage.

"I met her through a car salesman, and I fell madly in love with her. I thought she was Vivien Leigh, for chrissakes. She looked at me as sort of a ridiculous figure, because she knew I worked at the Naval Supply Center, and I didn't make a lot of money."

Like his other novels, this one bore Abbott's unmistakable literary fingerprints: An omniscient narrator who, at times, surrenders the floor to first-person monologues from the characters. A Norfolk setting. Barely fictionalized characters from Abbott's past. Sex, and lots of it. He shipped it off to New York. Agents hated it.

"I was sure they were wrong," he says. "I was sure I was the great American writer, despite constant rejections—I said constant, too. Don't forget that word. Use it. Read my lips."

He kept tinkering with the novels and with forty short stories he'd completed, kept sending them off to New York, kept getting rejection slips. And fight as he might to stop it, as years passed, then decades, a question began to creep into his head: What if they're right?

"After getting constant rejections I began to realize that maybe I wasn't so hot," he says. "Everybody told me. They were emphatic. 'You want to be a writer, for chrissakes? What have you got? A bunch of pornographic trash.'

"Over a period of many years, my friends heard the writing—I'd read it to them—and even they'd say, 'What are you doing? Throw that stuff out. Throw it in Stockley Gardens.'"

Trouble was, by now Abbott had forty-odd years invested in producing his art. In striving to be recognized as an artist. In trying to move people. Even if he wasn't a great writer, he couldn't give up: To do that would be to admit that his life had been wasted. So he kept going back to the typewriter. Tweaking. Rewriting. Retyping. Shipping off his manuscripts. "He was diligent," recalls Wayne Boggs, for fifteen years his upstairs neighbor in a Ghent boardinghouse. "You'd be talking to him, and he'd say, 'I have to go to work,' and you'd hear that typewriter. Every day he'd be up there, banging away on that typewriter.

"You could tell when he made a mistake, too. He'd start cussing."

Now just what did Gilbert most admire about her? Ruth wore golden, spike-
heeled pumps and a sky-blue Baby Doll negligee of a material about as thick as
his honest intentions. (From chapter 4 of "The Last Time")

Not long after finishing his seventh version of "The Fiery Furnace,"
Abbott was struck by a car as he crossed Colley Avenue. The accident
broke his neck. At the hospital he was fitted with a metal "halo," designed
to immobilize his neck. It is a crude-looking contraption, heavy and un-
comfortable and bolted into his skull, and since then the halo, his loneli-
ness, and the despair he feels at being bedridden have conspired to hush
Abbott's voice.

His literary voice, anyway. "I can't create in this hellhole!" he yells in
the day room of a Norfolk nursing home in which he's slowly recover-
ing. He screws up his face at his lunch as other patients struggle to ignore
him. "This chicken is a disgrace to any chicken who ever lived! Good God,
it's horrible! Good God!" He points at the meal. "Get thee behind me,
Satan!"

So go many of his days these days. Which might make for a bleak close
to Eugene Abbott's story, except for a brainstorm he had years ago, when
he found himself admiring the illustrations in a volume of W. Somerset
Maugham, and wondered: Why not me? Why not illustrate my books?

Maybe, just maybe, illustrations would help sell his writing. He couldn't
afford oils, so he bought crayons, and colored pencils, and felt-tip pens, and
Testors enamels, the dense paints normally used on model airplanes. He
began to churn out paintings of scenes from his novels—of soldiers under
attack in "The Fiery Furnace," of Gilbert and Carol in "The Last Time."
Night after night for years he painted alone in his room, hunched over his
illustrations whenever he wasn't sitting at the typewriter. And over time
he hit upon a style, bright and blocky and primitive, all of his own.

He kept painting even after finishing the books—dramatic maritime
scenes, famous ships, World War II battles, and portraits of Elizabeth Tay-
lor, Lady Diana, and the British royal family, his olive and silver and sky-
blue airplane paint slathered thick on typing paper.

Rudy dropped his bag; and Jane rushed headlong into his outstretched
arms, for his were those strong arms of protection that every real woman
wants, even while she's spouting about wanting something else! (From the con-
clusion of "The Fiery Furnace")

Nine years ago, give or take, Ghent critic and folk art connoisseur Linda McGreevy was rummaging through a Norfolk thrift store when she encountered dozens of explosively colorful paintings by an artist she'd never heard of. "I was practically in tears, they were just so wonderful," she says. "I bought all I could carry out of there. I've shown them to other people, and they're absolutely fascinated. They're so genuinely *there*. These are very intense paintings."

Not long after that, Peter Pittman, a Norfolk artist and restaurateur, met Abbott on the street, and accepted an invitation to the boarding-house to see his paintings. "I thought I'd discovered a genius," Pittman says, comparing Abbott to Howard Finster, a folk-art icon, and Newport News's Anderson Johnson. "I thought this guy had it all. He had a painting of a dog licking a woman's face, and on the tongue of the dog was written 'I love you.'"

In the spring of 1993, Pittman organized the Ghent Art Tour, a combination neighborhood open house and gallery showing. Abbott was among its featured artists. He sold a slew of paintings. Pittman introduced him to Gary McIntyre, a restaurateur and the proprietor of an antiques and collectibles store called The Atomic Lounge. McIntyre was floored, and hung Abbott's work in his shop. Over the past year, he's sold a half-dozen pieces. Some have fetched hundreds of dollars.

Abbott believes his paintings to be "definitely mediocre," and doesn't understand why someone would want to part with a goodly pile of cash for one. But in a way he never expected, he has finally reached an audience. Those nights and weeks and months and years he spent alone in his room have paid off. People are interested in his message. They are buying his work. Quite by accident, he has become the artist he always wanted to be.

"I've been a failure all my life," he says. "A failure. Read my lips. I was always an outsider.

"The times have finally caught up with me, thank God. Maybe I'll live to have the last laugh." He grimaces, shifts in his wheelchair, struggles against the halo's weight. "If I do live to get out of this hellhole, I'll write a novel about this place," he says. "And the novel will be called 'Nightmare.' That's it. That's exactly it: 'Nightmare.'"

He sighs, eager to get back to work. To tell a story. Create. His neighbors in the day room watch TV, oblivious to the artist in their midst.

The
Tangierman's
Lament

In the beginning was Joseph Crockett.

And Joseph Crockett begat ten children, who begat others, and they others, and so on through centuries.

And one of these Crocketts married Ira Eskridge, and with him had a son, William. And Will Eskridge fathered seven children, the last of them a son, James. And on this spring evening forty-one years later, James "Ooker" Eskridge is crouched astern in a flat-bottomed skiff, hand on the tiller, ball cap pulled low, flannel shirt flapping in a stiff southwesterly.

Off to his right, cordgrass lines the crumbling edge of his birthplace, his family's seat for more than two hundred years. He swings the tiller left. The boat veers right. Its hull rasps on sandy bottom, and Eskridge steps ashore onto Tangier Island.

He strolls up the rising beach to high ground, two feet above the tide.

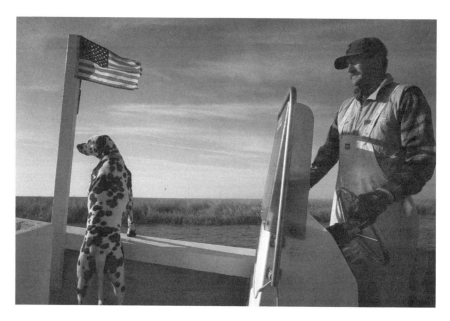

As his kin have done for generations, Tangier native James "Ooker" Eskridge heads for work on the water. (Ian Martin photo; used by permission)

Virginians have lived on this speck of mud and marsh in the center of the Chesapeake Bay at least since Joseph Crockett arrived in the late eighteenth century. Some 650 of them live here still, passing their days as their forefathers did: working the water, and marrying neighbors, and raising families, and praising the Lord.

Away to the north, the island's steep-roofed houses float, gleaming, on the rushes. Eskridge pauses a moment, eyes the distant spire of the Methodist church. Up there, among narrow streets, scoured weatherboard and the old words and phrases of island speech, Tangier seems more woodcut than real, a throwback to a simple, mythical American past.

But here, on the sand spit that curls from the island's southern end, clues abound that Tangier is not as it was, and won't last long as it is. Eskridge weaves among quivering blackberry, wind-bent sprigs of salt grass, steps past the rust-caked remains of a motor launch buried past its gunwales. When he was a boy, the launch was in the water. It's twenty yards from it now.

He walks toward the spit's southern tip, where the bay's gentle surf breaks over a broken concrete pad, washes around a platoon of slime-

blackened pilings and a brick pillar that once supported a fish-meal plant. Farther on, where the spit doubles back on itself, Eskridge passes a dozen more pilings jutting from the shallows. Used to be that they were on the island's far side; in Ooker Eskridge's lifetime, the shape of the land has changed that much.

And that's nothing, next to what's on the way.

Years from now, when Tangier Island is the stuff of history, the descendants of Joseph Crockett may differ on what brought the end. They might trace it to the arrival of television. Might blame the demise of the Chesapeake Bay oyster, or erratic crab harvests, or government red tape. Or they might say Tangiermen were their own worst enemy, that they invited their own demise.

But most likely they'll say it was erosion that did in their home place, for with that word they'll summarize all the vexations now facing this far-flung village. The Chesapeake has chipped at Tangier's edges since long before its settlement, has stolen the land under its pines and marshes and homesteads. While that physical drama has unfolded, other, less apparent forms of erosion have steadily whittled Tangier's culture, its livelihood and its population.

These problems went all but unnoticed, at first. Over time, they've grown almost insurmountable. And if they play out as they seem sure to do, a community unlike any other in Virginia will be lost: a place of equal parts water and earth, and a people built the same way; of stout, old-time Methodism, and unwavering faith in God and sobriety; of an almost foreign tongue, a singsong brogue of Cockney vowels, clipped consonants, and strange rhythms.

Ooker Eskridge worries that it's not far off. "After awhile, it will speed up," he says. He pauses, purses his lips. He is a lifelong Tangierman. His wife is an islander, as well. Two of their four kids were born here. The island is dotted with the graves of his forebears. "I would try to stick it out as long as I could," he says. "But it would be very difficult. And a lot of people, they're not even attempting to do it."

In the beginning was Joseph Crockett. And his sons had their own, and they others, so that the Crockett name endured through generations. And his daughter, Molly, married Richard Evans, and they had a daugh-

ter, Rhoda. And Rhoda Evans married Job Parks, and bore his sons and daughters. And so the Crockett line braided with the Evans and Parks, and likewise the Pruitt and Thomas and Dise.

So it went until Merrill Crockett, six generations removed from the first Joseph, married Ruth Parks, descended from the same man, and they had a son, Dewey. And on this spring afternoon fifty-two years later, R. Dewey Crockett is sitting at a conference table in the Tangier Combined School, a single building in which all one hundred of the island's children take class, kindergarten through twelfth grade.

"I think of this little island often in the fact of all the storms that have come," Crockett says in a soothing baritone. "You look at the weather, look at the map, and see how it's coming right on up, straight right here at this little island, and then all a sudden there's a report a few hours later where it's turned off or turned in.

"So over and over, we've seen the hand of God," he says. "The good Lord's for us."

Crockett is the school's assistant principal. He is also Tangier's mayor, its funeral director, and the music director of Swain Memorial United Methodist Church. Of these roles, mayor might be the least important: Sharp of mind, six feet six inches tall, blessed with that reassuring timbre, Dewey Crockett would be the town's anointed leader even if he didn't hold the post. He commands with a kindly chuckle, a hand on the shoulder, an encouraging *Amen, brother.* In these ever more troubled times, his calm is highly prized.

But this afternoon, Crockett allows himself a moment of doubt. "You're losing the culture, the history here, everything," he says. "It's just going down the drain.

"With all the money in the United States and even in the state of Virginia that's spent for various things that aren't necessary, there should be money out somewhere that could preserve this island. I mean, how many islands are like this?"

There are not many, and no wonder: Even in the best of days, life is not easy here. No bridge or vehicle ferry links Tangier with the rest of America. It is a dozen miles—forty-five minutes by small boat—from Crisfield, on Maryland's Eastern Shore. The water all around is big, long of fetch, temperamental. It can turn from slick-calm to mean in minutes.

A 65-foot mail boat makes the trip across twice daily. From its wheelhouse, Tangier first appears as a low smudge on the horizon, a sky-blue water tower and Swain's steeple hovering above. It takes a map to see that

the looming ground is not one island, but a closely bunched, soupy archipelago a mile wide and four long, shaped like a seahorse.

A man-made channel separates the head from the body, and as the mail boat glides toward this cut, the seahorse's head, uninhabited swamp, stretches off to starboard. Away to port, three thin, parallel ribs of sandy loam rise imperceptibly from the surrounding marsh. All of Tangier's 250-odd houses are crowded onto these so-called ridges. The homes are much like the people who live in them: sturdy, ungarnished, one built snug against the next.

The business district is a cluster of fuel tanks, two small groceries, a hardware store, and a handful of summer-only gift shops and restaurants. Roads are no broader than sidewalks, built for beach cruisers, motorbikes, and golf carts. The graves of former islanders rise in some yards, along with a few cedars and tall poplars, the odd persimmon and fig.

Off the ridges, the wind that sweeps the wetlands on many a spring day carries the gassy stink of sun-drying mud. But no exhaust, no soot, and no sirens or screeching brakes, either. Among its guts of slow, shimmery water and peaty black muck, Tangier seems almost lost in time.

Such is its charm, and its challenge. The bay complicates the simplest tasks, turns minor emergencies major. Doctors fly out from the mainland twice a week, and a dentist once a month, but the hospital in Salisbury, Maryland, is thirty minutes away by helicopter.

"This is not exactly the place you'd want to come and just retire," Crockett says. "There are things about your life you have to change. There's a different way of getting things here, and planning to get off and on. That alone: You can't just jump in your car."

The island has required fortitude from the day Europeans first laid eyes on the place. Capt. John Smith, embarked on a 1608 exploration of the Chesapeake, spotted Tangier from his shallop and was promptly blasted by a gale so fierce he feared for his life. Joseph Crockett, the earliest documented resident, moved aboard in 1778 to fatten cattle and sheep on the lush marsh grass. He and his family endured storms that brought the bay over the land, and insects that rose like mist from the swamps, and months of lonesome quiet.

The months became years. Joseph Crockett's daughter, Molly, begat a daughter, Rachel Evans. She married a young fisherman named Joshua Thomas. And one day in Pungoteague, on Virginia's Eastern Shore, Thomas heard the Word of God and felt himself changed, and returned to his people as a Methodist.

And two years into the War of 1812, the British made the island their headquarters, building a fort on its sandy hook, anchoring their ships just offshore. And they asked Joshua Thomas, by this time a lay preacher, to hold a service before they laid siege to Baltimore. And Thomas stepped up to a makeshift pulpit and told these Redcoat thousands that their cause was unrighteous, and that the Almighty had assured him that they could not take the city. Rattled, they sailed into battle and proved him right.

Island life stayed complicated with the coming of peace. In 1821, a hurricane remembered as the "September Gust" swallowed all. "Even the highest land had 3 feet of water over it," another descendant of Joseph, Thomas "Sugar Tom" Crockett, wrote later.

Then, a new disaster: A cholera outbreak in 1866 killed "as many as six adults . . . in 24 hours," Sugar Tom wrote. "I could hear the voice of weeping nearly all night." Typhoid deepened the settlement's misery in 1870. Even so, the descendants of Joseph Crockett stayed put. They had children, many children, and the population grew, and space became tight. So islanders gave up farming, turned to the harvest that waited offshore. Over time, Tangier became the quintessential waterman's town, its fate inextricably tied to the bay's fish, oysters, and crabs.

This new reliance on the water put islanders at even greater mercy of the weather, for in the old days, the descendants of Joseph Crockett relied on sail to reach their oyster grounds and fish traps, and lacked any means of predicting storms. Ooker Eskridge's great-grandfather, Capt. Harrison Crockett, drowned when his boat capsized in an 1896 gale. His father, Will, barely survived the great August storm of 1933, which arrived without warning while he crabbed. "There was only two boats afloat when we come in the harbor," eighty-nine-year-old Will says. "There was a bleak-looking time."

So Tangiermen embraced their Methodist faith with a deepening conviction. They prayed for all that they could not control—for protection under sail, for haven from storms, for good catches and good markets. They prayed for relief from the freezes that marooned the island in 1900, in 1905, and for fifty-two days in 1917–18. And eventually they prayed over a new problem they noticed after the ice melted, the floods retreated.

Their tiny domain was getting tinier. Floes carried off tump after tump of marshland. High water sucked away sand and soil. Tangier was shrinking, and seemed to be sinking, as well; islanders began to see that even mild seasons left their mark.

The wear was particularly fierce on the west side. As a young man,

Ooker's grandfather, Ira, could walk west from the island's Methodist church and not run out of land for close to an hour. When he did, he'd find himself in a village of twenty-odd houses called Oyster Creek—oil-lit, privies out back, busy with playing kids and chatting women and, in the evenings, a straggle of weary watermen.

"You had to walk forever to get to it," Dewey Crockett says. "It seemed like the western side of the island went on forever before you even saw the water."

"They had pine trees grew over there. They used to play ball over there," Will Eskridge recalls. "Oyster Creek was a right big place."

Today, the curving road out that way dead-ends a half mile shy of the town site. Oyster Creek is invisible, the foundations of its homes a fathom under water, its location marked by a navigation beacon 150 yards offshore.

In 1964, a descendant of Joseph Crockett's named Asbury Pruitt jammed a stake into the western shore several yards from the water's edge, then checked every so often to see whether the surf drew near. It did. Rapidly.

In fact, an Army Corps of Engineers study later reported that Tangier's west side was retreating an average of eighteen to twenty feet per year, and had been doing so since at least 1850. In the time it took a Tangierman to go from diapers to skippering his own boat, his island narrowed by three hundred feet. And most of the lost ground was sod, not sand, so little of it was carried by currents to other parts of the island. Tangier was not, in other words, migrating eastward. It was simply disappearing.

That was plain with a glance at old maps: By the mid-1970s, all but a few slivers of Tangier lay east of the seventy-sixth meridian. Charts from 1872 and 1892 showed the island stretching far west of the line. They depicted, too, a mile-long island clinging to Tangier's northwest corner. It no longer existed. They showed the grove of trees where Joshua Thomas delivered his prophetic sermon. It was now far out to sea.

Even maps as recent as 1942 included Little Watts Island, a three-acre knob of sand southeast of Tangier dominated by a 48-foot lighthouse. By thirty years later, the only trace left of Little Watts was a shoal in the Chesapeake, littered with bricks.

They got a Tangierman worried, those bricks did. So did the pine stumps that studded the shallows off to the northeast, stumps that once were high and dry. So did Watts Island, just above Little Watts, which many an islander skirted on the way to his crab pots. Watts had been home

to farmers, way back. Now it seemed to be melting. High water swamped it. Its loblolly forests had thinned to a couple of clusters. The last vestige of its human habitation was falling into the water: its graves.

By 1975, the runway lights at the southern end of Tangier's airstrip had collapsed into the bay, and the trouble was accelerating: Asbury Pruitt's measurements showed that that part of the western shore had moved 181 feet east over the previous five years. It had moved 44 feet during 1974 alone.

"An emergency situation exists on Tangier Island which must be remedied immediately," a state panel reported three years later. "The erosion of the island is so severe that it will wash into the Chesapeake Bay in the very near future." Tangier had a host of other ills, the group told the governor and General Assembly, but if the erosion went unchecked, "the other problems will not need to be addressed."

Early on, Joshua Thomas and Rachel Evans had a son, John. And John Thomas begat a son, who had a daughter, and she a son, and he a daughter. And that daughter married Homer Pruitt, and with him had a daughter, Barbara.

And Barbara married Capt. Rudy Thomas, who ran the island's mail boat, as his father and his father's father had before him. And they had a son, whom they named for the captain. And on this spring evening forty-three years later, Rudy Thomas the younger is standing on a bumpy shelf of oyster shell and sand in the island's boatyard, eyeing the jagged gray sea wall that finally saved Tangier's western shore.

By the time it came, the bay had snapped great slabs of asphalt from the airstrip. It had crept little more than one hundred feet from the island's new sewage treatment plant. Now 68,128 tons of riprap, $4 million worth, looms high along more than a mile of shoreline. Tangiermen agreed to a fivefold hike in their real estate taxes to pay the town's share of the cost, an outlay most view as a bargain: Ooker Eskridge calls it "an answered prayer." Dewey Crockett says that without it, 1999's Hurricane Floyd "would have wiped the island out."

But the sea wall hasn't stopped Tangier from crumbling into the Chesapeake; it's only slowed the process. The upper part of the island, the seahorse's head, has shrunk alarmingly since the wall's completion in 1990. Used to be that part of its marsh guarded Tangier's harbor from nor'easters. The bay has chewed most of that shield clean away. On the harbor's east

side is Port Isobel, a disintegrating islet owned by the Chesapeake Bay Foundation. If much more of it falls into the bay, Tangier's densely populated Main Ridge will be wide open to winter storms.

The land's failing even faster a few yards from where Rudy Thomas stands. The sea wall ends here beside the boatyard, at the channel the Army Corps of Engineers carved thirty-five years ago between the seahorse's head and body. Now the channel is tearing at its edges. It started seventy-five feet wide; it's better than four times that now. Each new tide, it seems, reams it wider.

"I wish before that hurricane, that Floyd, that somebody had taken some pictures here," Thomas says. "Because when you go through there every day, you really don't notice the changes."

Rich Pruitt and Ed Parks, fellow descendants of Joseph Crockett, slowly shake their heads. The three stand among the yard's clutter of idle machinery and beached deadrises, boats that have dragged crab scrapes through the mud settled on Oyster Creek's bones. From here they can see the navigation marker winking over the former town site.

"I wonder what the babies'll see when they get to be our age," Ed Parks murmurs. He nods toward the channel.

"Lord sakes," Pruitt whispers.

Parks points toward a clump of trees a mile off, on Tangier's northern end. Within the memory of older islanders there was another village up there, Canaan — "Uppards," in Tangier slang — that had its own stores and school. A handful of gravestones is all that remains of it. "There ain't much good land left at Uppards," Parks says. "It's all gone."

"That it is," Thomas agrees.

"It sure is," Pruitt nods. "It's sure goin' away from here in a hurry."

<p style="text-align:center">II</p>

On some days, when the crabs aren't biting and the bugs are, when the wind's blowing the Chesapeake Bay into a froth, when the trip to the mainland's a carnival ride, it can seem that Tangier Island's faith is the only good it's got.

Sky and bay conspire against the place; nor'easters bring water up out of the guts and over the narrow lanes, often into yards and sometimes into houses. The marsh breeds gnats, skeeters and bloodthirsty greenheads, and the fool flies that foretell a north wind. Making a living here requires strong muscles, long hours, and a measure of luck, for as an old saying goes,

all that's known for sure about the blue crab is that she'll run from you, and she'll bite.

Yes, faith has been a key to the island's strength for nearly two hundred years. Church is not a weekly event on Tangier; it's the island's compass, and its radar, and its loran. The town council is made up of Christians. The public school is led by churchgoers. No town decisions are made without the assent of Swain Memorial United Methodist Church and a breakaway flock, the New Testament Congregation. Tangier might be part of the state, but it's led by the Scriptures.

So it is that no alcohol is sold on the island. No lottery tickets. The school's spartan library circulates no Harry Potter novels. In March 1998, the town council voted that *Message in a Bottle* could not film here because its script included beer drinking and fornication.

So it is, too, that the preaching at Swain Memorial will often take a pragmatic turn, that Dewey Crockett will stand before the congregation to voice worry about "the many weeks that a lot of our men have been out of work, and the difficulties that it makes on families and so forth," that he'll ask the flock to "pray that the Lord will open the door for financial help at this time for needy families."

Or that Otis "Strick" Crockett will rise in the soft light of the church's big gothic windows to say: "We thank thee, Father, for the oysters you've allowed our men to catch, the crabs that our men are catching, the clams." Or that L. Wade Creedle, beginning his ninth year as Swain's pastor, will welcome the island's watermen back after weeks away with an aside to the heavens: "Wish it could have been longer and more profitable for them, but we're grateful for what they were able to do."

So it's been since Joshua Thomas's day. He eventually moved away from Tangier, but fellow believers took his place, and they passed the Word down to those born behind them, and they in turn to others, and they to others. And on this gray and gusty afternoon, George "Cook" Cannon Jr., heir to this long line of Methodist lay preachers, is speeding across the airstrip's apron in his pickup, one of the few cars or trucks on Tangier.

He is worried. As pervasive as the island's faith might seem to outsiders, it has thinned in places. "It's more than just the beach erodin'—it's lifestyle," he says, skittering through a turn onto the empty runway. "The thing is, we noticed when Oyster Creek was gone, but it seems like the marshland, you don't notice too much. And that's what's happening to

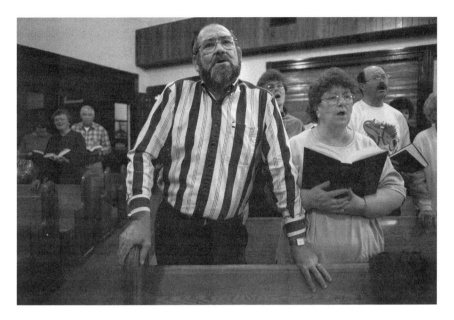

George "Cook" Cannon Jr. sings beside his wife, Jody, at a Swain Memorial service. (Ian Martin photo; used by permission)

the world: Them things that used to be bad, and sin, they say, 'Well, times has changed.' Things creep in."

He cites evidence unthinkable years ago: Unmarried couples living together. Unwed pregnancy. Bootlegging. Drug use. Not like on the mainland, perhaps, but foreign to Tangier. "It ain't like it used to be," he says. Indeed, it doesn't take a Tangierman to see the signs. A sticker on a kid's motorbike that reads "Porn Stud." The Divinyls' "I Touch Myself" blasting from the windows of a Main Ridge home. Dozens of empty beer cans lifting from the marsh during a late March nor'easter.

"We used to visit a lot on here," Cannon says, jolting the truck to a stop outside the sewage treatment plant, which he runs. "That's all people done, is visit, go to people's houses and sing, and just have a good time. Just some good-time fellowship and eating and sharing." No longer: "My brother, right here on the island, I might visit him once a year."

Somewhat to its chagrin, Tangier has become part of a greater, busier world. Island homes didn't get telephones until 1966; now, 60 percent of its children, Dewey Crockett reckons, have Internet access at home. Reli-

able boat engines have reduced time to the mainland; these days, families routinely visit Hampton Roads, Baltimore, Ocean City. And Tangiermen have left the island to fight America's twentieth century wars—more of them, per capita, in World War II than from any other Virginia town.

All of that has created a community far more world-wise than the outpost *Harper's Magazine* visited in 1914, where the Methodist pastor was "a benevolent despot whose word is law," and island children "came wide-eyed, silent" to "gaze wonderingly at the sight of strangers."

Most tellingly, satellite dishes seem to sprout from every yard. TV has brought a host of demons into Tangier homes—sex and violence and witchcraft, blasphemy and the bottle. It's brought other places and customs, too, perhaps to even greater effect; to bored teens on boggy Tangier, life just about anywhere else can look glamorous, exciting, easy.

And Lord knows, they are bored. The island's recreation center is often closed for lack of an adult chaperone. Tangiermen have no library beyond the school's carefully censored offerings. Music CDs, videotape rentals, clothes, shopping malls—all require a lengthy trip to Crisfield, Maryland, and beyond. A good many youngsters simply kill time by orbiting Tangier's meager road system on motor scooters or golf carts, looping down the Main Ridge, across the marsh and over the Big Gut, up the West Ridge, and back over the wetlands. Well into the dark they do it, no matter the weather. Sometimes they ride for hours straight.

And it happened that the descendants of Joseph Crockett took up nets, and built homes with the bounty they culled from the bay, and married, and raised families. And among the bloodlines to which they were bound was the Charnock. And these Charnocks, fishermen too, multiplied.

And one among them, John, married Dora Parks, and they had a son, Vaughn. And Vaughn Charnock married Virginia Thomas and with her had a son, Edward. And on this sunny Saturday afternoon fifty-three years later, Ed Charnock is repairing crab pots a few yards from the dock where Rudy Thomas—the nephew of Ed's sister's husband—ties up the mail boat.

Charnock wears what approaches a cool-weather uniform for Tangier watermen: bib overalls, sweatshirt, gumboots, ball cap. He carefully paints the buoys that will mark his pots, cuts new line to link the two, lets the rope ends soak in a muddy puddle before knotting them.

"Not much for 'em to do around here, the young kids," he says. A pause.

He clips a bar of zinc to a chicken-wire crab pot, without which the mesh would corrode to pieces in the bay's salt water. "Well, nothin'," he says. "There's nothin' for 'em to do."

When he was younger, the island had dance halls, a pool room. All gone. Outside the tourist season, there's no place for a kid to hang out these days but Lorraine's, a short-order diner down by the docks. Of course, when Charnock was coming up, there also was work to keep a boy busy: Most quit school on their sixteenth birthdays to follow their fathers into the oyster and crab business. "I know I dropped out," he says, finishing repairs on one pot, grabbing another. "Wanted to get on the water."

A good year working the bay brought a man at least as much money as a job on the mainland. And while it might be dangerous work—"You better know what to be afraid of," Charnock says, "or you get drownded"—a waterman was his own boss. He had only to suit himself.

"Now, with the way the water business is, I think most of 'em tries to stay in school," Charnock growls. He nods toward his stacks of crab pots. "There ain't no future in it."

The island's economic nucleus is a village on stilts rising from shallow, murky water—crab shanties, dozens of them, perched a few feet over the drink and all but hidden by stacks of crab pots. Boats are parked alongside, sterns lavished with the names of watermen's wives. The water is rainbowed in oil. The breeze carries the scent of two-cycle exhaust, fresh bait, and old crab. Six summer mornings a week, Tangier's deadrise fleet pushes away from these shacks and into the Chesapeake, on the prowl for *Callinectes sapidus,* the bay's famed blue crab.

On looks alone, it hardly seems worth the trouble. No bigger than a man's hand, the crab is sheathed in a spiky green-brown armor, its face an expressionless whir of wiggling feelers, its match-head eyes black and indifferent. But hidden in its exoskeleton are pockets of sweet, tender meat. Restaurants all along the Eastern Seaboard depend on the bay's harvest for their crab cakes, their steamed crabs, for the softshells they serve to the adventurous. A good piece of the time, that means they're depending on Tangiermen.

The island's roughly two hundred watermen account for more of a catch, man for man, than any community in the Chesapeake. Together, they comprise one of the nation's largest sources of softshell crabs. This distinction is partly the by-product of another form of erosion, for early islanders were fishermen until the fish left, and oystermen until most of their quarry was killed off by disease, pollution, and overharvesting.

But it's also a matter of geography. Each summer, millions of female crabs ride the outbound tides toward the Virginia capes, drawn by the saltiness of the water near the bay's junction with the Atlantic. It is an ideal nursery for their babies, which they carry up to 2 million at a time in eggs clutched to their bellies.

Bug-eyed and shrimplike, the hatchlings erupt in opaque blooms, drift into the open ocean for a short while, then return to the Chesapeake and start up the bay. Every few days at first, less often later, they grow too big for their skins and back out of them, resting in the cover of the bottom's weeds and grasses until their new, soft shells harden.

By late fall, millions of young crabs have reached the waters around Tangier, where they burrow into the muddy bottom for the winter. The following summer they reach adulthood and mate in the bay's Maryland waters. Afterward the male crabs, or jimmies, stay put. The females, or sooks, turn back for the lower Chesapeake.

On the way, winter again sets in, and the sooks again burrow near Tangier. When they emerge in the late spring they fertilize their eggs with sperm they've carried for nearly a year, and develop huge egg masses, or "sponges," that hatch a couple of weeks later.

All of this makes working the water around Tangier as close to a sure bet as there is on the bay: Young crabs, male and female, pass the island headed north on their way to mate, sooks once more on their way south to spawn. In the winter, Tangiermen hunt the hibernating crabs with dredges they drag behind their boats. The teeth of the heavy iron rakes bite into the bay's floor, uprooting the burrowed animals and scooping them into rope nets that trail the contraptions like lawnmower bags.

From April to November the island's watermen chase hard crabs. Some use scrapes, which resemble toothless dredges and skim crabs from the bottom. Most use crab pots, two-foot cubes of chicken wire on rebar frames, easy for crabs to enter but difficult to leave. And over the summer many of them seek "peelers." A live softshell can bring a crabber two dollars or more—many times the price of a hard crab—so Tangiermen catch crabs preparing to molt, and hold them in "shedding tanks" until they do.

The island is single-minded in its mission. The summer's daytime population is overwhelmingly female; all of the men are out on their boats. Aside from widows and retirees, the schoolteachers, a few merchants and three innkeepers, all of Tangier relies on the blue crab for its daily bread.

But how long it will last, no one can say. Virginia's fisheries experts have worried that the number of adult sooks is dropping—by 70 percent

or so in the lower bay, just in the six years beginning in 1994. The species' spawning stock may be in trouble.

Scientists worry that adult crabs seem to be getting smaller, too. John B. Graham III, vice president of Graham & Rollins, a Hampton crab processor, says there's no question the animals have shrunk; a pile that once yielded twelve, thirteen pounds of meat, he says, is likely to produce just eight pounds today.

A good many Tangiermen have little faith in scientists and bureaucrats, and even less in environmental groups like the Chesapeake Bay Foundation. The crabbers note they're on the water every day. They see up-close the "resource" they say the mainlanders only talk about.

Fueling the islanders' doubt is the dearth of hard information about the number of crabs in the bay, the number being caught, and the exact level of harvest at which the fishery becomes overtaxed. "They don't know what they're doing," Will Eskridge says. "They probably got a good education, but they still don't know much about the water."

The scientists can say this with certainty, however: More crabbers have spent more money to put more pots in the water, and they've not caught more crabs. For each of the years from 1994 to 1999, Virginia watermen pulled an average of 34.7 million pounds of blue crab from the Chesapeake. While the catch remained relatively constant, the number of pots in the water ballooned: Hard pot licenses rose by 14 percent between 1994 and 1998. The number of licensed peeler pots leaped from 202,000 in 1994 to 357,000 in 1999.

In short, the overall population of crabs has dropped, while the effort to catch them is at or near an all-time high. Add in the evidence that crabs are getting smaller and adult sooks are down, and it's all too possible that the blue crab is no longer holding its own.

So over the past few years the Virginia Marine Resources Commission has required crabbers to cut "cull rings," or holes, in the sides of their pots to enable undersized crabs to escape. It's cut the number of pots a crabber can put in the water. It declared a chunk of the lower bay a sanctuary to protect spawning sooks and their hatchlings, and later declared a huge swath of the middle bay off-limits.

It's also required watermen to buy a separate license for each kind of gear they use, whether it be hard pots or peeler pots, scrapes or dredges. And in 1999 it took the most drastic step yet: a lockdown on new crabbing licenses and a ban on most license transfers.

"It was a matter of a few years back that any job we wanted to do on the

water, we could do it," says Ronnie Pruitt, another descendant of Joseph Crockett. "But now, we ain't got no license, and we can't get no license."

What troubles islanders most about the freeze is that it locks many Tangier youngsters out of the business. "Which is unreal, when you've grown up on an island," says Jerry Pruitt, who owns the Tangier boatyard. "It's a-hurtin' bad. It's been hurting my business, certainly. We've not had any new watermen, because they've not been able to get a job."

"I think there's a fear that's been placed in a lot of our young people," Dewey Crockett says, "a feeling that, 'Yes, I could do this, and I probably would love to do it, but I don't know if it's going to last. I don't know whether I'll be able to get the essentials to do it with.'

"That's the scary part. It's going to be a fading profession, because there will not be anybody here to pick up and go," Crockett says. "We want to put people to work, but the only work that can be done around here is working on the water. And now, little by little, it seems to be taken away, and it just blows the watermen's minds."

As if crabbing weren't difficult enough, erosion in the seafood market now threatens the Tangier waterman, too. Uncertain catches and prices have prompted a growing number of restaurants and food distributors to ditch Chesapeake Bay blue crab for cheaper foreign crab meat. Right now, restaurants throughout the Mid-Atlantic, including some famed for their Chesapeake fare, are serving it in their crab cakes.

John Graham, the Hampton crab processor, says the imported meat has devoured much of the demand for blue crab. "The thought is now that if crabs come back, and we hope they do, we may have trouble recovering that market share," he says. "We may never recover it."

The foreign crab tastes nothing like the homegrown, but that's lost on many diners. "I don't think you can get no crab anywhere else that'll beat this for the taste," Ed Charnock says. "But I guess those restaurants don't care, as long as it's cheap. People get a crab cake, and they don't know how it's supposed to taste, so they don't know the difference.

"I'll tell you one thing: It makes a difference to us."

And so there is lamentation among the people of this shrinking land, for they conceive the decline of their livelihoods. And yet the people face another woe that promises their end. For they fall in number, and this loss they are unable to stanch.

Consider that Dewey Crockett was an anomaly when he decided to

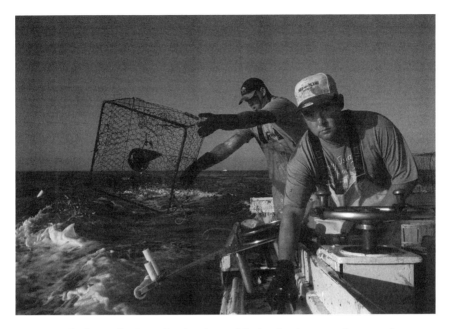

Michael and Allen Parks, distantly related, prowl for hard crabs nine miles west of Tangier. (Ian Martin photo; used by permission)

stay in school, and an even greater one when he left the island for college and seminary. In 1963, the year Crockett turned sixteen, the Tangier school graduated ten seniors out of an original class of twenty-six. Seven of the ten were girls. Crockett was a sophomore that year; his own class, twenty-nine strong in first grade, fell to ten.

By 1984, when he returned to Tangier, the course he'd set was no longer the exception. Throughout the 1960s and 1970s, a rising percentage of island boys had decided to stick with high school; male graduates now far outnumbered their contemporaries who dropped out. "I've been here sixteen years," Crockett says, "and I don't think we have had over three head who have quit school."

This might seem good news, particularly to an educator. But Crockett and other islanders have witnessed its troubling corollary: Those boys who stay in school usually intend to leave. This year, three of Tangier's nine graduating seniors will join the navy. Another four plan to attend college. Only two, both of them girls, will remain on the island. It's the loss of boys that most worries Tangiermen, for while women contribute to the island's

well-being in uncountable ways, they don't captain workboats, don't work the water.

Older islanders trade a host of theories as to what's brought about the change, and are particularly fond of blaming the license freeze and similar regulation. But those are recent developments; a more compelling explanation is that over the past thirty years, young Tangiermen have grown increasingly aware of options to the hard labor and uncertainties of a waterman's life.

"Even some of the fathers who work on the water, because of the hard work and the hours and so forth will say, 'Son, go get your education if you can get it, because the water business is awful rough and hard, you know,'" Crockett says. "So there's an encouragement from the family.

"Not that the water business is not a good profession," he says, "because people have made money, and you've got it in your blood, and you don't want to do anything else but that. But even the elderly people who have worked all their life on the water'll say, 'If you can get your education, son, go do it.'"

Tangier offers few ways to put such an education to use, however. "We can't jump in a car and go to Perdue's or Tyson's or go anywhere," Crockett says. "Jobs are very, very limited unless you're in education, and then they're limited because there're only so many positions.

"So young people who are graduating from college remain on the mainland, marry over there and stay in one of the cities or towns. A few come back if there's a teaching position or something they can do, but most of them can't. So there's diminishing of the fact of our young people, and the population among the youth."

The exodus has steepened a slide that began when Will Eskridge was a young man. Tangier was crowded then: In 1930, when Will turned nineteen, the head count stood at 1,120. But by the time he reached his thirtieth birthday, he had 100 fewer neighbors. As he neared fifty, the population was down by another 144. Twenty years later, another 110 Tangiermen were gone. Ten years ago, when Will Eskridge was seventy-nine, various government agencies put the count between 659 and 700. And the descent continues: In the space of two weeks this past March, three islanders died.

This isn't apparent at first glance, for Tangier today has more houses than ever. Suburban-style ranchers have sprung up beside narrow, plain-faced cottages on Canton Ridge. Two homes were under construction this spring on the west. But the island's households are far less crowded than

those of old. It wasn't unusual for midcentury couples to have seven, eight, even ten children. Those today are having far fewer, too few to reverse the population's tumble; the 1990 census found an average of just 2.6 people living under the typical Tangier roof.

"It almost makes me cry to think about it," says Cook Cannon, whose own children live in Crisfield. "It's pitiful. If all the young people leaves, we're not going to maintain the upkeep of the island. It costs a lot of money to run this town. And if there ain't enough money here to run it, what is gonna happen? I don't know."

This is not an idle worry, for as its population shrinks, Tangier is aging. Children fourteen and under accounted for nearly one in two islanders in 1900. Ninety years later, their share of the total had dropped by half. Over the same time, the percentage of islanders aged sixty-five and over underwent an eightfold jump. And their proportion has kept growing. "Most of the watermen now on Tangier are now, I'll say, from their forties on," Jerry Pruitt says. "Two-thirds of them are in their forties on. And a big end of the other third are in their thirties. Very few in their twenties."

Crockett notes that the Tangier Combined School's current kindergarten class has just two students, both girls. "We have a large number of people on Tangier that are in their seventies, eighties, and nineties, so we've got an old population, a lot of senior citizens," he says. "So we're about seven hundred in population now, but it will drop because of the fact of just natural causes of death and so forth, the age, and then young people not coming back.

"We all put it in the back of our minds, sometimes, and hope that things twenty years from now will be like they are now, or even better. But we also need to get real," he sighs. "They're certainly not going to need my services as a schoolteacher if there are no children here to teach."

Down through time the descendants of Joseph Crockett married and multiplied, and filled their island with a hardy and God-fearing people. And among them were John and Dora Charnock, who had a son, Grover. And Grover Charnock—who was brother to Ed Charnock's father, Vaughn—married Christine Crockett, and with her had a daughter, Nina. And on this quiet Friday noon thirty-eight years later, Nina Ruth Pruitt is sitting in the library of the Tangier Combined School, talking about what might be done to stave off the collapse of the island's population and economy.

"This is something we've said over and over and over, but we really need to do something about it now: We have got to look beyond the water business," Pruitt says. "We just need to look beyond and outside of the realm of the water business to see what we can do to expand—to grow, to keep our island community as it is now."

But what other business is there? What other line of work is suited to an island in the middle of the Chesapeake? Decades back, Tangier had several factories—the fish plant on the spit, a soft-drink bottling house, even a shirt manufacturer. But these days, building a plant to provide the jobs needed to keep the island working seems a dim hope.

"We don't have room to build a factory," Dewey Crockett says. "They'll say, 'You know, you ought to be looking into bringing other companies here,' and that'd be wonderful. But look at the difficulty of bringing everything here. I mean, not only building the building that you have to have to do this—if we had the land—but the price tag on the freight of bringing everything in, and taking everything out after the product's finished. You can't back a truck up to a door here."

One possibility, Nina Pruitt believes, is tourism. It has grown steadily since 1976, when ten thousand outsiders visited; some years it runs upward of twenty-five thousand. "We're in the process of receiving a grant for a visitors center," she notes, "which is something we've never had."

Most of today's tourists are day-trippers, however. They visit for a few summertime hours, shop in the gift shops, eat a meal, and leave. The bulk of the money they spend falls into few hands. That would have to change.

Tangier's habits might have to change, as well. Its people have not used their island gently: The marsh's austere beauty is blemished by discarded appliances, engine parts, blowing trash. At low tide, TV sets and car batteries and slime-furred bicycle frames appear in the guts. Junked cars are prominently displayed on the West Ridge. Empty oil bottles float among the crab shanties.

They may get quite a few visitors, leaving things the way they are.

But not many twice.

And so it has come to pass that the descendants of Joseph Crockett are a beleaguered people, for their island erodes beneath their feet, and their culture lifts from around them as a cloak caught in the wind. And their prey dwindles in the waters, as do those who would hunt it. And all around are signs of the end.

But on this Tangier afternoon 222 years after Joseph Crockett's arrival, Dewey Crockett, Joseph's great-great-great-great-great-great-grandson, is unwavering in his faith that the Almighty loves this island, and will provide for its people.

For history is rife with disease and disaster that might have spelled Tangier's end, had not God provided: when the cholera came and went; when the September Gust ruined croplands that the following year yielded their greatest harvest; when the oysters died off, and Tangiermen learned to earn their keep from crabs alone.

"Many you'll hear say, 'You couldn't be a waterman and not believe the word of God,'" Crockett says. "You look at the many, many times that life has been spared because of the rough waters." He leans back, opens his hands. "I feel—and maybe this is just being prejudiced—but I feel there has been a special anointing that has been put upon Tangier because of their strong religious stand and their strong belief in prayer.

"We're a blessed people," Crockett says. "It seems like when everything looks like it's to an end, that another door opens."

So it has been. So, with untold millions in outside aid, it may be again. Down on the spit, Joseph Crockett's great-great-great-great-grandson, Ooker Eskridge, ambles across the sand to his skiff. He whistles to his

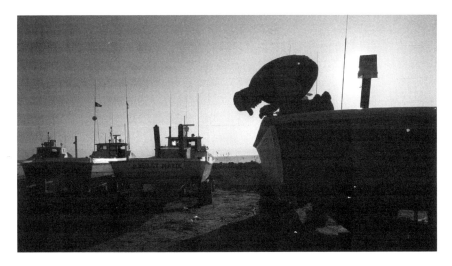

Freddie Laird readies his boat for the season as the sun sets on Tangier's boat yard. (Ian Martin photo; used by permission)

Dalmatian, Tino, watches as the dog bounds across the beach and vaults into the boat.

Outboard clear of the bottom, Eskridge backs away from the sand, then spins the craft north, toward the church spire. Grassy shore passes on his left. Houses loom on the Canton Ridge.

He reaches out to scratch Tino. A bracelet emerges from beneath his shirt cuff, bright nylon webbing lettered "Jesus Loves Me." The sun is low. He squints, pulls his ball cap lower. A silver cross glints at his throat.

The island may, in the Tangier way of putting things, be going away from here in a hurry.

But faith, Tangier has.

That it does.

Bang the
Drum Loudly

The club is packed. Two hundred heads are nodding to a cover band's take on ZZ Top's "LaGrange." It's near the end of the song, the part where the tick-tick-ticking whirls into a sonic tornado. Guitars are screeching. The bass is thumping and growling. And the drums—the drums are totally out of control. You can hear them outside. You can hear them across the parking lot. Clear across Shore Drive you can hear them. Inside, you can't hear your conscience. An artillery barrage is what it's like, and ground zero is the concrete dance floor in front of the Fifty-One-Fifty's stage.

And check it out: The guy making all the racket, the one beating the daylights out of the drums, isn't some gorilla-armed musclehead. He's this tall, skinny dude, long face expressionless, sticks and feet working a small white drum kit a dozen ways at once.

The song ends. The crowd whoops. The drummer's face remains a blank through the applause, stays that way as the band kicks into another number. Doesn't look bored, exactly—nobody bored whales on drums

with that kind of passion, that precision, that power. More like jaded. Like he's seen it before.

Which is true enough. This is a bar, after all, and he's played arenas. This is a good crowd, but one time the guy played to almost a thousand times as many metalheads. This is Plastic Eddy, a bar band, and see, the drummer is a rock star. His name is Scott Travis. And when he isn't doing this, he's the drummer for Judas Priest.

No lie: Judas Priest. Judas Priest, as in the heavy-metal hair band. As in the Defenders of the Faith, the leather-clad knights who helped lead the monster-rock ranks in a crusade against the New Wave infidels. As in "Breaking the Law" and "Screaming for Vengeance" and "Let Us Prey."

Yeah, that Judas Priest. And yeah, their drummer is Scott Travis — born at Norfolk's DePaul Hospital, raised a couple blocks away on Beverly Avenue, now the owner of a yellow-brick rancher just north of Pembroke Mall in Virginia Beach.

You wouldn't know a rocker lives there, to look at the place. Well-tended lawn. No dishes in the sink. A big recliner, the kind dads have, in the den. No drum kit. No gargantuan stereo. No harem of teased-hair metal chicks. A gold record for Priest's 1990 *Painkiller* album hangs on one wall, and a couple Grammy nominations, too — Best Metal Performance for *Painkiller* and for a song, "Bullet Train," off the 1997 *Jugulator* album. A reprinted magazine ad for Tama drums in the kitchen is headlined, "Scott Travis — Thunder, Sweat and Madness."

Otherwise, it's just a place in the suburbs. "When the weather's warmer, I have things to do around the house, just like any homeowner does," he says. He's sitting in the living room near a potted ficus, the six-foot-six length of him origamied into a chair. Like, he cuts the grass, he says. Takes out the trash. Rakes leaves. Cleans the pool. "The playing in the local band, that keeps me busy on weekends," he says. He shrugs. "It's really sort of a nondescript life."

Right now, maybe. But Judas Priest has a new album coming out, and the band'll probably tour to promote it, and when that happens, Scott Travis will hang up his suburban existence to return to his metal godhood. He won't be playing local bars any more. He won't be doing yard work.

The thunder, sweat, and madness date back twenty-six years, to when Scott Travis was thirteen, in junior high. That Christmas his mom, a widow four years, got him his first kit, covered in blue sparkle. Until then he didn't

have time for music: When he wasn't in school, he was in the garage, tin-kering with his motocross bikes, or in the yard, testing his work with twists of the throttle and unmuffled burps of exhaust.

But Scott's mom, Doris, was trained at Juilliard, and led the choirs at three local churches. She even sang the national anthem once for Richard Nixon. And maybe music runs in the blood, because something about the drums entranced him, and Scott threw himself into playing with the same focus that he'd devoted to winning a roomful of dirt-bike trophies. "His dedication—well, you could see that he was a perfectionist," his mom says. "He'd just keep at it until it was perfect."

A couple years passed. Trey Hannah, another drummer, remembers sitting in class at Granby High when this friend of Scott's announced, all cocky, that his bud could totally slay the school band's whole drum sec-tion. Like, by himself. Trey thought it was just big talk. "I said: 'Oh yeah? Well, I'd like to meet him.' So he introduced me."

And whoa: Scott could play every Rush song beat for beat. It was like having Neil Peart in the room. And he could whale on his kit like Alex Van Halen, too. "I was damn impressed," Trey says. "It was a given he was going to make it."

The two became fast friends. "We'd fantasize about his being in Judas Priest," Trey says. "Or any band, for that matter. But I remember that Judas Priest was one of the bands we talked most about."

One reason: The Priest had a lead singer, Rob Halford, who alternated between satanic growls and operatic shrieks, and guitars that sounded like band saws cutting through engine blocks, and a stage show heavy on leather and chrome studs and uncooked meat, and song lyrics about apoc-alyptic ass-whippings and wet monkey love.

Reason No. 2: The band's drummer, Dave Holland, wasn't lame, ex-actly, but he wasn't great, either. The dude was a timekeeper, no more. It was crazy to think Scott Travis could bump Neil Peart or Alex Van Halen out of a job. But Dave Holland? That didn't seem nearly so far-fetched.

Scott was still at Granby when he started playing with a Norfolk band, Caliber. They got some gigs, had a following. Bumper stickers, even. "He had a drum solo," Trey says, "and everybody in the place—sailors, mostly—would stand up on their chairs and cheer for him."

Once out of school, he worked by day at a tire place, into the wee hours on stage. He'd graduated to a new kit, a green Ludwig Vistalite Octa-Plus—a huge thing, a monster, an ugly reservoir of drums. The kit knocked fillings loose up and down Little Creek Road. By now he was

with another band, Teaser. They did Heart covers, LedZep, April Wine, a few originals. "They'd practice up on my second floor," Mrs. Travis says. "I had to lip-read the television. I don't think there was air-conditioning up there at the time, so when they'd finish they'd be slushing around in their shoes, they were sweating so much."

It's at this point that Judas Priest comes to town, and Scott finds himself mulling a scheme: He'll drive his van over to the Hampton Coliseum and unload his drums in the parking lot near the stage door, and "start kicking some double-bass ass when they pull up."

Nearly twenty years later, there's this myth that he did that, and got discovered right there on the Hampton asphalt. Actually, he just took some pictures of his kit with him to the show. "I don't think I even had a cassette of me doing some cheesy drum solo," he says. "At the least, I should have had that, you know? What were they going to do, look at my pictures, say, 'Hey, nice drums—OK, you're in the band'?"

Flawed or not, that was his plan. After the show, he went searching for Priest at the Sheraton, walked into the hotel bar and right there in front of him was Glenn Tipton, Priest's guitarist and leader, talking to some other dude. Scott asked for his autograph. Then: "I pull out my pictures, and I say, 'Hey, I gotta show you some stuff,' He looked at them, and I asked, 'So, what do you think of Dave Holland?'

"And he said, 'Oh, Dave's great,' whatever, and at that point I thought: 'Well, I guess he likes Dave, so I guess I won't try to break them up.'"

A lot of hotel bars have come and gone since then. They all look the same. These days a lot of them come with some wide-eyed kid holding a tape in his hand, asking the great Scott Travis to listen to him play.

We'll get to that. First, though, it's the mid-eighties, and Scott's still playing bars in Norfolk and the Beach, hanging and hoping. And a buddy in California sends him a copy of Bam, an L.A. music-scene rag, and in it is an ad from a band looking for a drummer. Scott and Trey load up a Ryder truck and head west.

The band turns out to be the brainchild of this dude named Doug, who's made a ton of cash selling taped heavy-metal guitar lessons through the mail. It also turns out to be a glam rock outfit with a stupid name— Hawk—and a sound that makes the name seem good. Soon enough, Scott is looking for a new gig. He knows this guy, Paul Gilbert, a total guitar whiz who plays in a band called Racer X. A metal band. A band building a reputation for fist-waving lyrics and riffs like shrapnel. Gilbert invites Scott to jump ship.

So the late eighties find him in Sherman Oaks, California, sharing an apartment with his Norfolk girlfriend, Sharon, and playing big clubs like the Whisky and the Roxy. Racer X puts out a couple CDs with Scott pounding away on the drums. The second has a wicked solo that he's particularly fond of.

The same years find Judas Priest struggling. Dave Holland is said to be unhappy. Priest isn't thrilled with Holland. Eventually, things come to a head. Priest's lead singer, Rob Halford, is talking one day with Jeff Martin, a singer who, like him, lives in Phoenix, and he describes the band's troubles. Jeff Martin is the erstwhile singer for Racer X. He calls Scott Travis, says: Guess who's looking for a drummer?

Dunno, Scott says. Who?

Judas effing Priest, is who.

No way, Scott says. You have to be eshing me.

So in the fall of 1989, Scott ships off the two Racer X CDs "as my resume." That November he flies to meet the band in the south of Spain. "People who knew me and knew Priest," he says now, "were: 'Dude, you're it. You're gonna get it.'"

Priest was holed up in an old sugar mill. The band had him whip through its concert standards—"Breaking the Law" and "Victim of Changes" and "You've Got Another Thing Coming"—then some stuff from a newer CD, *Ram It Down*. "After the audition we went out to dinner," Scott says. "Music is probably only 50 percent of the gig. I had never been on tour at the time, but now that I've done it, I know that you spend all your time with each other. You have to get along."

They hit it off. Rob Halford called the next morning to say he had the job. And just like that, Scott Travis was a rock star. A guy who'd long been a Judas Priest fan was all of a sudden the eighth drummer in the band's long history. "It was weird," he says. "You know your life's gonna be different, but you're not sure to what degree. It's like winning the lottery without the money."

"He actually called me from New York, from Kennedy Airport," Mrs. Travis says, "and said: 'Break out the champagne. I got the gig.' You could feel the excitement in his voice."

Few of his friends were surprised by his success. "He's a human machine," says Jeff Martin, now back with Racer X. "He is definitely the best double-bass drummer alive out there.

"It's a freakish sort of thing, what he does: He can do some things with his feet that a lot of guys can't even think of doing with their hands."

Bert Carter of Portsmouth, lead singer for a Van Halen tribute band called Eruption, calls Scott "one of the top drummers in the world.

"I knew he would get picked up by somebody," he says. "It was just a matter of who would see him first."

Least surprised of all was Scott's mom, who still lives over near DePaul. "I've seen just about all the headline drummers in this country," she says. "I used to think Tommy Lee, of Motley Crue, was great. . . . But Scott, I think, is the best there is.

"We had a big, big party for him at the house. Everybody in town who knew Scott, and a lot of people I didn't know, came by. Everybody was thrilled to death for him. It was like a Norfolk boy made good."

His debut with Priest came on the *Painkiller* album. A poster from the tour that followed now hangs in a front room of Scott's house, its central image an armored knight riding a tusked motorcycle, saw blades for wheels. Scott is pictured sitting at his kit, shirtless under a leather vest, his hair past his shoulders and teased to suggest an aggressive disdain for mainstream grooming.

Priest was huge on the tour, playing to arenas and, at a soccer stadium in Rio de Janeiro, nearly two hundred thousand people at once. The band stayed in four-star hotels, ate like kings, had it good. It isn't quite so high-style now. Metal peaked years before *Painkiller,* and despite Scott's expertise with the sticks, the demand for Priest's brand of noisy fuss steadily, inevitably eroded. By the time the band toured to promote the 1997 *Jugulator* CD, the venues were shrinking, the accommodations modest.

Over those years Priest suffered through some pains unrelated to public appetites. Rob Halford quit and formed his own band, Fight. Scott followed him for a while, then returned to Priest in time to play a deciding role in Halford's replacement.

Seems that Bert Carter was booking some acts into local clubs, and put a Judas Priest tribute band named British Steel into a Portsmouth joint, sight unseen. When he caught the band's set, he couldn't believe his ears: Its lead singer, a young dude from Akron, Ohio, sounded more like Halford than Halford.

Bert called Scott, said man, you have to hear this guy sing, and a few weeks later, Scott saw him at Scully's, a club on Holland Road at the Beach. "I got to meet Scott Travis," Tim "Ripper" Owens says now. "I was pretty damn excited. Got my picture with him. Gave him a videotape." When

Priest met in Scotland to discuss hiring a new singer, Scott brought the tape. Everybody was blown away. Owens flew over, got halfway through one song, and the band stopped him short, hired him then and there. All of which is to say that without Hampton Roads, Judas Priest would not exist in anything close to its present form. It might not exist at all.

These are waiting days for Scott Travis. Since "Jugulator," he's done a few albums with Racer X on the side, and the group's latest, *Super Heroes,* is said to be rocking Japan. He might tour over there later this year.

Of course, he may have to juggle his schedule to make some of those dates. There's the Priest CD that'll be coming out, remember, and that'll most likely take him on the road, too.

When the Priest tour comes, you can bet that Hampton Roads will figure on its itinerary. Scott's mom is looking forward to that. "The band calls me 'Mum,'" Mrs. Travis says. "They always let me stay backstage, so I don't have to stand in front of those amplifiers, you know.

"They're a nice bunch of fellas, I'll tell ya. I've never heard any dirty words come from them."

Scott's looking forward to it even more. "I used to go to concerts — Rush, or Van Halen, or whatever," he says, standing in his den, next to the recliner, the gold record glinting behind him, "and I'd be completely blown away, thinking, 'Man, that looks like a hell of a lot better way to make a living than changing tires.'"

He won't make much money on tour — bands generally don't — but it'll be good to get out on the road. To play places that dwarf the Fifty-One-Fifty. To hear oceans of head-bangers roaring, see their fists raised overhead, feel the adrenaline surge that comes with the opening notes. To pound the drums to Judas Priest songs. To rock.

In the meantime, there's Plastic Eddy, and local bars. A chance to play in public. To sit in with a band. To stay sharp. You need that, if you're a rock star who wants to stay a rock star.

Thunder, sweat, and madness don't come easy.

When the
Rain Came

I

The drought has gone on for two summers now. All along the Blue Ridge, stands of maple and sycamore, of ash and old man's beard, sag in the thick August heat. Pastureland crunches underfoot, baked as dry as a snake's rattle. Corn is stunted. Hay won't grow.

On the range's eastern face, the rust-red soil is parched hard, like concrete, and the streams that tumble from high on the ridges do nothing to slake it. They have no water to spare: The Rockfish River is half its normal size. The Tye's baring its bones. Davis Creek is so low the cows have given up on it. So low, in fact, that Tommy Huffman is praying for rain, and that might be the most telling measure of just how dry it is.

Stand on the ford below his house, Davis Creek more pebble than water underfoot, and it's difficult to picture the place as it was that night in 1969. But that night the water raced fifty feet deep at this ford. Houses washed away, and their pieces flew down the creek and into the Rockfish

River and across Nelson County into the James. Twenty Huffmans were in the wreckage.

The rain fell so hard that mountainsides turned to pudding and swallowed up forests and farms. It fell on a village one valley over, and when it stopped, most of Massies Mill wasn't there any more. A few miles west, the Maury River ran a half mile wide and faster than a racehorse, and it carried off entire families.

That night brought a rain the likes of which few places on earth have ever seen. A rain that drowned birds in the trees. That made rivers rise and mountains fall. In eight hours at least twenty-eight inches fell on Nelson County, a clutter of apple orchards, low ridges, and broadleaf forest overshadowed by the great, hazy ramparts of the Blue Ridge. Most of it fell in less than five hours, and in the flash floods and avalanches that followed, 125 people were drowned, crushed, or buried so deep they'd never be found.

The same night—August 19–20, 1969—rain on the far side of the mountains, in Rockbridge County, killed another twenty-three people. The U.S. Department of the Interior called the cloudburst "one of the all-time meteorological anomalies in the United States." The Army Corps of Engineers reckoned it "one of nature's rare events."

The people who lived through this biblical deluge recall it in stronger terms. That night was the defining event of Tommy Huffman's life, and his wife, Adelaide's—more so than their wedding day, than the birth of their children. It was the night that Warren Raines's childhood ended, and Bill Whitehead lost dozens of friends. The night Volney McClure was spared to later do the impossible. That changed Myra Jean Rion in ways she still struggles to understand.

The disaster began two weeks before and thousands of miles to the east. The day was August 5, a Tuesday, and its birth was announced by a weather satellite passing high over the west African coast. That afternoon Tommy Huffman was two hundred miles from the Atlantic and several times that distance from the Gulf of Mexico. Around him rose the stoop-shouldered peaks and wooded hogbacks of the Blue Ridge foothills. Oceanic weather didn't worry him much.

Huffman had left his Nelson County home early for Charlottesville, and a shift at the University of Virginia. At thirty-nine, he was muscular but whippet-thin, his body rawboned by hard labor; besides his university

Tommy and Adelaide Huffman stand on the ford across Davis Creek in 1999. (Ian Martin photo; used by permission)

job, he raised cattle, cut hay, and was the half-owner of a dump truck that he jobbed out to stone quarries around the county.

As Huffman worked on the campus's heating and cooling systems, the tropical Atlantic warmed under the sun's rays. As its temperature rose, the ocean water evaporated with increasing speed, until the air above was heavy with moisture. Clouds of vapor began to form. They'd formed an inverted "V" just west of Senegal when the satellite made its pass.

Tommy Huffman drove the twenty-five miles home. He parked his pickup beside the brick rambler he'd built about a mile off of U.S. Highway 29, at the junction of two narrow farm roads, and walked inside to Adelaide and their three teenagers. Their house was at the center of a Huffman enclave. It sat on a promontory, its backyard falling steeply into a narrow valley, and along the creek at its bottom lived several generations of Tommy's kin. One of the farm roads dived behind the house, passing the place where Tommy's brother Russell lived with his wife and nine children. From there the road switchbacked up the valley's far wall into "Huffman Hollow," where two more brothers lived with their families,

and another shared the old Huffman home place with Tommy's mother. The other road passed in front of the house and ran up the creek to its head. Up that way lived another two brothers, and two of Tommy's nephews who had places of their own.

In two weeks, fifty-two of the people living along these roads would die. But few people on the planet, and none in Nelson County, knew of the thin chevron of clouds off Senegal. The Huffmans had other things to talk about over dinner: Adelaide, thirty-five, had spent the day stocking shelves and running a register at the IGA market a few miles down U.S. 29 in Lovingston, the county seat, and the kids—Anne, Eddie, and Mary— had whiled away the afternoon doing chores and trying to stay cool in the damp heat that gripped the Davis Creek valley. Events beyond the Nelson County line, let alone the weather in the tropics, didn't much matter.

The clouds didn't amount to much to the meteorologists who interpreted satellite pictures for the U.S. Weather Bureau, either. Dozens of such formations appear each year in the eastern Atlantic, the breeding ground for hurricanes that threaten the United States. Most go nowhere.

But the bureau kept an eye on the inverted "V" as it arced westward across the Atlantic, and four days later its vigilance seemed well-placed: The clouds now sucked vast amounts of sea water into the atmosphere. The vapor rose until it cooled, condensed, and fell as rain—in the process releasing heat, which further warmed the clouds, which consequently sucked water from the Atlantic even faster. What meteorologists call a "heat engine" had started. Not only that, but the clouds were changing shape: They had encircled a column of low-pressure air, and were tightening into a knot.

On August 10 they slid over the West Indies and into the Caribbean Sea, dumping heavy rain on the leeward islands in their path. A day later, the satellite picked up spinning bands of rain within the cloud mass, a badge of tropical cyclones. While this happened, fourteen-year-old Warren Raines was passing another steamy summer day in Massies Mill, eight hilly miles southwest of the Huffman place. Warren's days were predictable: He stirred long after the sun had climbed high and the air turned gummy with heat. He ate some breakfast, wandered outside, pedaled his Stingray to his father's office, hung around.

Carl Raines Sr. managed the Miller Chemical Co., which furnished sprays, packing supplies, ladders, and such to the county's apple industry. Orchards dotted the hillsides around Massies Mill, then as now; Miller

Chemical did a brisk trade. On occasion Warren's dad would put him to work, but more often than not, he'd be back on his bike after a while, often sharing the banana seat with his brother Carl Jr., who was sixteen.

He had four other siblings: a sister, Ava, who'd moved off to Lynchburg, and another, Johanna, who'd just graduated from Nelson County High School; a brother, Sandy, nine years old; and a little sister, Ginger, who was seven. But it was Carl with whom he spent most of his time. They were both small for their ages, almost skeletally thin, and neither could sit still. They might mow lawns to pick up some spending money. Might work on an old Ford station wagon they were rebuilding in a shed out back. Might take their go-cart for an illegal spin.

Most likely, they'd wander down to the Tye River to fish, or cannonball in the river's swimming holes. The stream was only a foot or two deep and three dozen wide, but in places its bottom dropped eight feet or better. One such hole, framed by orange trumpets, mimosa, and mountain ash, lay cool and deep within a shout of the house.

The Raineses' place was typical of Massies Mill: Every house in town was within 250 yards of the Tye. In eight days, most of them would be in it, and twenty-two townspeople would be dead.

By August 14, nine days after its wispy debut, the storm had intensified so dramatically that the navy dispatched a reconnaissance plane for a closer look. Its crew found 55-mph winds inside the spiral of clouds. The Weather Bureau declared the disturbance the season's third tropical storm, and gave it a woman's name.

Early the next day the bureau learned that Camille was blowing at 115 mph, and upgraded it to hurricane status. That night the storm brushed over Cuba's western tip, dousing the island with ten inches of rain and killing three people. Then it lumbered west, into the Gulf of Mexico. The warm water there nourished the hurricane's already high-revving heat engine. By early on Saturday, August 16, Camille was a cloud mass with sheer, solid walls and high winds extending forty miles from its well-defined eye. The Weather Bureau labeled her "small but dangerous."

The following day, an air force crew returned from a flight into the eye with alarming news: Camille was blowing at close to 200 mph, and the barometric pressure at its center was the lowest ever measured from an aircraft. The wind speeds jolted millions of people living along the Gulf coast. Among scientists, however, it was Camille's low pressure, the stan-

dard by which hurricane intensity is truly judged, that inspired terror. This storm packed more muscle than Hurricane Donna, which had ravaged the Eastern Seaboard in 1960; than the Galveston storm of 1900, which had killed six thousand; than Hazel, and Carla, and Audrey, and Betsy, and the Great Atlantic Hurricane of 1944. In fact, a lower pressure had been recorded just once in the Atlantic, during the Labor Day Storm of 1935, in the Florida Keys. And unlike that hurricane, Camille was aimed for the U.S. mainland.

"Never before," warned Robert Simpson, the National Hurricane Center's chief, "has a populated area been threatened by a storm as extremely dangerous as Camille." A mass evacuation, one of the greatest on American soil since the Civil War, emptied coastal towns from Louisiana to Florida.

Eight hundred miles to the northeast, Myra Jean Rion slept through the hurricane's midnight landfall. It had been hours since her parents tucked her in, and the seven-year-old lay, blond hair tangled, in a bedroom painted pink and accented with rose-patterned drapes and bedclothes.

Her family lived in a brick house in Rockbridge County, an hour's drive over the Blue Ridge from Massies Mill. The one-story house backed into a hill, so that from the road out front its full basement seemed its main floor. Beyond the road, just fifty yards from the front door, flowed the Maury River.

Myra Jean knew the river could be dangerous: Once her little brother, Nolan, had wandered out of the yard, and her mother had been wild with fear that he'd fallen into the Maury. But the girl had no notion of how harsh the river, and nature in general, could be. She had lived all her life on the western flank of the Blue Ridge, and over those few years the place had enjoyed a run of good luck: There'd been dry spells, but no significant droughts; snow, but not in remarkable quantities; and, most important in this jumble of steep hillsides and fast-flowing rivers, not a single major flood.

Myra Jean slept as Camille rammed ashore at Bay St. Louis, a notch in the Mississippi coast just west of Gulfport. While the Rockbridge night passed to the thrumming of crickets, and the burbling river, and the rustling of the big American chestnut in the yard, the hurricane obliterated houses and flattened concrete hotels, picked up freighters and tossed them ashore, peeled up interstates, snapped railroad lines. Its winds screamed at 190 mph, stirring a wave twenty-two feet tall that rolled over seawalls and into beach towns to drown people by the score.

In Pass Christian, Mississippi, twelve people attending a hurricane party were crushed by their brick apartment house. A few blocks away, eleven others died in the ruins of a church. Wind and water unearthed coffins, sprung their tops, tangled their contents in the trees. Cottonmouths snatched from blackwater nests flew bare-fanged over the beach. Along sixty miles of the Mississippi coast, more than nineteen thousand homes were wrecked. All that remained of some towns were their names.

Camille trundled north, its counterclockwise whirl slowing. The warm gulf water that had stoked the hurricane's heat engine was absent as the storm cut inland, and it quickly lost its breath; before it reached the Tennessee line its winds dwindled to harmless gusts, and the Weather Bureau downgraded the storm to a tropical depression. But it remained heavy with the water it had drawn from the sea on its journey from the African coast: As the depression curved to the northeast, across Tennessee and into Kentucky, it released a fraction of its load, drenching the farmland below, but its center remained the color of charcoal.

Shortly after daybreak that Tuesday morning—August 19, 1969—Volney McClure kissed his wife, Fay, good-bye and strolled out of their pink-brick rambler, bound for work at a nearby carpet factory. Volney was twenty-five, six feet tall, a solid two hundred pounds. His quiet voice was tinged with mountain—he was prone to use phrases like "right" in place of "very," and "right much" instead of "lots." He smiled easily.

The McClures were among 1,400 souls in Glasgow, a moon-shaped grid of narrow streets and snug ranch houses three miles downriver from the Rions' place. In fact, not long after they were married they'd had the Rions as neighbors: Myra Jean's parents had rented a house a few doors down, and Volney had passed some time with Ernie, often had seen their daughter out in the street on her bike. He knew Myra Jean, as most of Glasgow did, as "Nubbins," a nickname her father had coined after watching her eat corn on the cob.

The Rions eventually had moved above town. The McClures stayed put in Glasgow. Volney was a native of the place, had lived there all his life, was fond of its people and of its setting, which by just about any standard was spectacular. The town was ringed by rock and water: Rising behind the McClures' house, on Glasgow's eastern edge, was Sallings Mountain, a lonesome cone fringed in maple and Judas tree. To the east towered Three Sisters Knobs, a knuckle-backed ridge too steep for roads, part of the Blue Ridge's western face. Just this side of the Three Sisters the Maury ambled by, fifty feet wide and three deep. And about 250 yards south of

the McClures' house flowed the great James River, which the Maury met in a jumble of boulders at the town's southeast corner.

Volney McClure was invested in the place, so much so that he'd volunteered for the Glasgow Life-Saving and First Aid Crew. He was proud of his place on the squad, was among its youngest members, took the duty seriously; he knew that Glasgow, at the mercy of tempestuous rivers and fifteen miles from the nearest hospital, depended on him to take it that way.

He and Fay had seen the TV reports on the hurricane, had gaped at aerials of Mississippi beach towns that looked as if they'd been bulldozed. Still, as he backed his Impala into the street, he didn't expect the storm to bring the rescue squad any business. The TV had said that Camille would wear herself out west of the Appalachians. That she was as good as dead.

Sometime that Tuesday, while Warren Raines wasted time and his father sold farming supplies, while Tommy Huffman repaired air conditioners and Myra Jean Rion followed her mother, Hope, around the house, while Adelaide Huffman stocked shelves at the IGA and Volney McClure pulled his shift at the carpet mill, the remains of Hurricane Camille did the unexpected. The storm turned sharply to the east—by twilight it had crossed the corduroy ridges of southern West Virginia and neared the Virginia state line—and began to loose the load of water it had carried a thousand curving miles over the South.

As night fell, and Camille crossed the border into Alleghany and Bath counties, Sheriff Bill Whitehead waited in the Nelson County Courthouse for the results of the day's primary runoff election. Henry Howell of Norfolk was vying with Bill Battle, a Charlottesville lawyer, for the Democratic gubernatorial nomination, and Whitehead, a staunch party soldier, was curious about the outcome.

His family was deeply rooted in Nelson County: Whitehead was its fifth generation to live at Willow Brook, a stout brick manor, 162 years old, that commanded a crescent of bottomland along Hat Creek, a small tributary of the Tye River. The forty-three-year-old Whitehead farmed as generations had before him, growing hay and corn, running a fifteen-acre orchard, and raising Angus beef cattle.

He'd ventured into law enforcement strictly as a sideline. The work had agreed with him, however: A yarn-spinner, Whitehead enjoyed all the talking the job required, the contact with people across the county. Besides, he looked the part of a lawman—he stood a thick-chested six foot five, wore his silver hair buzzed into a flattop, could scowl convincingly.

He was now in his ninth year as sheriff, and oversaw a staff of three regular deputies, a radio dispatching station, and the county jail.

At about 9 PM, the voting tabulated, the sheriff left his basement office and strolled to his squad car, an unmarked 1968 Plymouth. It was a sultry, breezeless evening, the sort favored by fireflies, and the cruiser's air-conditioning was welcome relief. As Whitehead drove home, a light drizzle began to strike the windshield. The same had happened, on and off, for weeks; the sheriff passed spongy lawns of deep emerald and thin woods turned lush jungle. Ten minutes later, when he steered into the long, curving drive to Willow Brook, a steady shower was falling.

At about the same time, Warren Raines was sitting on the front porch of his family's house in Massies Mill, listening to the rain. Volney and Fay McClure were tucking in their two-year-old daughter, Tara. Tommy and Adelaide Huffman headed for bed, leaving the kids to watch TV.

Sleep didn't come easy: The rain started coming down hard, drumming loudly on the shingle roof. Before long the phone was gone. A while after that, one of the kids came to the bedroom door to report the power was out. That wasn't particularly unusual in the hollow. But a bit later the Huffmans' white Persian cat, "Bunny," came scratching at the kitchen door.

She was an outdoor pet, toughened to all kinds of weather, but now she held a newborn kitten in her mouth and begged to come in. Tommy and Adelaide's daughter Anne thought the cat's behavior odd, but she opened the door.

II

Catherine Whitehead woke her husband after midnight. "I thought they said the hurricane was over," she said, "that there wasn't going to be any wind." Sheriff Whitehead stirred. The weather reports he'd heard throughout the day had been unanimous: Camille had withered after its Gulf coast landfall. The storm was all but dead. "That's what they were saying," he agreed.

"Well, listen to that wind."

The sheriff lay still for a moment, concentrating on a deep-throated, steady roar outside. The walls strobed with lightning. Thunder cracked and boomed. The house trembled. He climbed out of bed and crossed the room to a window facing the front yard. Rain was running so thick on the storm pane that he couldn't see through it, so he raised the glass and peered into what he expected to be a gale.

He was shocked to find there wasn't so much as a breath of wind. Just water: A few yards away, a tall ash almost buckled under the weight of the cascading rain. Its limbs were bowed, the lowest nearly touching the ground. Its leaves had turned to spouts. The lawn around the tree was invisible beneath a sheet of water that swept, gurgling, toward Hat Creek. The sheriff thrust his head through the window and squinted in that direction.

He didn't recognize what he saw. The creek, usually a dozen feet wide and a foot deep, was now a yellow-brown surge a quarter mile across and thirty feet high. Its surface heaved with great standing waves. Dirty whitecaps rode its crests. Entire trees, their trunks stripped of bark, bobbed past. The little valley was filled with sound—Hat Creek's hiss, the crack of splintering wood, the grinding of rock against rock. And a smell: The pungent mustiness of old mountain earth, of soil undisturbed for centuries.

A mile and a half away, in Massies Mill, a ringing woke Warren Raines. He sat up in his bunk bed to find that he'd fallen asleep fully dressed, minus only his sneakers. It was dark outside his bedroom window, the middle of the night. Down the hall, in his parents' room, his father was speaking to someone on the phone.

Calls didn't often come late to the Raines home. Warren jumped to the floor as his brother Carl crawled from the lower bunk, and together they trudged down the hall, sleepy but curious. They reached their father as he hung up the phone. A prank, he was telling their mother—someone saying they had to get out of Massies Mill, that the river had busted loose of its banks. If he knew who the caller was, he didn't say. Instead he looked over to the kids. "Just go on back to bed," he told them. "Don't worry about it."

As calm as Mr. Raines seemed, his family could hear that the rain had picked up, that it was falling on the shingle roof as if from a spigot. "Why don't we look outside?" Warren's mother, Shirley, suggested. The bedroom had two windows. From one they could see cars on the main road, and by their headlights they could see that the yard was a lake, the road ankle-deep in water. From the other, which faced the backyard, the neighbors' houses were islands ringed by water a foot deep, maybe two.

Mr. Raines told the children to dress. Warren pulled on a pair of rubber boots, olive-drab and midcalf-high, and headed downstairs. From the landing he could see water seeping under the front door, a puddle spreading across the oak floor.

The phone rang. It was a neighbor, Page Wood, saying he was sending his kids over. He couldn't leave, himself—Mrs. Wood was disabled, and he

couldn't get her through the high water outside—but if the Raineses decided to evacuate, would they mind taking the four children along? Fine, Warren's father said, and a few minutes later the Woods came through the back door, eighteen-year-old Donna Fay carrying Gary, Teresa and Michael holding hands, all of them soaked and scared. Mr. Raines sent Carl Jr. out to start the car and pull it around front, then sent the kids outside to climb in.

They had to force the porch door open against knee-deep water. It spilled over the tops of Warren's boots, and as he waded to the car, hand cupped over his nose, he felt a tingling combination of fear and excitement. At the car he climbed over the back seat, into the station wagon's cargo compartment, Carl Jr. and his little brother Sandy crowding into the space beside him. The Woods and Johanna Raines took the back seat, his parents and his little sister Ginger, the front.

Mr. Raines put the car into gear. Even before he pressed the accelerator, the Ford's engine died. He slipped the car back into park, turned the key. The engine turned but wouldn't catch. He tried it again. Nothing. Again. Still, the car wouldn't start. Outside, the water on the road looked deeper than it had just a moment before.

OK, Warren's father said, we'll walk. They climbed out of the wagon, stood for a moment in rain so hard and heavy that it didn't resemble rain at all. It seemed more a waterfall than a shower. Warren's rubber boots again filled with water. He had to tuck his chin into his chest to breathe.

The new plan: They'd stay on the road, which was crown-topped and built high, and walk Route 56 toward the center of town. A few hundred yards away, at the Lea Brothers store, they'd turn right onto Pharsalia Road and climb the hill just west of Massies Mill. At worst, they'd spend the night on someone's porch.

"Let's go," Mr. Raines said, and they started walking. Mr. Raines was holding Sandy's hand. Carl Jr. carried Ginger, Mrs. Raines holding onto both of them. The older Wood girl, Donna, was holding her little brother Gary. Teresa and Michael Wood, Johanna and Warren sloshed along on their own.

For the first minute or two the water was only calf-deep, but then it climbed to Warren's knees, and a minute later his thighs, and as it rose it picked up speed and strength. It came up behind them and streamed across the road diagonally, pushed them forward and toward the road's left shoulder. They stayed close to each other, yelling back and forth over the roar of the deluge. Lightning flashed so continuously that Massies Mill

was plain around them, turned hard blue-white, and the thunder was a ceaseless timpani roll punctuated by cracks and blasts.

Over the din they heard a neighbor, Buen Wood, yelling at his wife as they passed the couple's place, telling Lola to turn the damn lights back on, that he couldn't see. A second later Lola was hollering to them from the porch: Y'all come on, come in here with us. But just then the water jumped. Warren was waist-deep all of a sudden, and chest-deep a moment later, and the water was rushing cold and muddy around him, shoving him in the back, and he was half-running, half-swimming, struggling to stay upright, groping in the dark.

He caught hold of a honeysuckle, just a sprig, and as it started to tear away from the bush he glanced downstream, saw his mother and sisters were standing a few yards away, lit by lightning, bracing one another against the current. "Catch me," he screamed.

"Go ahead and let go," his mother yelled back. "We'll catch you."

He let go. A second later, when he reached the place where his mother and sisters had been standing, they were gone.

Until Camille, the hardest rain recorded in Virginia had come in 1942, when 8.4 inches of water fell in twelve hours on Big Meadows, in Shenandoah National Park. Three times that much was now falling on and near Tye River Gap, a sag in the mountains along the Blue Ridge Parkway at the seam between Nelson and Rockbridge counties. Some of the rain spilled east, into a web of rivulets that braid among the mountain's spruce, ash, and oak to form the Tye River, and turned the Tye into a monster. Some of the torrent drained west, into small brooks that downhill, near the town of Vesuvius, form the South River. As Camille lashed the mountains late on August 19, the South filled to bursting, blew through houses and roads, and gushed into the Maury River near Buena Vista. Downstream of the South, the Maury rose until it jumped its banks. Among the places its water found was Myra Jean Rion's house on the River Road.

That evening the seven-year-old was watching TV with her mother— *The Arthur Smith Show,* a country-western music program—when her father walked into the house, excited, saying the river was coming up, that they'd have to leave. Ernie Rion was a handy fellow. Dark-haired, round-faced, thirty-eight years old, he dashed outside, and in the rain disconnected his pickup's fan belt. If they ran into high water, as he expected them to, he didn't want the fan sucking water into the engine.

But the Maury came up so fast that they had no chance to drive to safety; the truck was swamped in the driveway. Soon the river poured into the basement, and Ernie and Hope Rion heard noises downstairs they took to be water dismantling the house's timber skeleton. Ernie picked up Myra Jean, Hope held three-year-old Nolan, and they stumbled, nearly blinded by the rain, across the yard and up the rise beyond, to Homer Hayes's farmhouse.

The power had failed all along the Maury. They sat in the dark with Homer and his wife and their two kids and watched the river creep uphill until it promised to take the house. The eight of them fled farther uphill, to one of Hayes's barns. Still, the water rose. It began to pour in, and they ran through the dark and the rain to a second barn, ancient and tall, and climbed into the hayloft. The Maury kept coming. Soon water was swirling over the floor below them.

Three miles downstream, Glasgow was roused by whistles summoning its volunteer fire and rescue squads. Volney McClure leaped from bed, pulled on his white coveralls, ran from the house. It was raining so hard he could barely make out the road as he drove his Impala to the building the squads shared. Excited chatter filled the office as he arrived. The rain had brought high water into town, and Gordon Street, always the first to flood, was waist-deep. Get over there, the squad's officers told him, and help those people out.

Shortly after midnight, McClure was wading among Gordon Street's small, frame bungalows, helping their occupants into rescue boats, pushing the boats to high ground. The downpour was blinding, the air so laden with moisture that he had trouble catching his breath, but he made several round trips. The street was clear when another squad member suggested they check out the other side of town. "What do you mean, 'the other side of town'?" McClure asked.

"You know," the fellow said, "over where you live."

McClure had lived in Glasgow all his life. He'd never known his place to flood, which is why he never worried about leaving Fay home alone with their two-year-old, Tara. "Shoot," he replied, "there's no flood down there."

Yeah, the man told him, there is.

A few minutes later, McClure and another young rescue squad member, John Birckhead, waded across Route 130, Glasgow's main drag. The town was filling with water: It swirled around the gas pumps at the Gulf station up the street, made islands of the business district, spilled into

neighborhoods always thought safe from flooding. McClure feared that Fay and Tara might be trapped. Fay's eleven-year-old sister, Kathy, was staying in their one-story brick rancher, as well; McClure's mother-in-law had died a couple of years before, and Kathy had lived with them since. He splashed up the highway's far side, past a cluster of gas station oil tanks and into his neighbors' backyards. McClure wasn't given much to worry: Quiet, quick to smile, he possessed an aw-shucks fearlessness that both awed and amused his friends. He wouldn't talk about some damn-fool stunt, then do it; he'd do it without a word. "Well," townspeople would shrug, "that's Volney."

Now, however, he was fretful. He and Birckhead half-waded, half-swam into his yard, brown water chest-deep around them, the house silent and dark. McClure yelled Fay's name, tried the front door. It opened. He yelled again. No answer. They'd gone, he told Birckhead. They got out in time. It looked that way, Birckhead agreed.

Then came a cry for help. Not from the house—this was a man's voice, and it drifted over the water from somewhere near the Chesapeake and Ohio's depot, just a few yards from the James. Sounded like Pickle Wright, who lived in a trailer over that way with his wife and two small kids. A johnboat was floating in a neighbor's yard. McClure and Birck-head hoisted themselves aboard and, finding no paddles, began pushing the boat through the water with a couple of planks. They churned south, among thickets of maple and locust, following the cries.

A surprise waited near the depot. The Maury had blown its banks to inundate Glasgow. It had created a new path to the James, which was running far lower. The result: Floodwater poured off the streets and down the James's bank, and this waterfall created a powerful current around the train station.

Oblivious to the danger, Volney McClure and John Birckhead paddled into the racing water, and in an instant they were spinning helplessly toward the brink, and a second later the boat dumped and they were swimming. The current sucked them toward the James, past the crown of a locust that normally stood thirty-five feet tall. Each man reached for a top branch, caught one, held on. The current pulled so hard that they were stretched out as if flying. The strain on the tree's spindly branches was fierce. If they snapped, the men would be sucked over the bank and into the James, and carried downstream into the chaos at the Maury's mouth.

If they beat the odds and lived, it wouldn't be for long. Just below the

confluence, the James muscled into a high-sided gorge, its passage through the Blue Ridge. At the canyon's head was the Balcony Falls Dam.

III

On Hat Creek, Bill and Catherine Whitehead woke their three children and told them to dress. They rounded up flashlights and lanterns and lit the house, then stepped onto the porch. The creek gushed by seventy-five feet away, thick with mud and stumps and boulders, and the sight of it, the sound of it, prompted Whitehead to turn a fearsome thought: We're seeing something here that no one else has seen.

He usually could take comfort in the notion that he was not the first to face the farm's myriad problems. His house had stood beside Hat Creek, with Whiteheads inside it, since 1807. Whatever happened had, most often, happened before, and worse. But he wasn't sure the place had ever seen such a rain. Knew of no time the creek had risen so high, turned so wild. History offered no guidance as to what might happen next.

Whitehead decided he'd better check on his mother. He and his older boy, seventeen-year-old Dick, jogged to his Plymouth. His mother lived alone in a sprawling, white-frame farmhouse a quarter mile uphill, where his own driveway met Route 151. Whitehead's father built it in 1911, and the sheriff had grown up there. If any house in the county was safe from flooding, it was that one.

Slides, though, were another matter. The forest and pastureland below the house sloped steeply in places. If the creek tore the toe off such an incline, the hillside above would be left without a foundation. As water-logged as the ground was, the hill's bottom might slump into the broken-off toe, and its middle into the bottom, and its top into the middle, until the whole mess, right up to the ridgetop, slid into the water.

They nosed slowly up the drive, under oaks and tulip trees bent under the rain's weight. At the top of the hollow they rumbled over a cattle guard and pulled in behind the house. The rain was heavier than ever, and the air crackled with electricity: Lightning bolts seemed to be shooting sideways, just above the ground.

Cupping a hand over his mouth, Whitehead stepped from the car and walked to the house's screened porch. Its door was latched. He pounded on its frame, but the sound of rain falling on the house's metal roof drowned him out. He took out a pocket knife and beat it on the house's siding. Finally, he honked the squad car's horn. His mother came to the

door. Get dressed, he told her. Something terrible is happening. The creek's up higher than ever before. The land's sliding.

"Pshaw, boy," she said. "There's been rains before."

"Not like this, Mama."

"Oh, don't be concerned," his mother replied. "Why, when I first came to the county as a teacher, when I was boarding over at Miss Gantt's, I can remember seeing a pig pen floating by."

"Mama, you may have seen pig pens floating down the creek," Whitehead said, "but you haven't seen anything like this. Get dressed."

Along Davis Creek, the tattoo of drops hitting the shingles bled into a steady drone. Every now and then a louder din would erupt overhead, the sound of water thudding in a stream, as if shot from a fire hose. At about 2:45 AM, Anne Huffman woke her mother to report that water was dripping from her bedroom ceiling. "Tommy, did you hear that?" Adelaide Huffman whispered, shaking her husband. "Our roof is leaking."

Tommy had built the house himself, and he'd cut no corners. "Something's wrong, if that roof's leaking," he mumbled. Adelaide got up, put a pan on Anne's bedroom floor to catch the dripping water, and spotted Bunny in the closet on her way back to bed. "What's that cat doing in here?" she asked. She was scratching at the door, Anne explained. She'd had kittens. Adelaide listened to the rain, saw lightning flash beyond the curtains. It wouldn't hurt, she decided, if Bunny stayed in the house for one night.

No sooner had she settled back into bed than she heard something odd, then heard it a second time: Her name. Someone outside was screaming her name. "Tommy," she whispered, again shaking him awake, "I hear somebody hollering for me, hollering, 'Adelaide.'" He blinked and sat up as Adelaide hurried to the back door, and as she reached it, up staggered Tommy's brother Russell and his wife and eight of his nine kids, water streaming from drenched and heavy clothes, hair plastered flat, faces tucked into their shirts so that they could breathe.

They were winded, three of the kids badly so. Davis Creek had come up, Russell gasped, had come up fast, and by the time he'd started the car the water was too deep to drive, and they'd had to scramble up the road. His station wagon had been carried away, lights still burning: He'd watched it go, half-sunk but moving fast down the valley.

A low rumble shook the house. Russell turned to Adelaide, asked: "What are you doing with the furnace on, this time of year?"

"I ain't got no furnace on," she replied. The sound grew, became a thousand jet fighters thundering through the hollow. The floor quivered. Windows rattled. Adelaide ran to the back door, pushed it open. "Oh, lands, Tommy, come here," she cried. "What's that noise? What is this horrible smell I'm smelling?"

Tommy Huffman had farmed these Nelson County mountains. He recognized the smell immediately—disturbed mountain earth, a vaguely unpleasant odor, strong and ripe. A signal that the rain was changing the lay of the land.

Soil covering the Blue Ridge was shallow, just two to three feet from top to bedrock. When dry, each foot of earth could absorb a finite amount of water—an inch to two inches, perhaps, and in thin patches even less. A four-inch rain would saturate a mountainside. The summer's frequent showers had left the slopes around Davis Creek sodden even before this cloudburst; with it, the soil no longer seemed soil at all but a grainy pudding, like wet cement, and it lost its grip on the hardy mountain gneiss to which it had clung for eons.

In a hundred little hollows and draws around Davis Creek it began to ooze downhill, picking up speed, toppling pines and hardwoods, undermining boulders, sucking them into its flow until it had grown into a tsunami of mud and timber and stone, falling ever-faster down the mountain. In places the debris snagged on standing trees or rock outcroppings, stacked into dams, and hundreds of tons of water and mud built behind them until they blew to pieces. The Huffmans' house quaked with each dam break that shotgun-sprayed downhill. Their roars blotted out the sounds made by the houses crushed in their paths, the cries of the people inside. Neither lasted long: The waves turned walls to matchsticks, scraped foundations from bedrock, scoured the ground until no clue remained that houses had been there.

Tommy sprinted across the side yard to the trailer where his wife's parents lived. The rain didn't seem to be falling in drops, but in a continuous mass, and he held the collar of his jacket over his nose, bandit-style. He rapped on the trailer door, told his in-laws to stay put in their miniature parlor. No telling how bad things might get, he said. He might need to account for everyone in a hurry.

Then he ran back through a thick, gray mist hovering over the yard. It was as if the clouds had descended to the very ground, as if he were inside the storm, rather than beneath it. The air was thick with the odor of sap and green timber and tree bark.

It was crowded in the house: From up Davis Creek, Eldridge and Gladys Harris had come seeking shelter, joining Russell's family and Tommy's own. Seventeen people now huddled under the Huffmans' roof. Most were children; they sat in the living room, listening to the roars out in the valley, feeling the floor tremble.

The Tye River was normally forty feet wide and a foot or two deep as it doglegged through Massies Mill. Now its gravel bed was invisible, sunk deep beneath a brown torrent that punched a quarter mile wide and seven feet deep through the town's heart.

Warren Raines clung to a weeping willow, soaking and chilled and scared out of his wits. By lightning's flashes he saw sycamores sucked from the ground by their roots, two-ton cars afloat and cruising downstream, cows wild-eyed and neck-deep and wailing with terror. The willow sagged and slowly toppled, and Warren scrambled to the upper side of its trunk, rode it down until it stopped just above the water. Tree trunks and telephone poles surged past, snapping through the willow's branches only a few feet away. Timber beams and slabs of roof, work sheds and porches and entire garages spun by, and Warren feared that one was bound to slam into him, began to worry more about being crushed than he did about drowning.

Crushed or struck by lightning, which came so fast and close that the town's destruction seemed played on a zoetrope. Bolts struck all around, thousands of them. They sounded like rifle shots. A hundred yards away, across the main road, the water shoved a neighbor's place off its foundation, and as Warren watched with growing alarm it was snagged by the current and flung toward him. It was a one-story bungalow, one of the smaller houses in town, but it looked huge as it bore down on the willow.

Warren peered downstream, searching in the rain and flashing light for an escape. There was none. But as he braced himself against the willow's trunk, sure the house would hit, it veered away.

The rain seemed to slacken. Bill Whitehead drove away from his mother's house and turned north on Route 151, one of Nelson County's main north–south highways. A mile and a half up, just shy of a crossroads settlement called Bryant, he found the road blocked by water and debris. He turned around, headed back past his mother's house toward Roseland,

and tried to raise his department's dispatcher on his two-way. He got no response, so he tried hailing Amherst County, just to the south. It was almost impossible to get a word in edgewise: Every small-town police department and sheriff in Virginia used the same radio frequency, and tonight it was jammed with excited voices talking over each other, carrying word of floods in Covington, Lexington, Buena Vista, Albemarle County.

He stopped the car at Mac's Market, a general store. Broken power lines lay in his path. Beyond them, plain in the squad car's high beams, the Tye River was storming across the road, frothy and coffee-colored and choked with debris. The concrete bridge across the stream still stood, but it was almost completely under water, and the highway on either end of it had been chewed away; the span now stood disconnected from solid ground in a channel widened to twice normal size.

As he stared at the Tye, a telephone pole came bobbing down the river's center. It smacked into the bridge and rose, jackknifing, in a high arc, sailed clear over the bridge and disappeared in the river downstream. Whitehead was trapped. Nelson County was in the grip of disaster, and its sheriff was marooned on a three-mile stretch of blacktop.

An hour to the west, Myra Jean Rion awoke to find the barn spinning. Seconds later the building caved in, and she and her little brother and her parents and four of their neighbors were thrown into water sweeping cold and muddy and fast into the Maury.

The river was running 170 times its normal volume. It climbed the sides of the ridges on its flanks, convulsed in huge waves, filled the air with brown foam and the smell of ruined forest and a roar that trumped all other sound. Myra Jean's father had an arm wrapped around a tree limb, another around her. But the current was strong, and Ernie Rion tired. I can't hold on any more, he told her. He shoved a hay bale under her arms. Hold onto this, he said. Whatever you do, Nubbins, hold on.

Then he let go. Myra Jean could not swim, and she clutched the hay bale tightly as she catapulted downstream. Everything whirled. As she rode great humpbacked waves and fell into their troughs, the hay bale began to come apart.

Downriver in Glasgow, Volney McClure and John Birckhead still held tight to a treetop. Every few minutes a maple limb or railroad tie or a chunk of furniture would sweep toward them, and they'd have to roll in the water, try to get out of the way without letting go of the tree. They

watched maples and sycamores topple in the current, trees about the size of the one they held, and Birckhead suggested they think about finding another. He nodded toward a big tree perhaps thirty yards downstream, thirty yards off to their left. That one, he said. Let's try for that one.

McClure eyed the distance they'd have to cross against the current. "Let's just hang on here," he said. "If this tree goes, then we'll worry about it." They could hear Pickle Wright still yelling for help from the roof of his trailer, where he and his family were ankle-deep in water. Massie Bradley, who lived in a big brick place next door to Pickle, had his family up on the roof, and they were hollering, too. And layered atop these screams was the sound of rain falling hard, the water rushing through the tree, the James's roar. The thunder's constant rumble and boom, and breaking glass, and the crack of splintering trees. And dogs barking, far off.

As the sky lightened they made out people on dry ground, three or four hundred yards away. McClure started bellowing, saying hurry up, hurry the hell up and get us out of this damned tree. Birckhead, a devoutly religious man, looked stricken. "Volney," he said quietly, "please don't cuss out here."

Bill Whitehead doubled back on Route 151 to check on his family. On his driveway he met a pickup headed the other way. It belonged to a neighbor who'd given a lift to Tinker Bryant, the local mail carrier, who lived a couple of miles up Hat Creek. Bryant's house had washed away, he told the sheriff, and his wife and three teenage daughters had gone with it.

Whitehead gathered a search party—his family, a state trooper, and two Roseland Rescue Squad members stranded on 151—and headed north toward Bryant's place. The rain further eased, and the floodwaters seemed to be dropping: The rescuers were able to clear the place where the water earlier blocked the highway. Once near Tinker Bryant's property, they split into two groups and walked Hat Creek. They found pieces of Bryant's house strewn beside the bank, along with luggage, furniture, clothing. They found no sign of Bryant's family.

In the squad car, Whitehead got a radio call from the Amherst County Sheriff's Department. They'd passed on his call for help to the region's civil defense coordinator, and the official had asked them to pass a message back to Whitehead. Don't worry, the message said. Floods shouldn't reach your stretch of the James River for a couple of days.

IV

Dawn came to Massies Mill. Warren Raines, still hugging the fallen willow, scarcely recognized the place. Houses near the river had vanished. Most of those left standing on the main road were empty and mud-spattered, their weatherboarding splintered, porches ripped away. Brown water flowed fast and whitecapped where the Presbyterian church had been, and streamed through the shattered stained glass of Grace Episcopal. An entire warehouse was missing from the intersection that passed for the town's center. A light shower fell. The storm, it seemed, had passed.

Warren shivered, searched the water around the willow for any sign of his father, his mother, the other eight people who'd been on the road with him. He saw none. Then, in the lightening sky, Carl Jr. appeared in the top of a tree of heaven about thirty yards away. Beyond Carl, to the west, a low cloud black as midnight slid toward them.

A johnboat headed Warren's way from the main road, neighbors inside. "Don't worry," one said as the boat drew near. "You're gonna be OK. We're gonna get you out of here."

"Make it quick," Warren told them, and he pointed back upstream to the cloud. "We have to get out of the way." He eyed the sky anxiously as the boat took him and Carl to a cottage set atop a small knoll beside the main road. Of more than sixty buildings in Massies Mill, it was one of a handful that hadn't been damaged.

The men told the boys to try to rest awhile there. But both were restless to find the rest of the family. After a few minutes they got up and walked outside. The black cloud had vanished, and the water was dropping rapidly, the Tye returning to its banks. Across the main road, where the warehouse had been, the river left behind a pile of rubble and a smashed Packard sedan veneered in slime. A dozen neighboring houses had been jerked off their foundations and squatted, warped and empty, in the mud. Castles of broken brick rose from puddle moats. And everywhere were dead fish, and dead cattle, and tremendous piles of smashed tree and house siding and furniture. The open ground seemed paved with riverjacks, bone-white stones the size of grapefruit.

They walked the main road to their father's office. It had moved: Miller Chemical now sat on a bridge over the Tye, squeezed between the guardrails, blocking both lanes. The boys examined the wreckage. They found no sign of the family.

They walked back across town to their house. Storm water had crushed the family cat between the porch door and its jamb, and the animal's body

was still wedged there, six feet off the ground. Inside, the refrigerator lay on its side. Upholstery was sodden, art torn from windowless walls, the whole ground floor knee-deep in a stinking, green-black mud.

A thumping emanated from the second floor. Warren and Carl climbed the stairs, hearts beating fast, and burst into their brother Sandy's room. Bo, the family's black lab, was sprawled on the bed, tail wagging. Otherwise the house was empty. Warren wandered the second floor, amazed at its pristine condition. The flood had dislodged a neighbor's place and spun it into the main road, where it had split the water's flow around the Raines home. The house had been in a protective eddy all night. If they'd stayed put, they'd have been fine. If they'd not received that late-night telephone call, or if they'd gone back to bed, as Warren's father had told them to, they'd have been fine. Instead, Warren sensed with growing uneasiness, his family wasn't fine at all.

In Glasgow, Volney McClure saw a speedboat chugging toward him, and he and John Birckhead were rescued. Fay waited on the high ground, where she and the kids had passed the night, and they held each other at the flood's edge, shivering and spent and in shock. Their town was ruined. The Maury River had punched through houses and stores and the carpet factory where most of Glasgow worked. The business district was under fourteen feet of water. Roofs along the highway through town barely peeked above the waves.

A few hours later, McClure and other members of Glasgow's Life-Saving and First Aid Crew received a radio message from Whitey Hostetter, a fellow squad member. The night before, Whitey had been part of a unit dispatched across the Maury and down the James River to rescue a man trapped on the rocks at Balcony Falls. By the time they'd started back for town, the Maury had come up, cutting them off. The crew had passed a miserable night at the foot of Three Sisters Knobs, a ridge that jutted 1,500 steep feet from the Maury's far bank. At one point a mudslide had started high on the slope above them. They seemed to be in its path, and they were sure they'd die. They all shook hands.

The slide had missed. Hours later Whitey was gazing out onto the Maury when something caught his eye, something in the middle of all that whitecapped water. A fellow crewman had a pair of binoculars. Look over there, Whitey told him. What is that? Nothing, the man had reported. No movement. It's a stump, a knot of timber. Whitey Hostetter squinted. "Damn," he said, "there must be something wrong with my eyes, then." He'd walked over to his rescue squad truck, flipped on its public-address

system. "If there's a person out there," he'd said into the mike, his amplified voice distorted and squawking, "raise your hand."

A tiny arm waved from the maelstrom's center. "Get a boat," Whitey now told Volney McClure on the radio. "A big boat. We got a man stranded."

Robert Massie, one of Glasgow's volunteer firefighters, owned an open speedboat he'd built himself. It was wooden and about eighteen feet long, with a powerful but balky inboard motor and poor rough-water manners. It did not inspire confidence.

He, McClure, and two other men launched it at the Glasgow Elementary School, usually a half mile from the Maury River but now its west bank. As soon as Massie hit the gas, the engine threw its drive belt and died. They fixed it. Massie hit the gas, and it happened again. Then a third time. Massie tinkered with the belt. "I think it'll be OK," he announced, trying to reassure his crew. McClure was unconvinced. Aw, me, he thought. I'm gonna wind up getting killed. But he said nothing as Massie again gunned the engine, and the four of them shot away from the school and across streets and yards under a dozen feet of water.

Out in the flood's center, Massie had to point the boat's nose upriver and open the throttle wide to overcome the current. The river's voice was a stadium cheer, and its water was clogged with rocks, tree trunks, chunks of fence and broken road, with clothing and tires and dead cattle. Massie edged the boat sideways, jerking it this way and that to thread among the debris. Huge waves thumped against the bow. Fountains of muddy water sprayed the cockpit.

In a few minutes they reached the far shore. Whitey Hostetter's crew grabbed the gunwales and pulled the boat tight to the grassy bank. "OK, Whitey," McClure shouted over the river, "where's this person you see?" Hostetter pointed downstream. "Right there." McClure followed his finger, to a tangle of tree and debris. "OK, I see it," he nodded. "We'll go see what we can do." They pushed off again, let the current suck them backwards. Massie kept the nose pointed upriver, used the engine to straighten the boat as they swept into an arcing stretch of whitewater. It end-ran the Route 130 bridge, a simple truss affair with crisscrossed girders flanking its roadbed. Only the topmost foot of the structure showed above the flooded river.

Below the bridge Massie gunned the motor. The boat slowed. The pile

of timber loomed, and behind it, a figure, shoulder-deep in the water, facing them. Staring, wide-eyed. With a start McClure realized he knew her. She'd lived a few doors down from him and Fay on Kanawha Street. He remembered seeing her out front of the house, a blond-haired toddler wobbling on a bike, back before her family moved away.

"My God," he said, "it's Nubbins."

<p style="text-align:center">V</p>

At daybreak the rain had slowed to a drizzle. Tommy Huffman and his brother Russell stepped outside to a world changed. They strode across Tommy's yard and into the Davis Creek valley, and looked down, through rising mist, on Russell's place. It was gone—house, cars, everything. The square, creekside meadow on which it had stood was stripped bare.

The brothers stumbled back to Tommy's house, blurted what they'd found, and at first their wives didn't believe them, told the men they must not have walked far enough down the hill. It wasn't until they walked the road themselves that they understood what the night's rain had done.

At their feet was a dribble of creek transformed to thick brown river, deep and powerful. On the mountainsides around them, white scars gleamed in the strengthening sunlight, light-colored bedrock laid bare by avalanches. Every few minutes, the earth rumbled underfoot as another waterlogged slope peeled away from the rock and slid, woods and all, into the valley. They couldn't see much of Huffman Hollow, where Tommy's mother and some of his brothers lived; the flooded creek blocked the only way in. Soon enough, though, a neighbor came walking along a ridgetop above the hollow, and he was hollering, "Everything's gone."

A mudslide had carried off Tommy's forty-four-year-old brother, Robert, and Robert's wife, and their three daughters, and their granddaughter. The ground had slipped at the old Huffman home place, too, where Tommy's mother lived with his younger brother, Jesse, and Jesse's family. It had spun the house around and brought its roof down. Tommy's mother suffered a deep cut on her leg, and Jesse clawed his way out of the streaming water on a guy wire that anchored a light pole.

They found three of Jesse's kids under a piece of collapsed roof, not a scratch on them. Just a few feet away was the baby bed where his youngest son slept. His bottle was still in it, but he wasn't, and he never was found. Jesse lost his wife, Lottie, and his oldest son, Jesse Jr., as well.

The family fared no better up the other road that ran past Tommy

Huffman's house, that followed Davis Creek to its head. Tommy's oldest brother, Lawrence, was swept away with his wife, and the mud and rock obliterated his brother James's house and a trailer next to it. James's wife, Virginia, and his son David died in the house. His son Rodger, Rodger's wife, Becky, and their son Rodger Jr. were crushed in the trailer.

Later that morning Russell learned that his boy Mitchell had died while spending the night at a friend's up that way. And in another trailer, a bit higher up the creek, James's oldest son, James Jr., died with his wife, Juanita, and their daughter, Barbara Lou.

Everyone figured James Sr. was dead, too—he wasn't supposed to have worked the night before, and they assumed he'd been home and swept away with the others. It turned out he pulled an unscheduled shift at his job. He fought his way over washed-out roads and missing bridges to get home, only to find that it no longer existed.

When James returned, rescue helicopters were already flying into the valley, and Davis Creek swarmed with state police and emergency crews digging out the bodies. But before that, in the first few hours of daylight on August 20, as the storm's destruction first revealed itself to Tommy and Adelaide Huffman, as they stumbled over heaps of debris that entombed their kin, Davis Creek was a world unto itself, cut off from the rest of Nelson County. That afternoon they could hear a neighbor shout from up on the ridge above the creek. "Is anybody alive?" he hollered. "Is anybody else alive?"

Outside their mud-spattered home in Massies Mill, Warren and Carl Raines found the Ford station wagon in which their family had tried to escape, pushed against a maple tree at the edge of the yard. The two-door wagon the boys had rebuilt that summer was smashed flat and lodged against a house one hundred yards away. Out on the back road, the Wood home, with Mr. and Mrs. Wood safe inside, had been lifted off its foundation, carried thirty-five feet and put down so neatly that it looked untouched.

Two of the Wood kids, sixteen-year-old Teresa and ten-year-old Michael, staggered out of the flood debris that morning. Two remained missing, along with Warren and Carl's parents, two sisters, and little brother. The boys meandered through the town's remains, picking up clothes and furniture they recognized as theirs, and as they lugged them home neighbors stopped to talk with them. Some said they'd heard that the family

was fine, that they were down at Lynchburg General Hospital, and for a while Warren and Carl were buoyed. Someone would be along to pick them up.

But shortly before dark, that someone had not materialized. A family friend, a local apple grower with boys of his own, took them home, returned them the following morning to a town crawling with state troopers. One approached them, said, "Boys, what's going on?" Warren and Carl answered that they didn't know, that their family was missing.

Something about the exchange cut through the daze that had enfolded Warren for more than a day, and he suddenly knew that they were in trouble. All of the hope he'd carried through the flood evaporated, and in its place came a suffocating dread. "Our family's missing," he said, and he started to cry, and for a while he couldn't stop.

"Who's your closest kin?" the policeman asked.

Grandparents, they told him. Their mother's people, down in Lynchburg.

"Tell you what we're going to do," the trooper said. "I'm going to have somebody take you to the Nelson-Amherst line, and from there we'll get you down to Lynchburg."

So later that day they found themselves at a police roadblock in Piney River, a few miles south of Massies Mill on the road to Amherst. And to their surprise, up walked their grandfather and their oldest sister, Ava, and their mother's uncle. "Where's the rest of the family?" the uncle asked, looking around.

The world did not yet understand what had happened at Massies Mill.

"Gone," Warren cried. "They're gone."

On the raging Maury, Bob Massie sidled his speedboat toward Myra Jean Rion. She had washed three miles downstream, had somehow found her way to this midriver eddy. The bale of hay on which she'd floated had disintegrated; now she balanced atop a half-submerged sheet of plywood that undulated in the current. She was smeared with silt and mud, bruised by the rocks and tree branches the river had flung against her. And she was cold: It was after 1 PM; she'd been in the water since daybreak.

Massie brought the boat to within twenty-five feet of the girl, but the current sucked it away. He steered the boat wide and gunned the engine, got upriver a little, then tried backing into the eddy. Again the current

snared the craft. Again Massie set the boat up for another pass. This time he could get no closer, and it didn't seem he would. Every pass put the four aboard the speedboat in peril; every second they remained in the river did so. "There's nothing we can do," Massie said.

McClure knew he was probably right. But no way, he thought, would he leave Nubbins Rion in the river. He knew her father, liked the guy: Ernie Rion had come by one winter when he and Fay were just married and still living in a trailer, and had unfrozen his water pipes with a welding torch, just to be friendly. "Robert, there's something *I* can do," he said. "I'm going after her." He told Massie to open the throttle, waited until the boat had surged twenty yards upstream, and dived over the side.

He was stroking the instant he hit the water. Even so, Volney McClure could feel himself sucked sideways, toward the Maury's rocky mouth, and it occurred to him he might not make it—that he should have been farther upstream when he started. He felt adrenaline surge through him, held his breath, put down his head and swam as quickly as he could swing his arms.

A moment later he was in the eddy. Myra Jean wordlessly clamped her arms so tightly around his neck that he couldn't breathe. The adrenaline rush left him, and he felt suddenly weak, rubbery. "Calm down, Nubbins," he croaked. "I got you. We'll be OK."

Massie made a pass, and McClure yelled for a rope. It took several attempts, but those aboard managed to toss the end of a line close enough for him to reach, and McClure grabbed the girl in one arm, latched onto the rope with the other. As Massie throttled the boat to keep it still in the water, the others aboard pulled McClure and Myra Jean through the river's tumult to the gunwales.

She was saved.

VI

The Blue Ridge is an ancient range, the offspring of forces as old as the planet. Ages ago the Earth's crust, roving on its molten bed, wrinkled here. Rain and snow have worn the resulting peaks to nubs, the wrinkle's knife-edges to low, broad ridgelines. The thunderstorm of August 1969 compressed a thousand years of that wear into a single night.

After Hurricane Camille, the landscape had so changed in parts of Nelson County that topographical maps were obsolete. Mountain contours had shifted, riverbeds straightened or bent. Cropland lay deep under

mud. Woods had vanished. Decades later, a mountainside overlooking Davis Creek still displays huge tears in its forest cloak. A watermark seven feet up the pine paneling of Grace Episcopal Church in Massies Mill recalls the night the Tye River burst in, sucked the organ out a window, and carried it to Buckingham County. In Schuyler, a power plant stands ruined, its walls felled by the rain-swollen Rockfish River and never rebuilt.

But to a surprising degree, most of the Earth's wounds have closed. New timber has replaced the trees felled that night. Soil again covers rock exposed by landslides. Beef cattle, cornrows, and apple orchards occupy bottomland that was lunar in its desolation. It's the storm's survivors, who lost those they loved and endured the night's terrors, who bear scars today.

They've shared their grief in monuments across Nelson County: At a wayside on U.S. 29, near Davis Creek; at the county library, dedicated to those who died; on the county courthouse lawn; and in a stained-glass window at the same Grace Episcopal in Massies Mill. It depicts a man on a ship in a wild sea, rain slashing the deck, lightning bolts above, both fear and hope in his eyes. "Noah," it reads, "found Grace in the eyes of the Lord."

Sometimes he'll hear a helicopter, and Warren Raines will find himself back under the tent in the cemetery at Jonesboro, the coffins before him, navy and Marine Corps choppers swooping overhead. He can still conjure the smell of Massies Mill after the water dropped back into the riverbed, the stink of sun-baked mud and mountain earth. Every so often he'll hear an old song on the radio, and his memory will produce a snapshot from that summer, and of all that he lost.

Places around Massies Mill hold terrible significance. On the way into town, he'll point out the red-roofed tractor barn where they found his mother. The wooded bend in the Tye River where they found his father, and his big sister Johanna, and his little brother, Sandy. And down toward Norwood, where the Tye empties into the James, the riverbank where his little sister, Ginger, lay.

Even so, he has chosen to stay in Nelson County. He's fit-looking these days, his hair thin but more blond than gray. He's quick to smile, tells a good joke, and speaks in lazy vowels. His voice might catch when he recalls some details of that night and the days that followed, but it happens

rarely. Warren can speak with disarming matter-of-factness about Camille and what followed.

No one stepped forward to claim the boys, and he spent a hellish year at the Staunton Military Academy. A Nelson County couple eventually took Carl and Warren in, and he stayed with them until he was seventeen. The Christmas after, he moved back to Massies Mill, back into the house his family abandoned during the storm. A year later, at Sunday school, he met Sharon. Turned out she was a Huffman—her mother, Frances, is Tommy's sister. They married in 1974 and stayed that way. They have two kids.

Warren's old house still stands on the village's northern edge, plain-faced and ringed by empty lots. Long-timers know those weedy spaces for the homes wrecked on them, and never rebuilt. At the town's erstwhile heart an Odd Fellows hall stands derelict, and the Masons no longer use the old buff-brick bank. The post office fell into such disrepair that the government pulled out of the building, and the tall, frame general store that once dominated local commerce is empty. The only signs of its past prosperity are the rusted bottle caps and pull-tabs embedded in the asphalt out front.

At the spot apple growers pulled off the road to do business with Warren Raines's father, a small forest of mimosa and maple rises now, a tribute to those who died nearby. A footpath meanders among the trees and a carpet of sumac to the Tye River's edge.

Bill Whitehead still lives at Willow Brook. His son, Dick, lives in the house the sheriff's mother owned when Camille ravaged the valley below. He did not stay marooned on Route 151 for long after the rain stopped: Whitehead borrowed a Marine Corps helicopter and worked around-the-clock coordinating searches and getting aid to the flood's victims. The task was a grim one. Besides the seventy-four people killed in Massies Mill and Davis Creek, Nelson County lost fifty-one of its citizens—in Tyro, where nine died; in Norwood, where the last words of two residents were screams for help as their house floated down the James; in Roseland, where, as the Army Corps of Engineers later reported, "nobody knows where the post office went."

Afterwards, Whitehead had Hat Creek rechanneled on his property; it now runs straight, rather than in loops, and is theoretically less likely to jump its banks. He was defeated for reelection in 1971, and went to work

for the state Department of Emergency Services, from which he eventually retired. These days he doesn't move with the hustle he had as sheriff—his legs give him some trouble—but vestiges of his days behind a badge remain. He still wears his hair short, speaks with a rumble, can affect a troubling scowl. He drives his pickup like a cop, slow and gazing off to his side. He calls everyone "sir" and "ma'am."

He is known throughout Nelson County for his love of local history and his ability to describe past events almost cinematically. He and Catherine were married for fifty-four years before her death in 2002.

Volney McClure has not seen or spoken with Myra Jean Rion since he saved the girl's life in the Maury River. Nor has he ever been publicly recognized for his heroics during the disaster. "People just came up and said, 'Way to go, Volney,'" he recalled. "And really, that was fine."

When the water went down, the McClures returned to their house to find it filled with mud and overrun with rats. A fat, black snake fell out of the drapes as Fay took them down. She dreaded thunderstorms for years.

The couple had a second daughter, Nicole. Volney took up golf, and made some investments that enabled him to retire at fifty-five. He also went on to become president of the Glasgow Life-Saving and First Aid Crew, and served as its captain, as well. The volunteer job kept him busy: The James and Maury came up again in 1972, during Hurricane Agnes, and again in the terrible freshet of November 1985.

The McClures moved from Glasgow in 1999, when they bought a house in south Lexington to be nearer the county's golf courses. Most days, Fay McClure said, her husband seems unfazed by the events of thirty years ago, the chances he took, the close brushes he survived. "But after he's talked to somebody about it, he'll get quiet for a couple of days," she said. "He'll say things to me like, 'What if I'd been killed? What if I hadn't come back?'"

All seven of the people who fled the storm with Myra Jean Rion perished—her parents, her little brother, the four Hayeses. Myra Jean was raised by an aunt in Goshen, near the Maury River's head. In high school she started dating a fellow named Wayne Stuples, and they've been together since. They have two grown daughters and live on a hillside high above Kerrs Creek, a tributary of the Maury west of Lexington.

It is about a twenty-minute drive from Volney McClure's house. On the wall are portraits of relatives, and angels fashioned from brass, and

Myra Jean Stuples stands beside the Maury River, just downstream from where she was rescued in 1969. (Ian Martin photo; used by permission)

a picture of a guardian angel looking down on two children. The master bedroom is decorated with roses.

The Stupleses have a pool in the backyard, though Myra never learned to swim. "Everybody thought I was crazy when I got that," she said. "They said if they'd have been in water like I was, they'd never get in it any more. They'd be scared to even take a bath." She shrugged. "Being seven, I think you overcome things."

Just the same, she didn't visit her childhood home until she was in her twenties. It remains standing on River Road, by appearances empty: Knee-high weeds and ash saplings have taken root along the driveway, and grass has grown thick under an old hatchback in the back yard. "I never actually went back in the house," she said. "You know, Mom had a picture of Jesus on the Mount of Olives on the dining room wall, and they said the water only got up to about an inch below that frame. If we'd stood up on the countertop, we would have been all right."

She has been tormented by a question common among the survivors of disaster. "I was told all my life, that since I was the only one who survived, God must have had plans for me," she said. "My grandma was famous for

it, always telling me that there was some reason why I was the only one who survived. And I would live my life trying to figure out what that was, day to day, you know?

"Maybe I'm just looking for something spectacular, or something that's never going to happen," she said. "If I was supposed to be here for a reason, for something special, I don't know what it would be."

Myra Stuples works at a Little Debbie plant in Stuarts Draft, operating a machine that plastic-wraps and boxes the company's snack cakes.

As for Tommy and Adelaide Huffman, they still live in the house on the promontory overlooking Davis Creek. A couple hundred yards away, silhouetted on the next hilltop, monuments to Camille's dead fill an entire section of the Oak Hill Cemetery. The Huffmans have three generations buried there.

Most were found in the days after the rain along Davis Creek and the Rockfish. The water swept others into the James; it carried one of Tommy's brothers, Lawrence, almost to Bremo Bluff, two counties away. A few—among them Russell's son Mitchell, and James's son, Rodger—simply disappeared. Countywide, thirty-three victims still are listed as missing.

Just after the storm, the Huffmans' house became a command post for search teams. Tommy was called on to identify some of the dead, an experience that he describes as "so bad, I'd just as soon people didn't know.

"From our house up to the head of Davis Creek, there were fifty-two people killed," he said. "I knew all those people—most of the kids, young 'uns, old 'uns, everybody, besides our family.

"We think that it was fast, that they were hit hard," he said quietly. "Most of the people didn't drown. Most of the people died of injuries."

An army of researchers descended on the valley, as well, to study its mudslides—"debris flows," in engineering parlance—hoping to glean something constructive from the destruction. One professor found that slopes facing north and west were more vulnerable to collapse than others. State geologists discovered that slides were most common on mountains made of a particularly old metamorphic rock. The work didn't prevent a reprise of Davis Creek's troubles. In June 1995, an intense storm spewed thirty inches of rain on the Blue Ridge's eastern slopes in Madison County, and waterlogged soil again sluiced off the mountains, to catastrophic effect. Evidence suggests, in fact, that hard rain and avalanches have been regular visitors to central Virginia for centuries. Between 1844 and 1985,

at least fifty-one "debris-flow events" occurred in the Appalachians. Most were in the Blue Ridge.

Nelson County's 1969 downpour, and Madison County's twenty-six years later, rank among the most intense rainfalls in recorded American history—along with such deluges as the twelve inches that fell on Holt, Missouri, in forty-two minutes in 1947, and the thirty-four inches that pelted Smethport, Pennsylvania, over twelve hours in 1942. It created a bulge of water that a few days later swamped Richmond, and that carried the shattered homes and forests of Nelson County all the way to Hampton Roads. Debris filled the shipping channels for days.

The U.S. Weather Bureau, later renamed the National Weather Service, judged it unlikely that a storm of Camille's intensity would revisit Nelson County for at least one thousand years. Still, some people in the county get nervous when a summer thunderstorm rolls in. They don't look at mountains the same way, nor the earth itself; the permanent, the solid, they now know to be anything but. To survivors who saw fifty-foot trees fire through the air like arrows, and slide butt-first by the hundreds in mudslides, the woods that blanket the county's high ground seem less sanctuary than menace.

"It took us a good while to realize just what had happened," Tommy Huffman said. "We were kind of in a daze, you know? I think being in that daze helped us get through it.

"Nature," he said without irony, "has a way of taking care of you."

Both he and Adelaide are weathered by years of living on the land. They've faced many trials together since Camille: They lost their son, Eddie, to a boating accident in 1983, and three of Tommy's brothers have died of cancer. But the couple has seven grandchildren and a passel of great-grandchildren, and more are on the way.

Adelaide retired from George's Supermarket, the successor to the IGA, after thirty-three years. She was so well-known to shoppers that the weekly Nelson County Times ran a story about it. Tommy is leaner than ever. Veins stand out like cables on his arms. He retired from the University of Virginia and now farms full time. He cannot remember a summer tougher on the land than this one: The ground is so desiccated that in place of the three harvests of hay he usually gets from his fields, he's eked out just one.

Down in the valley behind the house, a few yards from the meadow where Russell's house vanished, Davis Creek seeps from a tunnel of maple, mimosa, and Judas tree. It barely clears the small pebbles on its floor. The cattle are feeding on pastureland the color of sand. Wells are failing. Reser-

voirs are low. And the more the rivers fall, the thicker with sewage and fertilizers and pesticides they get.

Showers come now and then, but they barely moisten the topsoil. What the Blue Ridge needs is a good soaking to rescue its farms, its families.

It sure enough could use some rain.

A long, hard rain.

Playing the
Last Round

They were bringing up the rear, the Lunch Bunch's last threesome to tee up on this raw, runny-nose afternoon. They waited until the group ahead was better than halfway to the hole before they stepped up to drive. Cold or not, it was best to savor these final hours.

Stewart Womble swung. The ball whistled hard and flat toward the crowns of some big Virginia pines he remembered as saplings, then arced back into the fairway's middle and fell to a bouncing roll. Thomas Boze Kellam, defying the chill in just a V-neck sweater and a worn pair of cords, sent his ball high and straight. He stepped aside for Freddie Harris, the youngster in the trio at sixty-eight.

Between them, the three had belonged to the Northampton Country Club for more than 130 years. They'd each played the scrubby nine-hole course on Cape Charles's northern fringe several times a week, Kellam since 1948, Womble for a half century. Now their club was closing. The

three could squeeze in a last couple of rounds, at most, before they had to be off the property.

A stiff breeze swept over the fairway as the men stopped their carts beside their clustered balls. A few feet away lay a marker denoting that they were one hundred yards from the green. It was made from an iron disk that farmers like Kellam, and a lot of the club's roughly 130 members, dragged behind their tractors to plow their Eastern Shore fields.

"It's good to be outdoors, isn't it?" Kellam said as he eyed the green.

"Yeah, Boze," Womble replied. "It is."

Another frigid gust swooped in. This one carried a diesel's growl, and the faint whine of an electric saw—the soundtrack of the club's demise. Womble seemed not to notice. "If the wind stays down," he said, in what might have made a fitting motto for these weather-beaten sixty-five acres, "we'll be all right."

By the standards of modern golf courses, the Northampton Country Club, which was due to pass into history in less than thirty-six hours, wasn't much to look at. Its fairways were weedy and unwatered, its terrain unsculpted, its sand traps small and benign. Its cart houses—eighty-nine of them, built by the members to house their privately owned golf carts—were plywood and tumbledown.

The course stretched over just three thousand yards, employing alternate tees to pass for eighteen holes. The clubhouse was low-slung and plain, its postgame repasts meager: sandwich orders were filled conditionally, depending on whether the bread was fit to eat. Tournaments consisted of everyone ponying up a few dollars, the winner taking the pot. Members were unbound by dress codes. It was, in short, a course as unpretentious as the people who played it.

Now, a few hundred yards from where the threesome putted out the first hole, workmen were building the gatehouse to a new subdivision of expensive houses. Inside of a year, another subdivision would be under way right here. "Most of the carts gone?" asked Kellam, who was eighty-one and lived in Townsend, a few miles south down U.S. 13.

"Yeah, Boze," Womble sighed. "A lot of 'em. I think Randy sold his today."

"Oh, my Lord," Kellam said quietly.

"I mighta sold mine," Womble told him. "I don't know yet."

The sixth hole was 504 yards long, a broad dogleg left. Womble, seventy-five years old and retired from the insurance business, found his

ball six feet from Kellam's, heaved at it with a fairway wood. "Oh, yeah," Kellam said, rubbing his cold hands together.

"I didn't see it," Womble said, squinting. "You see it?"

"You went right down the middle."

"Ah," Womble nodded. "That's why I didn't see it." They drove their carts side by side toward the hole, which was shaded by a gargantuan pecan. Beyond it lay the head of an inlet, its water furrowed by the wind. One neck over, a dredge burped smoke and piled sand into a dump truck on the shore. The air was filled with metallic clanks. Not long before that neck would host a vast and luxurious marina that Virginia Beach developer Paul Galloway promised would be "the finest on the East Coast of the United States." Stores would rise there, too, and upscale restaurants.

Kellam knelt down like a TV golfer to assess the lay of the green as Womble sank a putt, flipped his ball from the hole with the nose of his putter, then into his hand the same way. They moved onto the seventh, a short par-3 split by a scruffy ravine, then turned up the long, straight eighth. Between shots they watched the workmen hammering away on the gatehouse, two stories of bright yellow plywood. Blacktop passed it and snaked across a treeless sea of sand to a big waterfront home, walls sheathed in Tyvek.

The lone mansion was part of The Colony, which looked westward over the Chesapeake. It was one of the few places in Virginia where one can watch the sun set over the water, and the view didn't come cheap. Galloway, a partner in the development, figured the 118 houses at The Colony would be worth $74 million. Later in the year, work would get under way on a second phase of residential construction on Cape Charles's north side, which would add another seventy big homes. The third phase would erase any sign of the Northampton Country Club.

View Cape Charles from the air, and it was plain that what was happening around the club was part of a vast shift: Virginia's lower Eastern Shore, for centuries home to farmers and blue-collar laborers, to merchants and railroad men, was fast becoming a getaway for the northeastern rich. The town would soon be ringed by an enormous doughnut of second homes, retirement homes, playgrounds for the well-to-do. The city's southern hinterlands were already home to a lavish complex of big houses nestled around an Arnold Palmer golf course.

"They've offered us a discount to play there," said Bob Heath, a member at Northampton for forty-one years, and now part of a foursome playing ahead of Womble and company. Even with the break, though, playing the

new course will cost far more than Northampton's four-hundred-dollar annual fee, beyond the means of most members. "We've been spoiled, as far as golf is concerned," Heath said. "And now we're getting ready to pay for it."

"What do we do now? Cry, is what we do," Womble said. "We cry."

Cape Charles enjoyed a long prosperity as the terminal for railroads from the North and ferries from the South, and it was in those fat times that the country club came to be. In March 1927, forty-odd businessmen and farmers convened in the auditorium at old Cape Charles High School to plan its creation. They kicked in fifty dollars apiece to get it started, renting a patch of well-drained farmland from a big local landholder.

By the following year, the same in which the town got streetlights, the course was complete. But its organizers made a critical mistake: They never bought the land on which it sat, even when it was offered to them for a thousand dollars an acre in the mid-1960s. In the meantime, Cape Charles's economic foundations cracked. When Kellam joined the club, the ferry terminal was about to move to Kiptopeke. Within a few years of Womble's joining, passenger rail service ceased, the Chesapeake Bay Bridge-Tunnel went up, and few outsiders had reason to visit.

The club's faithful kept playing golf, even as their town shrank around them. They invited preachers to play for free on Mondays, taught their grandkids the game, but mostly they played among themselves. A dozen or more started showing up for a "Lunch Bunch" game every day at noon, and some went months without missing one. One member, eighty-six-year-old Billy Wilkins, caddied on the course during Herbert Hoover's presidency, and kept playing there until this week.

The members kept playing as the Eastern Shore economy bottomed out, and as a new generation of out-of-towners discovered the Shore, and as farmers sold out to developers. They played as the ground beneath their feet changed hands, and nice bed-and-breakfasts opened in town. Cape Charles's economic salvation loomed.

It carried a price: In a letter dated September 16, 2002, the owners of the club property, Bay Creek LLC of Virginia Beach, announced that the lease would not be renewed.

"It was a unique way for people in Cape Charles to get some affordable recreation, and that's what's sad," Galloway allowed. "I would hate for it to happen to me—to have a place that was my place, and have somebody come in and take it away.

"What are these guys going to do? I don't have any solutions," he said. "But I think the positive thing that can come out of this is how the town of Cape Charles can prosper. A lot more people will benefit in the town than who benefited from the golf course."

Freddie Harris, a compact southpaw from Exmore, drove off the eleventh tee and watched his ball sail high and fall short. "That was bad," he murmured with scientific detachment. "That wasn't very good at all."

He followed up with a chip too strong and wide of the hole. "That's bad," he sighed. "What am I starting to do?"

His partners fared no better. Kellam putted from thirty feet, only to see his ball catch the rim and slingshot out. Womble's putting game collapsed. Pars gave way to bogies. Soon the bogies looked pretty good. "We need some birdies," Harris said.

"I think you'd best just hope for par," Womble told him.

On the fifteenth, Harris swung too hard and grazed the ball's top, squirting it just one hundred yards down the fairway. Womble's third shot bounded eagerly for a trap in front of the green. "Get up!" he cried. "Get up!" A sigh: "It didn't."

They plodded on, in no rush. It was cold, and the wind was damp and chapped their fingers and faces, and they weren't exactly burning up the course, but they were outside with fresh air in their lungs and an ice-blue sky overhead, on familiar ground and in comfortable company. And it would all end soon. It was like Steve Warren, another member who'd played here forty-three years, said on the fourteenth tee: "I've been thinking, at every tee, and every green: 'That's the last time I'll make that shot,' or 'That's the last time I'll make that putt.'"

The three chipped onto the fifteenth green under the big pecan. Another member was outside the long row of cart houses, loading his golf cart onto a small trailer, preparing to tow it off. Womble, Kellam, and Harris watched wordlessly. They putted, then climbed in their carts, drove on to the sixteenth tee, reviewed their scores. "We're in trouble, Stewart," Kellam said.

"Well," Womble sighed, as the breeze bent a nearby wetlands ruff, "if the wind doesn't pick up, I think we'll be all right."

From over the water came the beep-beep-beep of a backing dump truck.

Where Is
the Fabulous
Dewey Diamond?

Somewhere out there, in hands unknown, is a relic of Virginia that once amazed and excited all who beheld it, and which provoked an exchange of money such that only the rich might contemplate, and which moved journals of the day to wax of its charms in long, convoluted sentences fairly abloom with words and phrases aflowered.

It was a diamond, found against all reason among the streets of Richmond—a gem of fine clarity, and the subtlest green hue, and a size not seen before that day anywhere on the continent. Such was its fame, and so singular its rarity, that its twin was fashioned from glass and displayed at the Smithsonian Institution.

But whither ventured the diamond itself? It was bought and sold a number of times before at last it fell into the hands of a New Yorker, one of that state's great characters, a man equal parts gambler, brawler, and politician.

With his death in 1878, the gem vanished from public view. Its whereabouts are a mystery yet.

Know, up front, that this is a tale of no news and few uncontested details, commencing with the rock's name: Dewey Diamond was the most common, but in its heyday this exemplar of nature's wondrous hand was known, too, as the Manchester Diamond and the Om-I-Noor, as the Old Dominion and the Morrissey. Its weight yields further disagreement: Over the years, it has been given as 18.75 carats, 19 carats, "more than 23" and "a little more than 24 carats," as 22.5 carats, 23.75, even 27.75.

This much may be stated without fear of contradiction: that though it has been since surpassed, the Dewey was the largest diamond yet discovered in North America when it came to light in the spring of 1854. The place was Manchester, then a Chesterfield County city across the James River from the fair capital; today the spot is in south Richmond, where Ninth and Perry streets meet, in a district once given over to modest shops, stables, and houses, but these days of a more industrial character.

The discoverer: one Benjamin Moore, "a worthy, industrious, hardworking resident," as the Richmond papers labeled him, who was one of several laborers tasked with leveling a small hill there. About two feet down, one of his coworkers found "a sparkling substance, which he threw aside as of no value," said Richmond's *Penny Post* of May 20, 1854. "Mr. Moore took it up, and upon examination was so much impressed with the singularity of its appearance that he determined to keep it."

At first, Mr. Moore supposed the stone—which was about the size of a present-day gumball—"to be simply a very pretty fragment of sparkling, transparent glass," the *Richmond Enquirer* reported. But in time he showed it to his employer, James Fisher Jr., who thought otherwise. In Fisher's care the pebble so appeared at Mitchell & Tyler, Jewelers, where John H. Tyler "at once pronounced it a diamond in the rough," as his son would recollect. "It had no sharp angles but had four projecting points at the apex of the angles," the son further stated, "and was so slippery that it was hard to hold between the thumb and finger."

Mr. Tyler arranged for it to be examined by Capt. Samuel W. Dewey, a Philadelphia geologist who had spent the prior months embarked on what the *Enquirer* termed "mineral explorations and wonderful discoveries" near the Carolina line. The consensus was that it was "a gem of the purest water and of exquisite beauty," the *Penny Post* vouched, adding: "It

is worthy . . . of a place in the most superb cabinet of jewels upon earth, and would form a conspicuous ornament in the richest imperial diadem in modern times." Capt. Dewey was so taken with the stone that he bought it from Moore for $1,500—a fortune the likes of which a laborer might not accrue in a lifetime of toil.

The diamond's second owner was a man of fine reputation and considerable intellect, who had devoted much of his forty-seven years to the maritime service, wherein he had earned his august rank, and who happened to be in Richmond to assist in the arrangement of a display of his mineral discoveries.

"Captain D. comes cordially commended by some of the best and ablest men in the State," the *Enquirer* informed its readers. "He is a private gentleman—unconnected with any public institution and wholly unaided by any kind of patronage—who has, nevertheless, at his own expense devoted the last five years, with unflagging zeal, in the genuine spirit of science and philanthropy, to the exploration of the mineral treasures of the Dan and Yadkin, mountains and vallies, west of Danville."

"In his valuable and persevering 'labors of love,'" said the newspaper, this but a brief aside in a story that occupied a generous fraction of May 30's front page, "Capt. Dewey has brought to light the treasures which a beneficent Providence has imbedded in the bosoms of our mountains and vallies; and has shown, beyond all rational doubt, that they exist in such quantities as to furnish the most magnificent rewards for the capital and labor required for their development."

Beyond that, Capt. Dewey was reputed to have beheaded a warship's figurehead carved into the likeness of President Andrew Jackson, the leader's politics being in variance with his own, an act for which he was much acclaimed in Boston. Known, too, is that at some point early in their acquaintance, Dewey subjected the stone to a test by fire—"which," the jeweler Tyler's son later wrote, "turned out to be a bad thing to have done, as an original flaw in it increased, thereby lessening its value." Other testimony has the crystal surviving the test without hazard, though some describe it as marred by a large flaw, or speck, on one side.

In 1855, the captain took his diamond to H. D. Morse, a pioneer in the science of gem cutting, then applying his delicate and as-yet nascent ministrations in New York, and in an effort to eliminate the flaw engaged Morse to cut it. By some accounts, the diamond broke. Dewey is said to have

given a fragment to his cherished friend James Gordon Bennett Sr., who as publisher of the *New York Herald* is perhaps best remembered as the man who dispatched Henry M. Stanley to Africa to search out Dr. David Livingstone, and as the author of that great journalistic truism: "Remember, son, many a good story has been ruined by over-verification."

The bulk of the stone—reduced from 23.75 carats, that being the most reliable measure of its original weight, to 11.15 carats—remained with Dewey, who by one report in a Richmond newspaper found it necessary to mortgage the diamond and was unable to later redeem it, and so lost its company to a man named J. Anglist. Whatever the case, the jewel eventually made its way to John Morrissey, whose fame was such that it dwarfed even that of James Gordon Bennett Sr., for he had gained renown as a prizefighter, and for most of the 1850s was the American boxing champion.

Morrissey's bare-knuckle skill bested all comers by dint of his indifference to punishment; in an early bout he was tossed into a stove, and his back ground into its glowing coals until his skin caught, earning him the sobriquet "Old Smoke," and yet he prevailed, drawing strength from his injuries and delivering unto his opponent such battery as befits only rugs, drums, and the devil.

Born in Tipperary, Ireland, the only son of eight children of poor parents, Morrissey moved to Troy, New York, at three years of age and gained a bullish constitution in a youth spent on little schooling, an abundance of hard factory labor, and rough-housing of fearsome aspect. His street fighting had already gained notice among the sporting set when, in 1851, Morrissey struck out for the gold fields of California, where, though not unearthing any of the prized metal, he established a faro game in San Francisco and launched upon a profitable career as a keeper of gambling houses. Returning to the East, he invested his boxing purses in a succession of ever-grander casinos in New York City, an endeavor encouraged by politicians dependent on his influence among the sons of Ireland who at an ever-quickening rate arrived on the city's shores, and who before long made for a powerful bloc of voters.

It was this influence that fueled a resentment toward the pugilist in Bill "the Butcher" Poole, who led a gang of native-born rounders and opposed all manner of immigrant sway in the affairs of the city; nearly 150 years later he would be represented by the actor Daniel Day-Lewis in the film *Gangs of New York,* although in somewhat stylized manner. Poole dealt Morrissey his only defeat as a fighter, in a match in which the butcher's exertions were subsidized with blows and kicks from his gang. "Poor Mor-

rissey was weakened to such a degree, that he required assistance to get him on his feet at the close of the encounter," a New York paper related. "The fight now became general, and for a time the wharf was a scene of the wildest confusion. The friends of Poole being very numerous, beat Morrissey's friends dreadfully, and [one] was taken away almost insensible, and quite prostrated from the great loss of blood."

Morrissey's camp evened the score not long after, when some of his gang cornered Poole in a saloon and dealt him a fatal wound. Perhaps not coincidentally, the champion, recently married and alert to his bride's entreaties for a gentler life, left the city for Troy and, later, Saratoga Springs, a summer resort in fashion among the wealthy. At the latter he opened a casino of the first order, and with partners started a horse-racing track that survives to this day.

Rich beyond imagining, he quit prizefighting and, at some point in the late 1850s or 1860s, paid six thousand dollars for the Dewey Diamond. It is said, by some, that he had the stone set in a ring; the same is said for that portion of the gem owned by Bennett, so that for some period in the middle part of the nineteenth century, two of the most remarkable men in America may have worn, concurrently, the rock discovered on a Virginia street corner.

Certainly, Morrissey was embarked on a life of such drama as to defy belief. His Saratoga business grew with each new season. He employed the telegraph to pioneer modern offtrack betting. He acquired a professional baseball team in Troy. His New York City gambling houses became destinations for "flocks of well-dressed and fashionable-looking men of all ages," as one observer put it, who "pass in and out all through the day and night; tens of thousands of dollars are lost and won; the 'click' of the markers never ceases."

At the ball celebrating Ulysses S. Grant's first inauguration, in March 1869, Morrissey's wife, Susan, wore $35,000 in diamonds, drawing voluminous commentary from the newspapers, though they made no specific mention of the Dewey. Morrissey was well familiar with a new career by that date, having been elected to the Congress in 1866, and reelected two years later, his popularity owed, in some measure, to his rising position in New York's Tammany Hall political machine, controlled at the time by the notorious "Boss" Tweed.

He did not stand for reelection in 1870, instead devoting his attentions to his gambling empire—that year he built Saratoga's famed Clubhouse, hailed by no less than the *New York Times* as "undoubtedly the finest

building, devoted to its especial purposes, in the world." Yet he remained
active in politics: After Tweed's ouster, the same *New York Times* objected
that this former fighter, little better than a common thug, had emerged as
Tammany's strongman, and thus, as a controlling power in state affairs—a
prospect most "disgraceful and dangerous."

"Whatever is done by Tammany is, in fact, done by Morrissey," said the
Times. "Whatever morality Tammany may have is Morrissey's in reality.
He ... has stepped into Tweed's place." Indeed, Morrissey didn't appear
to comport himself as a man worried of the public's trust; a witness in his
casino described him as "a short, thick-set man" who "wears a long beard,
dresses in a slovenly manner, and walks with a swagger."

As it happened, the *Times*' judgment was premature. Morrissey was
ejected from Tammany by a rival and in his later years devoted himself
to chastising machine politics with all the tenacity and vigor that he had
brought to bear against his foes in the ring. He served two terms in the
New York State Senate, on both occasions winning election in districts
home to Tammany's hand-picked young princes, and in office demon-
strated himself a great friend of political reform and fair play, and a
humble servant to his constituency.

He had lately won a third term when, in the spring of 1878, he was
struck with pneumonia and died in his forty-seventh year at a hotel in
Saratoga Springs. So complete was his rehabilitation in the eyes of his
countrymen that the state legislature closed for his funeral, which drew an
audience numbering twelve thousand. It may come as little surprise that
John Morrissey was inducted to the Ring Boxing Hall of Fame in 1954
and to the International Boxing Hall of Fame in 1996. What may surprise,
however, is that the *Times,* which had just a few years since so agonized
over his activities, now eulogized him as, "in public affairs, a man of sturdy
common sense, clear perceptions, and unbending rectitude.

"New York will remember the noble services which Mr. Morrissey per-
formed against political Rings and Municipal jobbery," the paper decided,
"long after the sins and shortcomings of his private career have been for-
gotten."

With the redoubtable Mr. Morrissey end the diamond's known trav-
els. No record has been found of its passage to other hands; indeed, none
avers that it remained in Morrissey's to the end. In his obituary, the *Times*
reported that he mortgaged his holdings to finance his Senate campaigns,
and once lost a fortune in a stock market crash. Might he have sold the
stone, at some juncture, to raise capital?

He left no heirs to whom to bequeath the diamond, as his only son, John Jr., died before he did; thus, if the stone was inherited, it likely was by a friend or a relative of his wife, and has not reappeared in any public manner since. As it might well never: "It sounds like it wasn't a very good-looking stone," observed Russell Feather, the manager of the Smithsonian Institution's gems collection, and whose expertise is unmatched in his field. "If it got mixed up in some estate or something, and no one knows the history, then it becomes just an ugly diamond."

Its only truly redeeming feature, in Mr. Feather's estimation, is its Virginia provenance, for diamonds are not often associated with the state: All told, just four such stones have been found, and another just over the state line in Monroe County, West Virginia. Two were found in gold mines; the rest, among them the Dewey, were found not far from creeks or rivers.

Therein may lie the solution to more than a century's questions as to how the Dewey came to be discovered in Richmond, which at first inspection seems unlikely a venue for such treasure: Far up the James, in the southwest corner of Rockbridge County, is a geological formation, called a kimberlite, whence these gems typically appear, and which might have produced the stone in question, and from which the diamond might have tumbled downstream, carried by one flood or the next over the centuries until it was deposited in the alluvium near the river's falls, and covered with the silts of later freshets.

The world is, happily, not without some notion as to the Dewey's exact appearance. At the height of its notoriety, in the months before Capt. Dewey had it cut, the rough stone was made the model for a number of glass copies, which were distributed to museums in several cities. One remains in the Smithsonian, in the reference collection.

It is, sad to say, in a back room, and not available for public inspection.

In the
Radiance of
Master Charles

Alan had a Mercedes and a backyard grill. Murray balanced a company's books. Carol was a Jewish housewife and mother. Steve taught college in Indiana. One by one they left their pasts to seek Truth and Beauty and meditative bliss. One by one their quests brought them here, to an oak-shaded enclave in the Virginia Blue Ridge, and to the side of its spiritual leader.

He was a master of meditation. A swami who'd once worn saffron robes and lived on an Indian ashram. A mystic who'd wedded modern technology to the wisdom of the ancients, and so blazed a straight and smooth path to awareness. They came, as dozens of others have come, to live with Master Charles.

In twenty years these pilgrims have helped him build a New Age wonderland—part monastery, part retreat center, and part, of all things, record company—in the woods and red clay of Nelson County. In return, Master Charles has helped them unlock some of life's many mysteries.

While remaining a bit of one himself.

In purely physical terms, Master Charles's domain is 450 acres of rural woodland interrupted by a straggle of buildings. Calm abounds; off the trails that crisscross the spread wait cool, green hillsides, whispered breezes, still ponds.

To those drawn here over the years, though, its appeal is largely unseen: This is the "Sanctuary," a locus of powerful spiritual energy. Alan Scherr felt it the moment he stepped onto the property, nearly a decade ago. "Pay attention to how you feel while you're here," the fifty-three-year-old former college professor advises. "This whole place is one big pulsating meditation."

The epicenter of the vibrations was, and is, the master himself, aka Charles Cannon, aka M. C. Cannon, a musician, author, and monk whom followers describe as an "enlightening master." Such folks "unceasingly enjoy a truthful perception of reality, and they are free in the eternal now of oneness," Master Charles explains, by way of definition, in his 1997 memoir, *The Bliss of Freedom.* "They are not referred to as enlightening because of what they say, but rather because of what they are, because of what others experience in their presence, the radiance of their Source-field."

It was experiencing this Source-field that prompted Scherr's move to Nelson County with his wife and infant daughter in 1996. Today he's president of the Synchronicity Foundation, the nonprofit company that manages the Sanctuary's interconnected ventures—a line of music CDs designed to encourage a meditative state, and retreats that have drawn thousands, among them actress Ally Sheedy. "Suffice to say, I was blown away," Scherr says of meeting the master, from behind a desk busy with paperwork, crystals, a tiny Zen garden, and the nubs of burnt incense sticks. "I was so blissed."

"Here was a Westerner," recalls Scherr's wife, Kia, "someone like us, who'd watched *The Flintstones,* who drank Cokes, who was a real master. You could sit right there in the front row and ask him questions! And you could feel his energy.

"That's the mark of a real master, when you can feel it."

It is early afternoon when Scherr, playing tour guide, strides through a grove of trees to a handful of small purple mobile homes, where the foundation's thirty or so full-time monks fill mail orders for CDs, run a Web site, provide meditation support for customers, and organize retreats. He passes a small hut marked "Recording Studio," then weaves among a half-dozen larger mobile homes with names like "Harmony" and "Tran-

scendence," each broken into spartan cells in which most of the monks reside. The air is filled with the rumble and hiss of ocean surf, sneaking from loudspeakers.

Synchronicity's CDs incorporate such natural sounds, along with vocal chants and orchestral arrangements, in long, glacial pieces without dramatic peaks or toe-tapping hooks, music that when played over speakers seems as unobtrusive as wallpaper. Played over headphones, however, the music—written and largely performed by Master Charles—is said to provoke profound change in its listeners. Until recently, in fact, Synchronicity's logo was a Buddha wearing headphones.

The surf follows Scherr to the village's edge, and a wooden building called the "Environment." It is twelve-sided, with a gently peaked roof, a shape that he says helps focus energy. Inside, rows of chairs fitted with headphone jacks face an armchair on a low altar, flanked by a pair of tables. On one is a clown mask on a stick. On the other is a plastic figure that drops its pants with the squeeze of an air bulb.

The enlightening master is into clowns. "He thinks we're all clowns," Scherr says, "including himself. We put on costumes, assume roles. People begin to take their costumes pretty seriously, and to forget that it's all for fun, for delight."

Monks are required to spend nearly two hours here every morning, plugged into headphones, meditating. They must exercise twice daily. They must put in full workdays, seven days a week, and after dinner tend to chores until dark. Most importantly, they must be serious about growing their consciousness. They are unpaid, but supplied meals, a bed, and contact with Master Charles.

"This is not the Camera Club," Scherr allows. "About 5 or 10 percent of humanity, at any one time, is going to be open to something like this."

Master Charles once lived in a mobile home himself, within yards of the Environment and his fellow monks, but these days an audience with the man requires a first-gear climb up a narrow, steep drive to the property's crown and the "Parsonage," a $589,000 house that he shares with four monks. From the building's small foyer, a spiral staircase ascends to the master's reception room—twelve-sided, like the Environment, with pale purple walls and windows overlooking forest and foothill. Persian rugs cover the floor, which is otherwise decorated with statues of elephants and St. Francis of Assisi, a console filled with gifts to the master from admirers around the world, and a large Buddha. In the Buddha's lap is an array of toy clowns.

Master Charles breezes into the room in cream-colored silk lounge-wear, shakes hands, and settles into a wide, plum-colored velvet armchair.

He is tall, fit-looking, bespectacled, with dark hair cut into a short page boy. His skin is pale and pink, without trace of a tan. "I don't get out and about that much," he explains over the surf emanating from wall-mounted speakers. "If I travel out of here it's usually for professional commitments—programs, retreats, things like that."

That's not a complaint. "It's a magical place, kind of a mystical place," he says of the Sanctuary. His speech is melodic, deliberate, carefully enunciated, and punctuated with little hums; many of his sentences end with a querying "Hmmm?" "It's rural," he says, "very quiet, very meditative." Outside, a storm brews. Clouds hang dark and heavy over the Parsonage. Treetops sway. "It's also," he adds, "a good place to experience the weather."

A good place to contemplate the unity of being, as well. Everything and everyone is connected, he says—you, me, that chair over there—all part of an all-encompassing One, the Source. Life as we experience it is merely the Source amusing itself. One day might bring comedy, and the next tragedy, but it's all good.

"It's very entertaining for me," he says, "to be with people who still believe there's a God in heaven on a throne with a beard, surrounded by angels with harps, that they would pray to, and that God would somehow take care of them—when there's so much evidence that that doesn't happen."

He chuckles. A bolt of lightning lands close by. The house shudders.

What's offered at the Sanctuary, Master Charles says, is far more relevant than most mainstream religions: a lifestyle that not only nourishes the spirit but, through diet and exercise, the body and mind as well. It is a simple existence. He owns nothing, receives no pay, has no bank account. His needs are provided for, but all things material are in the hands of the foundation. The house. The land. The BMW Z3 roadster parked outside: It's a "hand-me-down" from the foundation's chairman, Michael S. Lang of Fort Worth, Texas—an "extremely wealthy man" and a "benefactor to this organization for many, many years."

"He told me, 'Here, you're modern—you ought to be able to enjoy driving around with the top down,'" Master Charles says, laughing softly. "It's a volunteer organization. It's a charitable organization. It's a labor of love." Thus, his colleagues down the hill embrace their spartan lives. "They're done with the material world," he says. "The monk is renouncing. He doesn't want to be surrounded by things that make his mind busy."

Some subjects get a mind busier than others, and at Synchronicity none does so quite like Master Charles's past. Alan Scherr says that's because

the media have "misquoted, intentionally edited and misrepresented" the master on what he did before he began his spiritual quest. "It seems endless and ridiculous," he wrote in an e-mail. "All this mess of misrepresentation has gotten so exaggerated and out of hand that Master Charles just throws up his hands and laughs."

Granted, the stories have been strange. Two accounts, published shortly after Master Charles's arrival in Nelson County, quoted him as saying that he'd portrayed Ernie on TV's *My Three Sons* for a few months, that he'd played a doctor on a soap opera called *Love Is a Many-Splendored Thing,* and that he'd appeared on Broadway in the cast of *Jesus Christ, Superstar.* A later story, in the *Los Angeles Times,* reported that he was a musical prodigy who at age ten had toured the country with jazz drummer Gene Krupa.

Master Charles says, through Scherr, that none of it is true—not only did he not do any of it, but he never said he did. But the stories refuse to die, perhaps partly because the journalists involved have insisted the quotes were accurate, and perhaps partly because the notion that they'd deliberately manufacture such a resume seems a stretch.

Then again, maybe it's because Master Charles won't say what he was doing when he wasn't doing what he says he never said he did. As Scherr said via e-mail, "he purposefully keeps private and unavailable what he considers the irrelevant and distracting details of his first twenty-one years."

Master Charles edits those years to an amorphous few sentences: He was born in Syracuse, New York, to Italian-American parents. He has two sisters, and the three of them enjoyed a happy, All-American childhood replete with ice cream and Santa Claus and shopping at Woolworth's. His name wasn't Charles Cannon at the time. What was it? Master Charles doesn't say. His memoir does reveal that he did some modeling, took acting, singing and dance lessons, and that an itchy skin condition so tormented the young mystic-to-be that the family moved to Florida, in part to provide him some relief.

Where in Florida? Master Charles doesn't say. Where did he go to school? Won't say, beyond that it was Catholic. What year did he graduate? Sorry. His book mentions that he played the drums in public, and that in his mid-teens he did so behind exotic dancers in a burlesque show. It suggests that he was no stranger to public performance, and that he spent a lot of time "in the world of entertainment." It provides no details, however.

A photo in his memoir depicts him in football gear, and folks at Car-

dinal Newman High School in West Palm Beach say it matches a student they remember as one Chuck Ceravolo. Was it under that name that he entertained? If so, he failed to leave a lasting impression: Google's never heard of him, and the newspaper of Mr. Ceravolo's youth, the *Palm Beach Post,* doesn't have him in its files.

Master Charles went on to college, Scherr says, declining to discuss where or when. As for his degree: Scherr says the master "majored in the arts." A Synchronicity pamphlet says that his education emphasized "comparative religion and philosophy."

What's fact? What's fiction? Does it matter? No, says Steve Pauley, one of Scherr's predecessors. "What he did or didn't do when he was nineteen years old," he says, "doesn't mean a hell of a lot to me."

Life, after all, is simply entertainment. Most of us take it far too seriously.

One aspect of the master's past doesn't get short shrift. Beginning in his childhood and continuing through his teens, he says he experienced episodes of expanded awareness that left him weak with joy.

In 1970 he visited friends who'd just returned from a trip to Asia, during which they'd met an Indian master of meditation named Muktananda Paramahamsa. They offered a photo of the swami. When it met his eye, the portrait "dissolved into a whirlpool of scintillating, hallucinogenic energy," he recalls in his memoir. "I was immersed in a rose- and blue-colored magnificence, permeated with minute particles of dancing, diamondlike light that slowly moved upward and entered the area just above the center of my eyebrows."

Not long after, he set out for India, where he met Muktananda at his ashram and found that the swami's proximity had a similar effect on him. He took up the monastic life. In the years that followed, Muktananda traveled the globe establishing the Siddha Yoga Dham movement, and his American disciple accompanied him, eventually as his personal secretary—a job he landed even though he and his boss needed an interpreter to communicate.

Muktananda's tours brought him to the United States, where Siddha Yoga soon had thousands of followers, while Cannon became so practiced at meditation that Muktananda decreed he be a spiritual guide himself. Cannon so became Swami Vivekananda, and under that name was dispatched in 1979 to Houston, where others detected a power about him.

"I just found being in his presence addictive," says Carol Wise, a Houstonian who'd felt no such energy when she'd met plain "Chuck Cannon" in 1974. "I just dreaded not being with him." When Swami Vivekananda left Houston, "we all wept, because we hated to see him go," Wise recalls. "I have that same feeling about being with Master Charles that I had with (Muktananda). There's no separation. They're one."

Physically speaking, they were soon to part. In 1982, Muktananda died.

Within a year, Siddha Yoga was racked by scandal—reports of money squirreled away in Swiss bank accounts, charges that the supposedly chaste Muktananda had bedded women and young girls at his ashrams, intimations that the swami had employed threats and intimidation against his critics.

Swami Vivekananda had left the movement by then, and in short order moved to Virginia. "I traveled the world constantly, so I always wanted to park it one day, you know?" he says. "And many times I traveled through this part of the country, and I liked it. So when it came time to finally stop the traveling and settle, I decided this was where it would be."

He moved into a cottage in Shipman, south of Nellysford, in April 1983, then lived with a small band of followers north of Charlottesville. Most held regular jobs while Cannon, who dropped his monastic name in favor of "Brother Charles," immersed himself in a project inspired by his late master. Muktananda had believed that meditation would achieve its potential in the West only if it shed its ancient Eastern trappings. He "looked at me one day and said: 'You're an American. You must contemporize this,'" Master Charles says. "You must find a way to take this into your culture, that makes it part of the West.'"

The result: meditation soundtracks. "His original idea was to replicate the sound of the caves in which the monks in India meditated," Scherr says, but that gave way to music engineered to foster specific brain activity. Played through headphones, some recordings reputedly induced brainwave frequencies in the Alpha range, said to promote a light level of meditation; some tapped into the deeper, creative Theta range; others, the Delta range, provoking a meditative state akin to deep sleep.

By 1987, four years after the group bought the first piece of the now-sprawling Sanctuary, its cassette tapes of those early recordings had gained a following around the world. Mail order sales were brisk. Scherr, a long-time practitioner of Transcendental Meditation, says he was skeptical

before he tried one of the tapes himself. "I put the thing on, bemused, thinking, 'What can this offer me?' And in one minute, I was totally astonished."

"Without it," he says, "it's like riding to California on a horse: You can do it, and people have done it, but it's a hell of a ride. Why not take a jet?"

The storm passes. The thunder recedes. Master Charles, who assumed his latest name at his followers' behest, smiles serenely. He can count many blessings. He has a staunchly loyal following, for one. Sydney Jane Miller, a Sanctuary monk and Synchronicity officer who has known him for twenty-four years, calls him "the most loving person on the planet."

"The longer I know him," she says, "the more I am in awe of him."

Even monks who've left the Sanctuary speak well of him. "He's a born teacher, and a wonderful teacher," says Steve Pauley, who spent two and a half years with the mystic, and who still drops by with gifts on Master Charles's birthday. "I'd actually spend more time with him, if I felt I'd grown enough that he could be proud of me."

Tens of thousands of Synchronicity's tapes and CDs have sold over the past two decades, an affirmation of the master's powers not only as a meditator, but as a musician. The foundation enjoys online success, as well: A free e-mail newsletter, "The Meditation Toolbox," reaches thousands each week.

Then there are the retreats. A couple of dozen times a year, seekers arrive to draw inspiration from monks and master, meditate in the Environment, and enjoy wordless meals in the dining hall—again, a twelve-sided room that resounds with the soft crash of surf. Each spends several hundred dollars for the experience.

Their numbers don't overwhelm—112 people in 2001, according to the group's tax records; just 98 in 2000, and 232 in 1998. A program through which the foundation counsels CD meditators serves modest numbers, as well. Still, Synchronicity has never tried to be "the McDonald's of meditation," as Scherr says, and it isn't exactly hurting. It took in more than $1.3 million in 2001 and boasted total assets of $4.2 million.

Success in matters of the spirit can't be gauged in dollars, anyway. "Seeing the transformation in peoples' consciousness is amazing, absolutely amazing," Master Charles says. He rises, shakes hands, leaves the reception

room. A minute later, he reappears with a gift: a flat river pebble painted with the face of a clown, and a business card that reads, "May the Farce Be with You."

A reminder, he says, that life isn't so serious, that it exists to amuse our oneness, that we need to lighten up.

Fact, fiction, comedy, tragedy. All entertainment.

Ricochet

It takes him a minute to get his bearings. It's been fifty years since he last stood here.

This spot, Earl Whitehurst finally sighs—this is where he parked his car that night. And this building: This is the apartment house he and his buddies visited, and where one of them started mouthing off.

There, in the dirt at the foot of the front steps, is where words gave way to fists. Used to be some cottages across the street, in that patch of tall weeds, and that's where he was, Whitehurst says, when he heard the first shots.

He scowls down Hillside Avenue. Just over there is where it ended—in his car, as he drove away. That's where Phil Ybarra died.

You can imagine how the papers played it. One cop shot by another, in front of a third, after they'd been out boozing. Ybarra stretched out in the street in full uniform, feet still hooked inside the car, head in a puddle of blood.

Still thinks about that night all the time, Whitehurst says. Not a day goes by. Terrible thing.

Across town, Reid M. Spencer turns an envelope over in his hands. It is folded in half, and sealed with five staples. It's been fifty years since it was last opened.

The official account of Ybarra's death never sat right with him, Spencer says. He prosecuted the case. Saw a man convicted. Saw him off to jail. Just the same, he didn't believe some of the story. Didn't then, and doesn't now. So he locked this away in his safe deposit box, and he's kept it there ever since.

A drama played out in the predawn dark of a long-ago Sunday morning nags him as surely as it haunts Earl Whitehurst.

Inside the envelope is a tiny cardboard box. Under its lid is a layer of cotton. Under the cotton is a gnarled lump of lead.

The morning in question: February 6, 1955. Temperature in the forties. Cloudy. Damp. Spencer found the Chevrolet parked in the middle of Hillside Avenue at Chesapeake Street, two blocks off the bay.

He was an assistant commonwealth's attorney. He wasn't called to most crime scenes. But then, this wasn't your average crime. The victim, he learned, was a twenty-five-year-old police officer assigned to the department's traffic division. He'd been shot in the face at point-blank range while a passenger in the Chevy's rear. The weapon was a .38 Special revolver, fired from the front passenger seat by one Harold Rotch Strickland, twenty-three, a police rookie. Behind the wheel was another traffic division patrolman, twenty-six-year-old Earl R. Whitehurst.

The shooting had occurred seconds after the officers left the home of a retired detective sergeant lionized by the press and public. Prior to their departure, they'd engaged in a noisy scuffle witnessed by several neighbors. Alcohol had been a factor throughout.

It fell to the prosecutor to sort out the mess. Spencer and Ted Miller, his office's investigator, started with the car, a maroon '51 two-door sedan. Blood had pooled in the carpeting of the rear footwell, behind the driver's seat. It had also soaked the forward edge of the rear seat cushion.

Two things struck Spencer as odd, right off. The rest of the back seat was clean. No blood, no gore, no bone, nothing. Man was lying in the street with a gaping hole in the back of his skull. Yet you could settle into

the back seat—which would have been right behind him when he was shot—without dirtying your suit.

The other thing: Spencer couldn't find the bullet.

In the photo, Earl Whitehurst is in his twenties and in uniform, his patrolman's hat cocked jauntily. A half century after leaving the force, he displays the portrait alongside family snapshots. He liked being a cop. He was suited to the job. He was on the fast track.

His uncle, police chief E. Leroy Cason, had broken him in on foot beats through the toughest parts of a tough sailor's town. East Main Street, possibly the scummiest few blocks on the Eastern Seaboard. A downtown of booze, B-girls, sidewalk fights. Waterfront rats the size of dogs.

"I was going to go up for sergeant," he says. Ybarra's death ended that. His fists clench at the thought of it. "I messed my whole career up," he says. "I could have taken him home, got him sobered up. That's what should have happened."

As Whitehurst remembers it, the trouble started shortly after eleven the night before, almost as soon as their shifts ended: They were fresh off the streets, still wearing their guns, still in the parking lot outside the police station.

Whitehurst shared the Chevy's front bench seat with Strickland, who'd joined the department three months before. They were neighbors in Lamberts Point. Whitehurst had arranged to drop him off on the way home. Ybarra sat in the back. He was from the Los Angeles suburbs, had moved to Norfolk with the navy, and had joined the force in September 1952. Whitehurst had agreed to give him a lift, too.

Except that Ybarra pulled out a fifth of whisky. A guy who worked a used-car lot on Granby Street had given it to him, he told the others, about a half hour before he went off duty. A quarter of the bottle was already gone. Ybarra offered to share what remained.

They should have gone home. Whitehurst had a wife and two small children waiting for him. Strickland was still on probation. Ybarra was a husband, and a father, and a screw-up who couldn't afford to get into trouble.

But it was Saturday night, and early by cop standards. Instead they drove out past the city line to Military Highway, where they met Albert Carl "Buster" Lee. By day, Lee did business as the owner of a wrecker service. By night he resold store-bought liquor at a markup. The three officers

bought a pint of whisky from him about 12:30 AM. About a half hour later they were back for two more.

At about 2 AM they arrived at the City Employees Protective Association, a tin-roofed private social club at the southwest corner of Hillside Avenue and Beach View Street. A popular place with off-duty cops. A big-bellied older man met them at the door. The evening's fun was over, he said. He was locking up. The three mentioned they were policemen. In that case, the man said, you're welcome at my place.

They followed the legendary Leon Nowitzky home.

He was fond of fat cigars. He wore round-rimmed eyeglasses. He scrabbled sideways like a crab. His suit jackets tended to ride up his ample rear. Leon Nowitzky was no clown, however. Before the war, he'd led Norfolk's homicide bureau for more than twenty years. He'd been the bureau's only member for a good piece of that time. He'd closed hundreds of cases. He'd reputedly killed seven men, sent seven others to the electric chair, and shot thirty-eight more. He'd been wounded several times himself.

His notoriety bordered on celebrity. Nowitzky was the hero of several detective magazine stories, and by one estimate the Norfolk papers devoted more than a million words to his exploits. Five years into retirement, he was now a private eye, justice of the peace, and a sundries merchant. He and his wife regularly had his cop buddies over.

Whitehurst, Strickland, and Ybarra followed Nowitzky a couple blocks west to a three-story apartment building at 1021 Hillside Ave. They left their guns and uniform jackets in Whitehurst's car. They accompanied Nowitzky to his ground-floor apartment. They were joined by Nowitzky's daughter, Doris, and her husband, Leonard Iredale, who shared a bungalow across the street.

Leonard Iredale would later report that Ybarra was obviously drunk. That as he talked to Doris about women's clothes, his character, his mood, shifted from moment to moment. That after while, Ybarra proposed a toast to their host. Nowitzky's wife opened a fifth of Planter's Club. They all drank a round. Ybarra threw his empty glass into the kitchen.

Strickland apparently tried to settle him down, with limited success. At some point, Ybarra went out to the car and put his tunic back on, along with his Sam Browne belt and his gun. Nowitzky would recall that he was in his bedroom when Ybarra "came back in full uniform and saluted me." He added, "I saw the boy didn't know what he was doing."

Eventually, Ybarra again left the apartment. Strickland followed, admonishing him to behave. The two descended the front steps to the yard. Leonard Iredale went out, too, but stayed on the porch. As he watched, the two cops began scuffling. Before long, they were rolling around on the ground.

Ybarra had his revolver out.

Iredale would later tell police that he left the porch, grabbed the gun away from Ybarra, and threw it to the ground. The two men stopped wrestling. Strickland got up. He thanked Iredale for his help and told him he could go back inside. He'd take it from there; he didn't want Ybarra to get into trouble.

Iredale returned to the porch. He'd later report that Strickland told Ybarra they were leaving, and to pick up his gun. That instead, Ybarra grabbed Strickland's shirt with his left hand. That with his right, he pressed the muzzle of his gun into Strickland's neck.

Ybarra was no angel. The previous August, he'd slugged down some whisky before going on duty, and had fallen asleep behind the wheel of a moving police cruiser. He'd ended up in the hospital. He'd also been suspended without pay for two months. A few weeks after he'd returned to work, he allegedly got liquored up in uniform and unloaded his gun into the wall of a motorcycle dealership near the naval base.

But this beat all. In the second-floor apartment directly over the Nowitzkys', Elizabeth Doar heard the sounds of a fight, went to the window, and watched Ybarra back Strickland against the hood of Nowitzky's car. He "seemed to have the urge to kill," she'd say later. He was screaming and crying. He said: "I'll blow your head off, I'll kill you."

He said: "I'm going to kill you. You know I'm going to do it."

He said: "Say your prayers, buddy."

A bullet doesn't just disappear. Still, when Spencer and Miller pored over the Chevy's interior, they turned up no projectile. No holes in the upholstery, either. "There's got to be a bullet," Spencer kept saying. "There's got to be a bullet."

The city's medical examiner studied the victim in the street at about 6:20 AM. He found a hole three-sixteenths of an inch wide above Ybarra's right eye—a bullet's point of entry. The round had left the back of his head at just above eye level. Where it ventured from there was a mystery.

The cops could only get so much from the car, forensic analysis being

what it was in 1955. They released the Chevy to Whitehurst later that day. Not long after, Spencer had a conversation with police Detective Sergeant Ernest M. Towe, chief of the homicide squad. Towe told the prosecutor he had good news: The missing bullet was in police custody.

Spencer asked where it was found. Towe's reply, which he repeated to the newspapers, was that it had dropped into the front seat of Whitehurst's car. The policeman had been driving home, had turned a corner, and the slug had fallen from the overhead sun visor. It had been wedged, apparently, between the visor and the headliner.

Well, how on earth, Spencer asked, did it get up there? Towe answered—and he said this in the papers, too—that the bullet must have struck the inside of Ybarra's skull and ricocheted back to the front of the car. Bounced right back the way it had come. It happens sometimes, he told Spencer.

Fifty years later, Spencer's shock seems fresh. "I remember I looked at him and I just shook my head," he says. "I couldn't believe that a police sergeant with his kind of experience, and knowing me the way he did, would tell me such a cockamamie story."

Whitehurst says he saw none of the fight. He was across Hillside Avenue in a bungalow behind the Iredale home. Nowitzky kept photos and trinkets there from his more than thirty years on the force, and was showing off the collection, Whitehurst says, when they heard gunfire.

Iredale had again left the porch. He later told police he slipped off his shoes, padded up behind Ybarra, and knocked the revolver away from Strickland's neck. As he did, the gun discharged. Ybarra fired a second time into the ground. Strickland dropped.

Iredale thought he'd been killed. Elizabeth Doar thought the same, as did others: From her window, Doar said she saw Doris Iredale run into the yard screaming, "You've killed your friend."

Whitehurst ran up. As he recalls it, Nowitzky arrived with him and yelled that he was calling the police. Nowitzky remembered it differently; he later testified that he'd gone to bed, was roused by the sound of gunshots, and immediately phoned Towe.

Either way, a crazy scene greeted Whitehurst. "Ybarra had put his uniform back on—hat, gun, everything," he recalls. "This other policeman still had his civilian coat on, like I did. He was lying face-down on

the ground. I thought he was dead, because Ybarra was standing over him with the pistol. I hollered at Ybarra, 'Put that gun down!'

"He looked wild at me," Whitehurst says. "He walked over to me and shoved the pistol in my stomach, and I shoved my hand into the hammer of the gun. And I took my fist and really cold-cocked him, sent him half-way down the hill, and I grabbed the pistol at the same time." He put the gun in his own pocket, he says.

Strickland got to his feet. He had not been wounded. Elizabeth Doar later said that he kicked Ybarra "in the ear" several times, and that others in the yard "all stood around letting Strickland kick Ybarra for a while"— a story Iredale refuted, and which Whitehurst said she got backward: Ybarra, he said in 1955, kicked Strickland. Strickland testified he didn't remember.

By all accounts, they left soon after: Nowitzky was said to have emerged from the house to tell them he'd called the police, that they'd all be fired, that they'd better scram. Whitehurst says he and Strickland hurriedly dumped the unconscious Ybarra in the back of the car. He lay on the floor, rather than the seat—a '51 Chevy had tremendous leg room. "I knew the police were on the way," Whitehurst says, "and I knew we'd be in big trouble if we didn't get out of there."

They took off to the west.

The cardboard box is edged in green. Hand-written along the top of its lid is *2/6/55*. Along the bottom is *Case # 1468*. Between them: *1 bullet marked E.M.T.* Towe's initials.

Towe's explanation of how the bullet came into police hands never made sense to Reid Spencer. Still doesn't: It called on the bullet to travel toward the Chevy's rear and into Ybarra's head, then execute an about-face against the inside of the dead man's skull while simultaneously creating what the medical examiner took for a classic exit wound. It required that the wound fail to produce a spray of blood, broken bone, and brain. It required the deflected bullet, now traveling forward, to miss the front seat and Whitehurst, whose own skull was inches from the visor.

Was it possible? As Dr. Marcella Fierro, Virginia's current chief medical examiner, puts it: "Bullets in enclosed spaces do funny things." Still, Spencer so questioned the explanation that he did not call Towe to testify in the case. The detective appeared at trial for the defense.

Spencer nods toward the box. "Go ahead," he says. "Open it."

Under the cotton is a Western-brand .38 Special cartridge, its brass dull. An old fingerprint is visible on the metal. Beside it is the slug. It is dark gray. Only a few flecks remain of the copper coloring that once sheathed the lead. The bullet's round nose has been mashed flat in two places.

"I didn't know what to do with it," Spencer says quietly. "I couldn't put it in the police evidence locker. It would have disappeared."

Police crime-scene photographs show Ybarra's body beside the Chevy. He's stretched face-down on the pavement, perpendicular to the car's left side. His ankles are crossed. His feet are draped over the doorsill. Left arm is bent up, hand beside his head. Right arm bent down. Shoulders bunched high, as if he's been dragged by his armpits.

Blood forms a black oval beneath his head, tapering to a rivulet that drains toward the curb. The Chevy's door is ajar. In the footwell carpet, just beyond Ybarra's feet, more blood can be seen. Most of it is pooled in the front half of the footwell, just behind the driver's seat. A smaller amount is smeared on the bulkhead aft of the door opening.

A half century later, Earl Whitehurst examines the images. The blood appears to have soaked, rather than spattered, the carpet. In the footwell beside the blood are a policeman's ticket book and what looks to be a pamphlet of some sort. Next to the hump is a shiny chrome flashlight.

It loomed large in the surviving policemen's accounts of the shooting. They held that the three cops had traveled only one hundred feet or so when Ybarra stirred. He sat up on the rear floor. Strickland saw something shiny in his hand, mistook it for a revolver, not knowing that Ybarra's gun remained in Whitehurst's pocket. He screamed, "Don't point that gun at me any more." Reached under the front seat. Grabbed his own gun. Swung wide to the left with it, until it was pointed over his own shoulder at Ybarra's head. Pulled the trigger.

"If he had fired a second sooner, he'd have blown *my* head off," Whitehurst says. As it was, he says, Strickland shot Ybarra from about eighteen inches away. Ybarra fell back without a word. The flashlight wound up on the floorboard.

"I could hear the blood coming out of him," Whitehurst says. "It sounded like a gallon of water. I knew he was hurt. I stopped the car and got back there to see if I could help him and I could see he was dying, and had the quivers." He taps a photo of the car's interior. "That's where his

head hit—where all the blood is—before I could get him out of the car," he says. "This all happened instantly."

He folded his own seat forward and dragged Ybarra out. No sooner had he done so than a prowl car pulled up. Sergeant B. V. Moore later testified that he asked Strickland who shot Ybarra. He said the officer replied: "I did. Everything's happened to me today."

Justice moved swiftly in 1955. Strickland's first trial on a charge that he murdered Phil Ybarra took place that April. A statement Strickland gave to Towe shortly after the shooting was read aloud; in it, he said he had no memory of pulling the trigger, but that "it was my gun in my hand." He did not know Ybarra was unarmed, he said, adding: "If I had, I certainly wouldn't have shot him."

The jury heard testimony that Ybarra had made eyes at Doris Iredale. Her husband testified it wasn't true. The jury heard accounts of the fight that differed on minor points. When it came time to decide the matter, the jury could not do so, and the judge declared a mistrial.

On May 24, a second trial commenced. A new jury convicted Strickland of involuntary manslaughter two days later. It fixed his punishment at a year in jail. The state's case was built on Strickland's admission to Sergeant Moore. Not much else: Spencer had decided against calling Towe, Whitehurst, and Nowitzky as witnesses. They differed with him on a key point. "I never thought the man was shot in the car," Spencer says.

He wanted to look around Nowitzky's home. He and the old detective knew each other well: His father had been Nowitzky's partner decades before, and Spencer was good friends with one of Nowitzky's sons. He wasn't invited in, however. He considered getting a search warrant. He and others in his office talked it over. But search warrants weren't as easy to come by then. And he had shaky grounds to seek one, he says. Everyone at Nowitzky's house that night agreed on where the killing had occurred.

So he didn't call the men, and he didn't enter the bullet into evidence. He put the little cardboard box in an envelope stamped with the address of the commonwealth's attorney. He wrote his name and "Keep—Ybarra bullet" across the envelope's face. He folded it in half. He stapled it five times. He put it in his safe-deposit box.

He didn't dwell on the case. Spencer prosecuted many others in his tenure, which ended in 1959. He enjoyed many years of success as a defense attorney. He was appointed a judge. He served more than a dozen years

on the bench. But he never stopped wondering about what happened that night. "I do not know who shot him," he says. "Strickland said he shot him, and he may have shot him." He shrugs. "It got him twelve months in jail."

He held on to the bullet.

Earl Whitehurst stiffens with indignation. "He's absolutely wrong. Absolutely," he says of the judge. "The man sure did get shot in the car. I can still hear the blood coming out of his head." He sits on the back porch of his house in the Roosevelt Gardens neighborhood, a scrapbook on his lap. In it are newspaper clippings about the case. They have turned brown and brittle. Flakes break from their edges with every turn of a page.

"I don't like that at all. Because Lord knows, it happened in my car," he says. "I don't have to lie about it. It happened in my car. I know it, and God knows it, and Strickland knows it."

Strickland still lives in Norfolk. After his release, he married, had a couple of children, found work as a die maker, and rose to a supervisory post in a company that made cork gaskets. He won't talk about the shooting. He and Whitehurst, the latter says, haven't spoken in decades.

Whitehurst turned in his badge a few days after the verdict. In 1956 he joined the Norfolk Fire Department, from which he retired twenty years later. Some nights, over the years, his nightmares woke the firefighters bunked around him. He dreamed of three babies who burned in a camper near the naval base, and the dead child he pulled from bed in a house off Church Street. Of a shipboard accident he saw in the navy, before he joined the force, that ripped a man in half. Of that night on Hillside Avenue.

But not because he has a heavy conscience. Strickland shot Ybarra, he says, and he saw him do it, and it happened in the back of that '51 Chevy. "I wouldn't be crazy enough to put a dead man in my car, bleeding and all that," he says. "Three of us know the truth: The Lord, myself, and Strickland. We know the truth. We know exactly how it happened."

He was surprised when the bullet fell out of the visor. So were the police when he told them about it. But that's what happened. He was there to see it. He was the only person there to see it. So he ought to know.

He was driving home. He must have hit a bump, or something. He heard a plunk.

He looked down to find a bullet in his lap.

Meat

They stood aft as the boat thundered nose-high into the Atlantic, studiously nonchalant as wind-whipped hair stung their eyes, and the deck underfoot lurched and yawed like a surfboard. Behind them Rudee Inlet had dissolved into the predawn black, and Virginia Beach into a string of sodium-yellow pearls. They watched the lights wink out of sight, and they talked about meat.

Meat—as much meat as the box at the stern would hold. They'd motor out sixty miles, out over the edge of the continental shelf, out to the curb of a highway of fish that runs off the East Coast. Hang out their lines. Reel in the meat.

The boat bucked through three-foot swells, diesels growling, wake surging and fizzing, chill wind buffeting the cockpit where Hunter Brooks sat slumped in an electric wheelchair. He was the hub of the social wheel aboard the boat this late June morning, the trip's organizer. Thirty fish, he

figured they'd catch, a mountain of dolphin and tuna. A day of good sport. Weeks of good eating.

"Meat!" he yawled. He nodded, smiling, at Bob Selvaggi, who stood smoking a cigarette in the lee of the cabin. "We're gonna get us some meat!"

Bob blew out a jet of smoke, smiled back. "Yeah, man." The boat plowed farther offshore, into the sunrise. Neither man knew that they'd soon be eye-to-eye with the biggest slab of meat they'd ever seen.

The *High Hopes* is big, as sportfishers go. At fifty-eight feet, it can comfortably carry a dozen fishermen, twice the payload of a typical Virginia Beach charter. But this morning the *High Hopes* seemed, as boats will, to shrink with every mile it ventured from shore. Alone in the Atlantic, ringed by miles of fused sea and sky the same ghost-gray as the diesel smoke off the stern, the 24-ton vessel became an insignificant speck.

Off to starboard, a floating clot of pale yellow. "Sargassum," Bob Selvaggi said, eyeing the plant. "Won't be long now." Off the stern, a flash of white, gliding fast over the waves: a flying fish. Flying fish were food to dolphins. Dolphins were meat.

The passengers clustered at the stern. Hunter, thirty-eight years old, paralyzed from the chest down since a car wreck a few years ago. His nursing aide, Laurie. Her father and uncle. Hunter's friend Rowena. His neighbor Howell. Johnny, Knut, and Scott, all from the Beach, all in the building trades, all Hunter's buddies since his days hanging drywall, before the accident. And Bob Selvaggi, the only Norfolkian aboard, another drywall contractor. The sunburned mate, Jason Wooten, began to bait the lines. Up on the flying bridge, Capt. David Wright cut the boat's speed. The diesels dropped an octave. The wake flattened. Hunter nodded happily. "It's time to fish!" he yelled. "Let's get some fish!"

David Wright drove the *High Hopes* with his back to the console. In twenty-one years as a charter captain he'd developed an eye for fish: As his mate tossed some of the baited lines into the water, clipped others into the outriggers that stretched like wings from the gunwales, the skipper swept his gaze right, left, right, across the "spread" of seven hooks in the water.

Before long, he found Hunter some meat. "Dolphin!" he yelled from above the cockpit, and instantly a rod on the starboard side bowed, the fish on its line running hard. Howell slid into a fighting chair as the mate passed him the rod. Before he'd cranked the big reel's knob a dozen turns,

one of the outrigger lines twanged from its clip and spooled from a rig on the port side, and Scott grabbed the rod and started pulling. The first fish hit the boat, then the second, slippery missiles of teal and chartreuse, and before the mate had closed the box, another line had sprung. Then another. Then another.

Knut, standing, pulled in a yellowfin tuna that thudded dense and heavy on the deck, silver belly flashing. Johnny pulled in another, an ornery, hard-fighting thirty-pounder bleeding from the gills. "Where's the beef?" Hunter bellowed. "It's in the box!"

The lines fell quiet. Knut opened a Miller. Wright steered the *High Hopes* in a wide circle, eyes aft, sweeping the water. The mate rebaited the lines, set up the spread. As he did, an enormous, spear-snouted beast, ten feet of flashing silver and cobalt blue, cruised the dark ocean below the boat.

At midday five lines popped at once, reels clicking like coasting ten-speeds, and Knut and Scott and Howell and Bob Selvaggi and Laurie's dad were all fighting fish and crisscrossing the cockpit and trying to keep their lines from tangling. "Meatfest!" Hunter screamed behind them. "Yeah! Yeah!"

Four tuna, one small dolphin landed—twenty-two fish so far for the day. David Wright, up in the flying bridge, scanned the spread, looking for more, and spotted something. Port side. Big. A flash of silver trailing one of the lines. A "just in case" line, aimed at a long shot.

The captain had started the day's expedition as he always does, saying a prayer over the VHF radio, a plea for protection, for the safe return of the Rudee Inlet fleet—and for great fishing, great sport. Now his prayer was answered. The shadow surged in the water, the line went taut, and Wright pointed out over the stern, screaming at his mate and everyone else in the cockpit: "Marlin! It's a marlin! It's a blue marlin!"

Wooten spun around, wild-eyed. "All the lines in!" the mate barked. "We need to get all these others in now!" His clients grabbed rods, cranked in the lines, hauled hooks and bait into the boat as Wooten latched onto the marlin rod and slid it from its holder. Bob Selvaggi happened to be standing near the big fighting chair. "Bob," someone yelled, "get in the chair!" He hesitated for a second. Whose turn was it? Whose fish was it? "Get in!" somebody else hollered. "Get in the chair!"

He got in the chair.

Everyone aboard could see that Bob Selvaggi was no giant. The Con-

necticut native weighed 160 pounds, give or take, packed into the wiry frame of a fellow who spent his days lifting drywall. Everyone knew that he was, at forty-one, among the older people aboard. That he smoked cigarettes, which surely cuts into a person's stamina. That he'd had a few beers. And everyone aboard knew that a blue marlin is a big animal. *Makaira nagricans* is a sleek bundle of muscle that can top a half ton, that routinely crosses the Atlantic, that can outrun a nuclear-powered aircraft carrier doing it.

As the *High Hopes* began backing up, following the marlin as it pulled desperately at the line, the matchup between man and fish seemed hopelessly one-sided. Bob, oblivious, jammed the rod's butt into a chrome cup built into the chair, which turned the pole into an efficient lever—and started to pull. "Git him, Bob!" Howell yelled. "Git him!"

"Yes, suh!" Scott hollered. The mate slipped a bucket seat under Selvaggi's rump, clipped it to the reel. It made holding on easier, but it also meant that if the marlin somehow yanked the rod overboard, Bob would go with it.

Wright was backing down the boat fast now, slamming the stern into the ocean's swells, forcing water through the cockpit's drain holes to slosh six inches deep on the deck. "Come on, big daddy!" Scott said. "Come on, big daddy! Bring it in!"

"You can do it, Bob."

"You got it. You got it."

The fish suddenly ran to port, and the mate swiveled the chair to follow it. The fish cut back to starboard, pulling the line Bob had just reeled in—and more—back out. And then, seventy-five feet away, it burst from the water, nose high, tail jackknifing wildly, as big around as an oak tree, and a gasp left every throat on the *High Hopes*. The marlin made a bomb's splash, came up again, skipped ten yards across the water, scales flashing, tail thrashing, twisting against the hook. And dived deep.

It's one thing to know that a big fish is on the line. It's another to see it arc over the water, to see that it's enormous beyond imagining, to recognize in its violent jerks an all-or-nothing proposition. The sight inspired terror, admiration, excitement. For a minute, no one said much, just looked at each other and the place the fish had disappeared. Then the marlin was pulling out line, yard after yard of it. Selvaggi, already soaked in sweat, chest heaving, had no choice but to watch the reel spinning backward.

"Want a beer, buddy?" Scott asked.

"Water," Bob croaked.

The fish wouldn't break any records—at roughly 450 pounds, it was less than half the weight of Virginia's biggest marlin, a 1,093¾-pound behemoth hooked in 1978 by Edward A. Givens of Virginia Beach—but it outweighed Bobby by a factor of three. He went back to cranking, more slowly now, strength draining. The boat kept backing, water gushing in.

Twenty minutes passed. Thirty. Forty-five. Bob slowly, painfully cranked the fish in. The fish took the line back out. He brought it back in. The fish ran back out. "He's got me," Bob muttered to the mate. "He's got me, to tell you the truth. He just won't give up, and I can't do anything about it." He took a deep breath and gave the rod a forceful pull as Knut poured a bottle of water down his back. Again the fish ran with the line.

Bob looked thrashed—his face was contorted into a pained grimace, his arms were sweat-slick and trembling, his breath came in gasps. An hour into the battle. Seventy-five minutes. Ninety.

The sun slowly crossed the sky, broiling the cockpit, sharpening its smell of bait and salt and diesel. Selvaggi, thirsty for calories, asked for a beer. Johnny helped him hold the rod steady as he drank it. "He ain't pulling as hard as he was," Bob gasped, "that's for sure."

Maybe so. Still, it seemed a safe bet that the marlin looked better than Bob did. He sat hunched behind the rod, muscles screaming, T-shirt drenched. Salt left behind by evaporating sweat caked the crow's feet around his eyes, his neck, his arms. Hissing through his teeth, Bob slowly cranked his reel, brass and as big as an oil can. Inching the fish toward the *High Hopes*. The other passengers wandered between the saloon and the cockpit, some growing restless. There was no reason to think the fish would ever stop letting Bob reel it close, then erase his effort by bulleting off.

Bob kept cranking, paused as the marlin bolted and the reel spun in reverse. But the dash, oddly, lasted just a moment. Far shorter than the fish's earlier breaks. Bob resumed reeling. Inching it in. "You got it, buddy!" Scott yelled.

"You got it," Hunter seconded. "You gonna whup its ass, Bob."

Bob kept cranking. Inching it in. Inching it in.

And then there were no inches left. Jason Wooten, the mate, was bent over the side, wrapping his hand in the wire leader that linked hook and fishing line. Killing marlins has fallen out of fashion: Most fishermen "land" them by bringing them alongside the boat and "wrapping the

leader," then let them go. Wooten's move was lost on some of the others in the cockpit, even when the mate maxed out the drag on Bob's reel, and the 100-pound fishing line connecting fisherman and fish stretched until it snapped. Bob collapsed in the chair, limp and empty. Somebody groaned, "Awwwww."

Wooten stepped forward, hand thrust toward Selvaggi, face crinkling in an excited smile. "Congratulations, man! Congratulations! Man!" Bob Selvaggi had landed a marlin. It had taken one hour and fifty-five minutes. He could barely lift his arm to shake the mate's hand.

Up on the flying bridge, David Wright steered the *High Hopes* westward. It was 2:30 PM, and the boat was two and a half hours from shore. A little more than that, actually—the fish had dragged them 4½ miles farther into the sea. It was time to head home. There'd be no more fishing.

Bob staggered into the saloon for a celebratory beer. The others—Scott, Knut, Howell, Johnny—followed him in. Hunter Brooks remained in the cockpit, studying the trenches carved by the boat's racing props, the turquoise rooster tail between them. Dropping his gaze a little to the ice-lined box that held the day's fish.

Twenty-two in the box. And a fish still out there that outweighed all twenty-two.

Not bad for one day's fishing. A whole lot of meat.

Flush
with Success

It happens every day, often several times a shift: Winfred L. Griffin will be piloting his big tanker truck through traffic, or stop to pick up payload, when a passing stranger will read aloud the slogan painted down the truck's sides and stop to ask: Is that for real? Griffin will smile, and nod, and say yes, that really is the motto of the E. W. Brown Septic Tank Service. Has been for decades, since just after the company's creation in 1945.

So it is on this raw February morning: Griffin stops at a 7-Eleven for ice water, and the clerks marvel over the slogan; Griffin pulls up to a pine-shaded home on Lynnhaven Bay, and the owner chuckles at the truck's paint job. And close to lunchtime, Griffin prepares to pump out a grease trap, a steaming vat of gray water and congealed fat hidden beneath a manhole cover out back of a Norfolk restaurant.

He's prying it open when a delivery van stops nearby. Its driver, stag-

gering under the weight of a big sheet of Plexiglas, slows as he passes Griffin's truck. "'If it don't go down,'" he reads, "'call Brown.'"

Griffin nods sagely. "That's right."

"If it don't go down, call Brown," the man says again, this time booming. He walks on. Griffin watches him weave toward the open grease trap, oblivious to the danger.

"Watch out for that hole, or you *will* go down," Griffin yells. The man corrects his course as Griffin adds: "And ain't nobody from Brown gonna pull you back out."

If they worked for any other septic tank service company, the men of E. W. Brown might crisscross the region incognito, their mission all but overlooked, the contents of their 3,000-gallon tanker trucks a mystery. As it is, they enjoy a minor celebrity status. Griffin's truck provokes smiles in traffic, waves, shouts of recognition.

The slogan is one of those rare pieces of advertising copy that transcends salesmanship to border on art. It is funny. Its unabashed honesty feels oddly nostalgic, almost sweet. It is graced with haiku's brevity. It is instantly memorable, partly because it rhymes, and partly because its ungrammatical "don't" makes it monosyllabic. And it's a little gross, the "it" unnamed but universally understood.

"Everybody says something," Griffin says, downshifting his truck with a stick a yard long. "I hear it, probably, three, four times a day.

"One thing about this job: You meet some really nice people."

The job most days requires Griffin to visit six or seven homes and businesses. Today's first stop: A two-bath Virginia Beach house with a septic tank that hasn't been emptied in years. Griffin pierces the lawn with a metal probe, eventually hears a hollow knock, then shovels away turf to expose the concrete lid to a 4-by-8-by-6-foot crypt. He pries it open. The hole utters a fragrant sigh.

Griffin marches to his truck, backs it to the lawn's edge, pulls on a pair of gloves, and latches a four-inch-wide, celery-green hose to the truck's vacuum pump. The other end he snakes into the lawn's dark chamber. Then he fires up the truck's diesel, flips a switch, and with a squeal and a tremble his machinery sucks 750 gallons of grim cargo out of the ground.

"This job ain't bad," he says, shoveling dirt back over the recapped chamber. "You do the same thing, but you're not in the same place."

Of course, this was an easy job. Some aren't. On some calls he's made over his twenty-four years with E. W. Brown, the fifty-three-year-old Griffin has really found himself up a creek.

And you know which one.

Griffin steers onto Virginia Beach Boulevard. Up ahead, a Cadillac headed the other way starts a turn across the truck's bow. Its driver spots the bigger vehicle coming. He slams on the brakes. As Griffin will attest, other motorists tend to give E. W. Brown a wide berth. This is wise, for a tanker carrying cargo is heavy: A full tank of pure water would weigh twelve tons, and the payload behind Griffin's seat is a long way from pure. All that sloshing weight makes for slow cornering, slow stops.

"We had a man flipped his truck," Griffin says. "He had a full load on." A long pause. He lifts his eyebrows. "None leaked."

A red light. The truck squeals and shudders to a stop. The cab's pine-tree air fresheners dance on their tethers. Griffin stares at the light. A sporty coupe pulls alongside, two young women peering through its windshield at the tank, the bright red paint, the crusty hoses, the slogan. And at three little words painted in Old English script beneath Griffin's window.

"Little Fat Buddy" has been Griffin's nickname since his boss, Vernon Bryant, started calling him that years ago. "He's a little rotund," Bryant explains. "And his name is Winfred." Bryant is the late E. W. Brown's son-in-law, and has worked in the family business since 1966. He has bestowed nicknames on many employees, and with rare exceptions those nicknames have been carefully applied to their trucks.

Thus, "Bear" has appeared on the left door of a company truck, and "Cabbage Head," and even "Love Doctor." The effect, on a vehicle devoted to such grave commerce, is that the E. W. Brown fleet has a certain swashbuckling jauntiness, the sort common among Spitfire squadrons in the Battle of Britain.

Griffin is matter-of-fact about what earned his colleagues their nicknames. "He had a big ol' head," he says about Cabbage Head. As for the Love Doctor: "He loved women," Griffin explains. "He just loved women."

The day's third job behind him, Griffin heads for the dump. He pulls into a Hampton Roads Sanitation District plant off Shore Drive, checks in at an office flanked by emergency breathing equipment, guns the truck past

ponds of settling sewage. The air is filled with the scent of chlorine working hard.

A five-point turn brings the tank's drain within range of a dump station. "This might be nasty work," he allows, letting the load loose. It gurgles down a hose and into an underground tank. "But there's a method to it, a process. What I can't handle is those portable johnnies." A shudder. "I just can't stomach that. That's *live* ammo, you know what I'm sayin'?"

He strolls to a slot through which the underground tank can be viewed. Topping its contents is a carpet of flotsam. Griffin grabs a rake, slips it into the tank and skims the floating matter out. "A lot of times you find rags, all sorts of stuff that people have thrown in there," he says. "I've even found dollars in there."

"Did you keep them?"

"Yeah," he nods. "What else would I have done with them?"

He goes back to raking. "One time, actually, I found $80," he says. "And . . ." He holds up his right hand, shows off a thin gold pinkie ring. ". . . found that in there, too."

A few minutes later, he's back in the cab. The truck, relieved of its cargo, clatters and jounces over every lump in the road. "Unit six to base," he says into his two-way.

"Go ahead, Griffin," comes Bryant's voice.

"Just done dumping."

"OK, I want you to head down onto Thalia Road," Bryant says.

"OK."

The big diesel roars. The truck shimmies. The air fresheners sway. Griffin steers onto Independence Boulevard, southbound, toward another neighbor who needs him, most likely needs him desperately. A neighbor whose "it" don't go down.

Weird thing, this line of work: As foul as it might seem, customers sure are glad to see you. Griffin grips the wheel. His pinkie ring glints in the morning sunshine. He doesn't bite his nails.

A Song
of Sorrow

There are some who say the wind blowing into Rye Cove carries the sound of wailing each May 2. Listen close, they say, and you'll hear the cries of those who died that strange and terrible afternoon in 1929.

Young voices, mostly. Even those who don't believe in ghosts and such will tell you that this speck of a settlement is still haunted by the cyclone that tore through it seventy-odd years ago, and that a big piece of the reason is that all but one of the lives it snatched away belonged to youngsters.

Rye Cove saw the deadliest tornado in Virginia history, and among the worst disasters to befall a schoolhouse in all the states. It was the most sorrowful thing to ever visit Scott County, too, which is saying something, for the ridges and hollows of the state's far southwest can recall centuries of heartache.

Even so, what happened in an oval valley just above the Tennessee line might be forgotten by all but kin, if a neighbor with a talent for song hadn't

been nearby, hadn't rushed to the school's ruins, hadn't clawed through snapped timber and broken plaster and piled desks in search of survivors.

Later that year he wrote a ballad about Rye Cove, and his family recorded it, and the song became a folk-music standard. *Oh, listen today to a story I tell,* it opens, *in a sad and tear-dimmed way,*
 Of a dreadful cyclone that came here and it blew our schoolhouse away.

Looking back, it seems the whole spring of 1929 foreshadowed what was to be. The forty-eight states were in the grip of uncommon weather that year, with late snows, unseasonable warm spells among sudden deep freezes, hail as big as hen's eggs. Storms swept the Midwest in continuous bands. Heavy rains pushed the Tennessee River over its banks three times in three months. And with alarming habit, the heavens turned violent. On April 10, a tornado of fearsome strength struck northeastern Arkansas, leveling a pair of towns and killing twenty-three people. On April 25, a twister in Georgia killed forty more and injured three hundred. Another swarm of tornadoes struck Arkansas May 1, ending six lives, and gales of near hurricane strength raked northern Texas.

The next day, the afternoon *Norfolk Ledger-Dispatch* carried a front-page story on the odd goings-on: "This year of grace, already notable for an enduring winter of snows and a warm and mellow March, enhanced its reputation for fickleness today by sending to Chicago a flurry of bona fide May snow."

But as out-of-kilter as the natural world appeared, that same Thursday morning carried no sense of foreboding in Scott County, least of all in the quiet valley around the Rye Cove School. It was warm and damp, with the promise of more rain coming, when 155 of the school's students reported for their lessons. Some came as far as seven miles, though most lived in or just outside the cove—a high, wide valley between curving, 500-foot ridges, its floor relatively flat and broken by outcroppings of gray limestone.

When people said they lived in Rye Cove, they usually meant this hole in the mountains, because there wasn't much to the village proper. A single, muddy road linking the place with Gate City, the county seat. A few houses and barns. A country store. And, of course, the two-story, oak-frame schoolhouse, which had opened in 1907 as a small grade school and since had been enlarged to eight classrooms and an auditorium, and now looked altogether outsized for its setting: tall and rambling, with a stout

bell tower rising from its roof. Youngsters of all grades and all ages took their schooling there.

The morning passed. The children sat at desks of wood and iron in rooms heated by coal stoves, listened to their teachers. Out in the cove, farmers tended their beef cattle or worked in their hay and tobacco fields. To the west, a cold front crossed the Cumberland Gap and rode the Clinch River valley into Scott County. The sky darkened.

Shortly before 1 PM, a farmer named J. M. Johnson, working on a mountainside that overlooked the school and the surrounding valley, noticed heavy weather forming about a mile off. Two banks of clouds appeared to collide there, and out of their union sprouted a thick tentacle that sought the ground below. Whatever it touched blew to pieces.

Another local, W. J. Rollins, watched as the funnel started up the valley, turning trees to powder and gathering up a great load of dirt and debris until it loomed black over the cove. A curious light emanated from its leading edge, Rollins thought. It looked like a headlight, the sort that guides a train.

Ahead of it, most of Rye Cove's students were dawdling in the playground. Five minutes remained of their lunch break, and while a couple dozen had reentered the building for their afternoon classes, well over one hundred remained outside, enduring a light rain. All of a sudden the wind picked up.

When the cyclone appeared, the song goes, *it darkened the air*
There was lightning in heaven's dome
And the children all cried, "Don't take us away,
But spare us and let us go back home."

Elizabeth Richmond, one of the teachers, noticed the sky change. She was standing in her second-story classroom, waiting for the stragglers to wander in, when through the window she saw trees swaying, and a black wall where the lower half of the valley was supposed to be. The sight rattled her, but she held her tongue—even when the wind leapt and howled against the glass. Even when the sound became too loud to shout over.

Back on the mountainside, Johnson saw the whirlwind climb the valley with building speed, growing as it went, sucking mature trees straight from the ground by their roots, ripping barns apart—then plow smack into the school.

For an instant the building seemed to lift from its limestone foundation. Then it exploded. Walls, roof, floors—the whole thing vanished in a

yellow-brown spray. Timbers flew like darts, rained to earth a mile off or more. A dirty caul fell over the playground.

The tornado moved on without pause. It lifted a lumber pile as a unit, and sowed its contents over the valley. It ripped the roof from the country store, razed a flour mill, smashed two dwelling houses and two barns. It trundled through a heavy log and stone house built before the Civil War, and "swept it away as completely as if it had been built of straw," as a Gate City newspaper put it, "carrying some of the furniture four miles away.

"A stone spring house was torn to pieces as if it were made of sticks. Rocks that weighed more than a thousand pounds were overturned."

Many in Rye Cove could trace their lineage to the early days of Western settlement in the valley, when Indian war parties raided homesteads here, kidnapped children, killed frontiersmen. It had calmed some by 1929, but the cove remained an isolated and unforgiving place. Winters were hard. Much of the land was too rocky to plow. Comforts were few.

Even as tough as they were, the cove's people were unready for the scene that greeted them in the cyclone's wake. They found the body of Ava Carter, a young teacher born and raised thereabouts, who'd been plucked from her classroom and hurled seventy-five yards. A teenage student, Polly Carter, had flown fifty yards and lay dead in the grass. The schoolhouse was a smoldering mountain of rubble.

Muffled cries rose from deep in the building's remains. One boy had suffered a broken back, another a fractured skull, others broken arms and legs. A girl had lost a leg to flying glass, and many had been maimed by shrapnel. "The whole scene was one of pitiful desolation," the Associated Press reported. "Anxious fathers worked feverishly in the ruins, fearful of what they might discover.

"The dead and dying children, some of them terribly mangled, and those less seriously injured were dragged from the debris, while automobiles carried the message of death to the outside world."

The village's few surviving buildings became makeshift clinics. Some also became morgues: As the rescuers worked down through the wreckage, they encountered eight bodies. "Mothers, fathers, brothers and sisters were crowding about the emergency morgues," newspapers of the day reported, "looking over the dead, still uncertain as to whether or not their own loved ones were numbered among the dead."

Among those who rushed to the school was a Scott County man by the name of A. P. Carter, who in his spare time had taken up songwriting,

and who performed his songs with relatives. *There were mothers so dear and fathers the same,* he'd later write, *on the horrible scene.*
 Searching and crying, each found their child,
 Now dying on pillows of stone.

Doctors were summoned from Gate City and beyond. In Clinchport, seven miles away, a passenger train was held to carry the injured to Bristol, the nearest big city. Parents and rescuers judged fifteen of the children too injured to detour to Clinchport; they were loaded into cars bound straight for the Bristol hospital, and jounced from the valley on the lone dirt road, which the rain had made a rutted mire.

Twenty-seven children were put aboard the train, where they made for "a pitiful scene," as a dispatch out of Bristol put it. "Children, many of them between 6 and 8 years old, were lying about the baggage coach in which they had been placed. Some had broken bones while others were lacerated and badly bruised. For the most part they bore their suffering in something akin to silence, bravely fighting to stifle their occasional outbursts of pain."

One of them died on the journey. Another youngster died in one of the cars making the trip. By day's end, the Rye Cove cyclone had killed twelve children and one adult. So many others seemed poised to join them: Of 155 children at school, "at least 145" were injured, the newspapers said, and "physicians expressed scant hope for the recovery of a half score of those more seriously hurt."

And Nature was by no means through with Virginia for the day. Up in Rappahannock County, a tornado bulled right through the village of Woodville, smashing a high school, four houses, and two churches. One high school boy was crushed, and some others from the school were found unconscious two hundred yards away. That same tornado moved northeast, as they usually do, to kill two more people in Flint Hill.

In Culpeper County, another tornado ripped into a house at supper time and killed a couple sitting at their table. It then rolled into Weaversville, where it killed another four people and a herd of cattle, and flattened a fourteen-room brick building. Fifteen people were injured, some severely.

A twister touched down in Loudoun County, wrecking buildings and injuring two people. In Bath and Alleghany counties, yet another took out several houses, 150 apple trees, and a barn where a woman was milking

her cows. Neither she nor the cows were hurt, but when the storm blew through some chicken houses, it killed the birds and plucked them bare.

A tornado outbreak, the weather people called it. The next day, under the headline "Nature Gone Berserk," a *Ledger-Dispatch* editorial lamented the tragedy: "It's done, and all our piety and wit cannot wipe out a line of the suffering that marks the faces of bereft fathers and mothers. There's nothing we can do, except soften our hearts and hope that peace will come to them soon." A big advertisement in the paper hawked tornado and windstorm insurance, advising: "This is the dangerous season."

As it happened, the newspapers were wrong about the injured: They lived, though some never fully recovered. The same could be said for Rye Cove. In 1930, the county built a new Rye Cove Memorial High School in the same place. It later became the Rye Cove Intermediate School, and stands to this day. The wrecked school's bell is displayed there, as a memorial to the thirteen who died.

A. P. Carter went home and wrote "Cyclone of Rye Cove," and later in 1929 his trio, the Carter Family, recorded it for the Victor Co. Like "The Wreck of the Old 97," it created a snapshot of big tragedy in a small place, and of an episode that might otherwise be lost in memory.

Rye Cove, Rye Cove, its chorus goes, *the place of my childhood and home,*
Where in life's early morn I once loved to roam,
But now it's so silent and lone.

Love and Justice

The hall outside Judge M. Randolph Carlson II's courtroom is crowded with old lovers this Valentine's morning. Most are wearing their coats, speaking quietly with attorneys. The lighting is harsh, the tile cool and hard, the mood, apprehensive. No one holds a bouquet or a box of chocolates.

Inside, the every-Monday business of Norfolk's Juvenile and Domestic Relations Court begins. Ernest and Diane are called. They were living together last October, they testify, when she came home from an all-night birthday party. Ernest was in the kitchen, cooking breakfast. They started to argue.

"She would say something, and I would come to the bottom of the steps and say something back to her," he testifies. "We were just bickering back and forth. And she'd say something that would get under my skin, and I'd come a few steps up the stairs."

She got so far under his skin that he climbed all the stairs, carrying

what he happened to have in his hands—a pan of boiling water and a steak knife. He threw the boiling water on the bed beside Diane. He approached her with the knife. He pushed her around and ripped her shirt. She felt fear.

"Why'd you take the pan of boiling water upstairs with you?" Carlson asks.

"I don't know," Ernest says. "It wasn't to hurt her or anything."

"Well," the judge squints, "you weren't going to boil the bedsheets, were you?"

"No, sir," Ernest says.

"That just doesn't make sense to me," the judge murmurs.

"I don't have to belabor the point," says assistant commonwealth's attorney Michael C. Rosenblum. "This was already an argument. Things were already getting out of control."

"I think the evidence is sufficient," Carlson agrees. He finds Ernest guilty of assault, and sentences him to a year in the Norfolk City Jail, with all but ten days suspended. Ernest and Diane leave the courtroom, their romance officially history.

Monday mornings are busy with domestic violence cases: Norfolk has two dockets of them, heard in two courtrooms, every week at this time.

Michael and his sister, Nancy, enter the courtroom. He's thirty-two. She is thirty-three. They both live with their parents. Last year, Nancy testifies, they got into an argument over whether Michael would cut the grass like their father asked him to. The siblings called each other names. Michael threw her across the room. She tried to dial 911 to summon the police. Their mother, who walks with crutches, tried to pull the phone cord out of the wall. Nancy and her mother struggled over the cord. Her mother fell down. Michael jumped on Nancy and "really whaled on me, punching my thighs."

Their mother is called into the room. She testifies that the fight erupted after Nancy accused her parents of trying to gas her with pesticides. "She has a problem," the mother says.

"She's crazy," Nancy says in a stage whisper.

"I've heard enough," Carlson rules. "This case is dismissed." The family leaves, and the judge leans back in his chair, shaking his head. "Tell me it gets better," he mutters. "Tell me it gets better. If not, I need to take a long break."

Carlson sits beneath a gold rendition of the commonwealth's seal, Virtue standing triumphant over the fallen body of Tyranny. Virtue is a woman. Tyranny is a man. They're both armed.

Tiyo and Adrienne enter. They are married. Last September, they had a fight in which Tiyo grabbed Adrienne in a headlock and lifted her off her feet. "It scared me, because he had always threatened to kill me before," Adrienne tells the court.

Tiyo takes the stand. "Every time I tell her I want to be with her," he laments, "she comes up with something like this." Carlson is unconvinced. He sends him to jail. The bailiff takes Tiyo away.

Next case: Lisa has pleaded guilty to assaulting David. "You guys haven't had any trouble since this incident?" Carlson asks her.

"No, sir," she says. "We have no contact at all."

"Don't you have a child together?" the judge asks.

"Yes, sir," Lisa says, "but he never comes to pick him up for visitation, so we never have contact."

The judge bites his nails.

Sharome and her boyfriend, Latika, take places before the bench. The judge is shown photographs depicting a puncture wound in Latika's arm, allegedly caused when he made contact with a steak knife Sharome held while they argued.

Latika takes the stand. The victim says the whole thing was an accident. "She took a knife out of the drain thing and sat down at the table with it," he says. "Usually when she does that I can take it from her no trouble, no cuts, nothin' like that. But when I jumped at her, she balled up."

Rosenblum, the prosecutor, notes that Latika failed to mention the accidental nature of his injury when his wound was still bleeding. He has seen such shifts in memory in other cases: Whether because love does conquer all, or because they depend on their partners for income, a good many victims actually wind up defending their attackers in court. Carlson decides to certify the case to circuit court, anyway. Sharome will stand trial.

Deonne and his girlfriend appear. The victim describes going out to a nightclub with Deonne, doing some drinking, and arguing. "I grabbed him by his collar," she says. "He grabbed me by my collar. We were hollering at each other."

Who shoved whom first? Rosenblum asks. I did, she says.

Carlson asks whether they're still together. They are. He finds Deonne not guilty. The two walk out.

The judge rubs his eyes. "Does that complete your docket, Mr. Rosenblum?"

"Yes, your honor, it does," the prosecutor says. "That completes our Valentine's Day docket."

Judge Carlson sighs.

To the
Lighthouse

I

From the top of the tower the western horizon is stratified, ruby and amethyst and hematite layered beneath a great moonless sky turning to coal. The day's last light glimmers weakly on the Atlantic, silhouettes the wispy curves of offshore sand spits. It sets pale gray fire to the marshland. Glows ghostly on white clapboard and concrete.

At the tower's base, 154 candy-striped feet below, nightfall has blackened the forest's pine-needle carpet. Any minute now.

Within the glass encircling the tower's crown, sharp-edged shadows fade to gray, sun-warmed air is swapped for midwinter's chill. I breathe jets of steam, pull on layers I discarded in the sunshine—down vest, parka, fleece hat.

The glass room is silent. The silver-painted drums at its center, three feet across, one bolted atop the other, transparent bull's-eyes at their ends, remain still. I peer across the riffled, charcoal sound, see that Chin-

In the crown of the Assateague Light. (Ian Martin photo; used by permission)

coteague's streetlights already shine blue-bright against the dusk. Head-lights inch down the town's streets. Wind buffets the tower, becomes a deep-throated, undulating moan. The wetlands below sink further into gloom.

Then, all at once, it happens: An electrical relay trips with a loud crack, the drums begin to revolve, the 1,000-watt bulbs in their hearts ignite, and yard-thick columns of light blast from the machine, punch through the glass, tunnel twenty-two miles through dark sky. The room is flooded with a brilliant whiteness, flashes as light strikes angled glass. Every pane becomes a mirror. The outside world vanishes.

I lean back on the iron catwalk that encircles the machinery, zip my parka, pull my cap snug over my ears. Watch the lights slowly, steadily turn, shafts as straight as cannon shots sweeping silently over ocean, marsh, inlet, forest, back to ocean. Around and around. Around and around.

And begin a long, winter night's watch in the Assateague Light.

Stand at the foot of the Assateague Light Station, neck craned to its lan-tern, and its beacons create a giant, slow-spinning "X" in the night sky. On the bridge of a far-off ship, these crisscrossed beams appear as two flashes, a three-second pause, two flashes, another three seconds, two flashes. It's

a code unique to Assateague, one from which mariners can infer a subtext as old as navigation along this Eastern Shore barrier island. Dangerous shoals. Stay away.

It was mariners for whom Congress ordered a lighthouse built here in 1833. On whose behalf the government later judged that lighthouse unfit. For whom the Congress tore down that light and built the present one, a brick tower topped with a domed lantern house, in 1867. It was for men of the sea that the light's keepers did their duty with unswerving fidelity, that they braved gale and thunderbolt and sleeplessness to keep the lamps bright. That they endured years of hard labor, same-seeming days, the lonesomeness of these quiet, loblolly woods.

But as they did all this for sailors, Assateague's builders and keepers created something else quite by accident: Here and at America's eight-hundred-odd other lights, simple aids to navigation became emblems of self-reliance and selflessness and steady strength. Frazzled city-dwellers began to yearn for the solitary simplicity of the keeper's life. And that public romance with lighthouses has grown, even as technology has replaced their human keepers and blessed ships with radar, and depth-reading scanners, and global-positioning gear that renders many a light little more than decoration.

So I have come to Assateague to live in its lighthouse. To watch the world from its lantern room, pace its windswept balcony, climb cast-iron stairs trod by keepers a century dead. To seek some understanding of the light's lonely life. To measure its romance against reality.

On a sunny but bitter Wednesday, I crossed the Chesapeake's mouth and drove up the Eastern Shore to Chincoteague. The marshes around it were swarming with geese and ducks on their commute down the Atlantic coast. The town was in midwinter hibernation, its prewar bed-and-breakfasts empty, post-"Misty" motels and gift shops dark. First stop: the Chincoteague Coast Guard Station, where I met Chief Petty Officer D. W. "Wayne" Merritt, de facto keeper of the Assateague Light.

The tower doesn't officially have a keeper; it's been automated for years, like every lighthouse in Virginia, every light in America but the beacon in Boston harbor. But Merritt, the officer in charge of the station's Aids to Navigation Team, oversees the people who do the little work the light requires. The chief sat, arms folded across his barrel chest, and asked me to explain again why I wanted to spend four days in his lighthouse. I tried. He stared at me.

Merritt is a fourth-generation Coast Guardsman, a guy who, as a

young boy, would sneak aboard his dad's tender for runs out to offshore lights. Who was climbing them before city kids ride bikes. Who has spent twenty-six of his forty-four years in the service, most of them around lighthouses. His expression said he couldn't fathom why I'd want to do such a thing. Just the same, he strode outside, jumped into a pickup, told me to follow.

We passed the Harbor Light Motel, the Lighthouse Inn, a lighthouse mural on the cinder-block shell of a penny arcade. Another lighthouse shone outside His and Her Seafood, still others from signs for Kelly's Dockside Fish Fry, the Maddox Family Campground, Etta's Family Restaurant. A lighthouse-shaped windsock spun and sighed outside the Bike Depot. A six-foot tower guided the tempest-tossed through the perils of miniature golf. Then the town gave way to a marsh-straddled causeway, and I was looking at the real thing: The top one-third of the Assateague Light, red paint bright and wet-looking in the sunshine, jutted from the pines across Assateague Channel.

A few minutes later we walked across crushed oyster shell to the foot of the tower, where the chief pulled keys from his pocket, opened the double doors. Inside, a second door took us to the bottom of the spiral staircase. An overhead bulb glowed weakly. The air was damp, cave-cool, and smelled of clay.

Ground Rule No. 1, Merritt said: The lighthouse has to stay locked. When I enter the tower, I must lock the deadbolt behind me. Otherwise, someone—perhaps a "lighthouse hugger" on a pilgrimage—might try to follow me in. Unstated, but understood, was that it's enough of a worry that I'll be in here.

Ground Rule No. 2: "Don't stare into the lights," the chief advised. He handed me the keys and wished me luck.

My next stop was the headquarters of the Chincoteague National Wildlife Refuge, which owns the surrounding woods and marshes and a concrete bungalow tucked into the trees 175 yards from the tower. The house is a keeper's cottage built in 1910, the second of two provided for the lighthouse's crew. A refuge official opened it for me, turned on the heat. It's used these days by the Department of Fish and Wildlife's summer interns, and has the hand-me-down feel of a college apartment.

I drove back into Chincoteague, carved a swath through the local grocery. When I returned, dusk was settling on the refuge. I crossed the yard and unlocked the lighthouse door. A switch on the far wall was fitted to a timer; turning it as far as it went would light the tower's spiral staircase

for one hour. Mindful of the chief's ground rules, I locked the front door beyond me, then started climbing the heavy iron stairs.

The bricks around me were smooth-sided and fresh-looking, the mortar between them uniform and bright. It was the work of master masons, a monument to craftsmanship, and looked brand-new. I took two steps at a time. It was a snap to reach the first landing, which coincided with one of the tower's windows. I pressed my face to the glass, saw that I was just above the vestibule's roof. I climbed another flight, reached a window on the tower's back side. Another flight, to a second window over the vestibule, level with the tops of the forest's smaller trees.

By the time I reached the fourth landing, I was taking the stairs one at a time and no longer thinking much about the bricks. At the fifth landing my legs were five times their normal weight. My heart was pounding, and I was using the handrail to pull myself on. The stairs ended at a wooden door.

Now darkness has fallen. An electric hum and an irregular, metal-on-metal squeal fill the air, and I have to avert my eyes as the lamps sweep past. Their beams pack the power of 1.8 million candles, are so intensely white that I expect to feel heat. There's none, however; the room is as cold as the stairs were. I shuffle onto the black iron catwalk ringing the glass room. Around and around the beams go. After a few minutes I descend to the watch room, the round, wood-paneled space just below the lamp, where keepers of old passed their long, lonely shifts. It's now traversed by bands of moving shadow and dazzling light. A ship's door with six dog-style latches is built into the outside wall. I undog it, give it a kick, and as it opens forest and inlet and the lights of Chincoteague swing into view, under a sky crammed with eerily bright stars.

I step through the hatch to the tower's balcony, and into an icy, thirty-knot wind that moans as it curls past the brickwork. The lamps sweep a dozen feet overhead, their beams sharply defined, surprisingly little of their light spilling onto my perch.

But it's too cold to enjoy the view. I head back inside, and notice I've been in the tower for forty-five minutes. Back on the ground, I find that the ground glows with cool, blue-gray light. It's so lunar that I look to the sky expecting to see a full moon, even detour to see around the lighthouse. There's nothing up there.

I stand there in the yard, staring up, slack-jawed. I find myself mesmerized by the slowly revolving "X." Around and around it spins. Around and around.

The scene is so sure, so permanent—the never-varying cadence of the light, the red-and-white-striped massiveness of the tower. It's a scene that's

played out every night for nearly 140 years. No matter what: No matter what else has gone on in the world, what hell has been breaking loose, that light has always come on.

II

The fog moves in with the afternoon, slowly swallowing the scrubby pines and marshland to the south and east. It pulls the color from the loblollies, then blots them out; erases breaking waves and the silhouette of an old lifesaving station on the beach, then consumes the sand itself.

I watch it come from the sixteen-sided glass room at the top of the light, where I've lain for hours in a waking slumber. I study a white-tail buck as it high-steps slowly over a tussocky stretch of wetland. Listen to the wind batter the glass around me. Two feet to my left, the lamps dominate the room's center, waiting for nightfall.

It's my second day in this candy-striped tower, and I've passed it as many Americans probably imagine the lightkeepers of old marking their days: locked at the tower's crown, my thoughts, a book, and the view from 154 feet my only company. It is a luxury that few real keepers ever enjoyed. I have no work to do, as Assateague's temporary keeper, because these days the lighthouse is switched on each dusk by a photoelectric cell mounted on the tower's skin. Its DCB–36 Rotating Airport Beacons are without moving parts. The 1,000-watt bulbs inside them, two-pronged, thick-coiled beasts that run seventy-seven dollars apiece, are mounted in automatic lamp changers that flip a new bulb into service as the old one burns out. The small electric motor that spins the beacons at six revolutions per minute has a backup.

But the lighthouse of old was a busy place at all times of day. The federal Lighthouse Board's instructions to the keepers of 1870 were simple but unequivocal: "The lighthouse lamps shall be lighted and the lights exhibited for the benefit of mariners punctually at sunset, daily," they began. "Lighthouse lights are to be kept burning brightly, free from smoke, and at their greatest attainable heights, during each entire night, from sunset to sunrise."

"During heavy gales of wind, snow, rain, and hail storms, the lights must never be left unattended by a keeper," the board decreed. "No circumstance whatever can, or will, excuse any lightkeeper for failing to exhibit at the prescribed time the lights in his charge, or for neglecting to keep them burning as brightly and with as great power as it is possible to make them."

Displaying the light meant not only standing a watch as the lamps burned but also devoting hours each day to cleaning and polishing their lenses, fitting them with new wicks, trimming those already in place. And that accounted for just part of the day's duties. Keepers also had to keep all the tower's machinery "perfectly clean in every part, free from dust, well oiled with clock oil, uniform in its motions." They had to clean the tower's stairways, landings, windows, watch rooms. To keep a neat house. To ride herd on the property's fences, dikes, and boat landings.

It was long, rugged work, made the tougher by its sameness, day after day after day—and by the knowledge that no matter how efficiently they performed their duties, they were expected to stay put "as continuously as possible."

The wind picks up. It whistles past the vent built into the lantern's domed roof, buffets the tower in gusts, and I realize that, as unlikely as it seems, I can feel the lighthouse swaying. Rain begins to fall. I listen for thunder, and notice, perhaps six inches beyond the lantern's glass, a thick wire that dangles from the lighthouse roof and disappears below the catwalk just outside—a conduit for lightning. I'm suddenly all too aware that I'm watching a storm gather from an iron shelf, in an iron cage, set on the highest perch for miles in any direction.

At Bodie Island, a lighthouse near Oregon Inlet on North Carolina's Outer Banks—and a structure very much like this one—lightning bolts hitting the top of the tower once traveled down the cast-iron spiral staircase, jolting a keeper so badly that he was numb from the waist down "for some time thereafter," as one account put it. No wonder that when you pore through the old lighthouse logbooks at the National Archives, weather dominates the entries. You flip page after flaky-dry page, looking for some personal note, some snippet of conversation, some little piece of poetry. Any observation that makes one day distinct from the next, that evokes a time and place.

You find few. Consider the entry at the Thimble Shoal Light off Norfolk's Willoughby Spit for June 20, 1910: "Light South West to S.E.," it said of the wind, "clear and dry." And the next day? "Light W. to South East light rain fog Started Bell at 6.16 AM stopped 8.30 AM light south fog." The next: "Light South West to South East clear dry and warm." June 23 brought bigger doings. "Light West to South clear dry and warm," the keeper wrote. "Tender Maple visited Station delived [*sic*] paint & oil, bell cord." Then it was back to the weather.

I watch rain streak on the lantern glass. Keepers rode out killer hurricanes at their lamps, braved storm-spawned monster waves and, in the

Chesapeake Bay, fought many a losing battle with ice. Floating blocks of it
tore the Hooper Strait Light from its foundation in 1877, overturned the
Pungoteague River Light, even carried Maryland's Sharps Island Light,
and its keeper, miles down the bay.

Nature loosed other perils. One winter's evening in 1900, a tremen-
dous flock of geese and brants swooped in on the Hog Island Light, a now-
demolished tower not far south of here. Hundreds of the birds became
missiles aimed at the lantern, forcing the keepers to open fire with shot-
guns to save their lamp and lens.

Worry over migrating flocks had spurred keepers to install a wire
shroud around many big coastal beacons, including Assateague, but such
a screen didn't last long when birds returned to Hog Island two days later.
Their ammunition exhausted, the station's crewmen clubbed 150 of the
diving fowl as wave after wave smashed into the glass, eventually knocking
the light out of service. Lights fell victim to man-made vexations, as well,
perhaps none more frequently than Thimble Shoal. In 1872, the govern-
ment marked the hazardous bar there with a screwpile light, a hexagonal
cottage on spidery legs screwed deep into the bay's sandy bottom. Its bea-
con, a feeble red flash, shone from a short tower in the cottage's roof.

Eight years later, a fire swept through the house; the Lighthouse Board
rebuilt it. In March 1891, a steamer smacked into it, wrecking a piece of its
gallery. In April 1898, a coal barge rammed the light, carrying away a long
stretch of deck, cracking its metal legs and lifting the cottage off its frame.
Then, in 1909, a schooner crashed into the cottage and upended a stove,
igniting Thimble Shoal's cache of lamp oil. For a brief while, the light-
house was the brightest on the bay.

Convinced that the shoal required a beefier tower, the board ordered
the burned cottage replaced with a caisson-style lighthouse—sort of a
giant, cast-iron Weeble, its bottom filled with concrete and sunk below
the bay's floor. Bad luck dogged Thimble Shoal even as the new station
was built. After recording the day's weather, the keeper of a temporary
light off Willoughy jotted an afterthought in his log entry for Jan. 2, 1914:
"Mr. Cavell was drowned in air Chamber of Caisson (at 10.30 AM)." An-
other entry, dated May 10, 1914: "Barge Mohawk in tow of Tug Virginia
Colided with station (at 8.55 PM)."

Finally this, as work on the caisson neared completion: "one man killed
on new Station." No detail, no explanation, no follow-up. You have to dig
through old newspapers to learn that the man was Fred Stanberg, a car-
penter, crushed by a collapsing scaffold. Fourteen weeks after Stanberg's
death, the new Thimble Shoal Light shone for the first time. "Light N.E.

wind. Part cloudy. foggy. damp," observed the keeper's log, laconic as always. "Light in New station lighted."

I close my book. Night approaches, hastened by the fog and a low ceiling of gunmetal cloud. Wind continues to rake the lantern. I wait until the lamps kick on, admire their quiet power for a few minutes, then head for the spiral staircase.

I have a fleeting premonition that trouble is on the way. I set the one-hour timer for the tower's interior lights as dusk began to fall, and as I'm jogging down the stairs, two thoughts occur to me: First, that it's been close to an hour. Second, that I have no flashlight.

Forty of the 175 steps down, I'm suddenly wrapped in darkness. It is utter, absolute. By day the tower's windows, three up the front and four up the back, cast enough light on the landings that an ambient glow reaches even those steps halfway between them. But by night—and a foggy night, at that—there is no light here between landings. I find my lighter, flick it. It sparks but doesn't light. I give it another try. The same thing happens. Once more. Still no flame.

Cursing, I fish around in my pockets and come up with a bent-back book of matches and, striking one, rush down the stairs to a landing. The next match gets me as far as the next landing, a third to the next, each throwing off just enough yellow light to make out the stairs before burning my fingertips, forcing me to shake it out.

A fourth match takes me to a window fifty steps from the ground. My fifth match is my last. I decide to conserve it, to give the lighter another try, and with a gush of relief, watch as it sparks to life. What an idiot, I think as I lock the tower's door behind me. I'm not performing any of the dangerous duties associated with lighthouse keeping—not staring down heavy weather or battling crazed birds or hanging in space to swab the lantern's glass—and yet I've nearly become a statistic.

What would a keeper of old make of that? He'd have a good laugh, I decide. Or simply kick me off the property. Or perhaps record my stupidity in the station's log. His entry would be short. "Visitor trapped on stairs," perhaps.

Then he'd get back to the weather.

<div align="center">III</div>

Astern of his desk hangs a painting, a spectral Jesus guiding the hand of a muscle-shirted young helmsman in a storm-tossed open boat. Dead ahead in his small office, and again on his starboard beam, are photos of the

cutters he's known. And broad on the starboard bow, enclosed by a large frame, hangs a collection of fossilized shark teeth, dozens of them, still lethally serrated, some of them two inches long—mementos of Chief Petty Officer Merritt's three years at the Cove Point Lighthouse.

The stucco-clad light has stood on the Chesapeake Bay shore at the Patuxent River's mouth, just south of Maryland's fossil-rich Calvert Cliffs, since 1828. Some years back, Merritt and his family moved into one of its keeper's cottages.

When the chief's father, Donald L. "Grit" Merritt, joined the Coast Guard in 1948, the service had keepers in more than four hundred lighthouses along America's seacoasts and Great Lakes. By the time the younger Merritt enlisted in 1972, only a handful of beacons were manned. The Coast Guard had automated scores of lights, replacing their keepers with machinery that kicked the lamps on each nightfall and required only casual human attention.

By 1995, when the chief's older son, Donald "Lee" Merritt, became the fifth generation of his family to join the service, just one of the Coast Guard's 425 active lights still had a keeper—and that was only because the Senate insisted that a Guardsman man the Boston Light Station, the country's oldest, dating to 1716.

So at Cove Point, the chief painted the tower and tended the lighthouse grounds but did little business with the light itself. Just the same, he and his wife, Bonnie, and their kids came as close to being keepers as a modern family can. "The worst part of living at the Cove Point Lighthouse was the fog horn," the chief says, leaning back in his chair. "You know how southern Maryland is, there's fog all the time. And that horn was loud—so loud that if you were in the house holding a glass of water and it went off, you'd feel the water shake.

"You'd be talking and you'd get so used to that horn that you'd pause in your conversation for it. And after it stopped, you'd still be pausing when you talked," he says, shaking his head. "One March, that horn was on for the whole month, from the first day of March to the last.

"When it stopped, it was like there was a child missing."

Later that morning, returned from my trip into Chincoteague to visit Merritt, I'm mulling the eclipse of the traditional keeper's life from the top of the light. Yesterday's fog and rain have given way to a cloudless sky, strong midday sunshine, and the glass-sided lantern around me has become an oven; my hat, gloves, coat lie heaped in the watch room below.

Beyond the glass a buzzard glides by, its bald head tucked into ruffed shoulders, fingertipped wings tipping uncertainly in wind that seems to blow continuously off the Atlantic here. Taking people out of the lights saved the Coast Guard money, I think to myself. But more than that, it eliminated variables—and if there's been a theme to the government's stewardship of the lights over the past 150 years, it's been that.

I glance to the lantern's center, and the searchlights that on the past two nights have started their work without fuss at 5:20 PM sharp. A few years before the Civil War, that might not have happened: As dependable a reputation as they now enjoy, American lighthouses and their keepers were all but useless to mariners in the first half of the nineteenth century.

No question, the young country recognized their importance to commerce and defense: Virginia Beach's old Cape Henry Light, built in 1791, was the nation's first public works project; George Washington personally approved the appointment of its first keeper. But good intentions didn't get later lights built where they were needed, nor competents hired to tend them, nor their lanterns equipped with strong, well-designed lamps. Assateague was typical: A light was built here in 1833, but its lamp shone dimly from a stumpy tower that in thick weather was virtually invisible from the sea.

The situation was troubling enough that in 1851, Congress ordered the creation of a board to study the nation's lights. Its report, delivered a year later, was brutally to the point. America's lights and buoys were "not as efficient as the interests of commerce, navigation, and humanity demand." They were not "constructed in general of the best materials, nor under the care and supervision of competent or faithful engineers." Their beacons were "nearly obsolete throughout all maritime countries," and "of improper dimensions, constructed ... without professional or scientific skill." In short, the board concluded, "There is not, in useful effect, a single first-class light on the coast of the United States."

The upshot was the creation of a new federal agency, the Lighthouse Board, which set about trying to make sense of the country's haphazard aids to navigation. It ordered dozens of new lights along empty coast and others to replace lights that weren't getting the job done. At Assateague, it judged the old tower too short by 150 feet and won financing for a new beacon in 1860. It was completed in 1867, after a five-year time-out for the Civil War.

The board ordered lights and buoys for America's busy harbor approaches, ending the seat-of-the-pants seamanship described in the 1857

edition of Blunt's Coasting Pilot: "As you approach Old Point Comfort," the guidebook advised mariners entering Hampton Roads, "you will observe a low tree. . . . Steer southwest until you bring the tree over the house occupied by the colonel, which is the first house to the westward and painted white." God help sailors if the colonel repainted his house.

Important changes came to lighthouse lanterns. Before the board, American lights relied on simple reflectors and glass lenses to focus their lamps into beams, but the contraptions lost all but a fraction of their candle-power to poor glass and "leaks" around it. A solution lay in a beehive-shaped lens invented by a French engineer named Augustin Fresnel. Tiers of prisms built into the top and sides of the lens captured escaping light, refracting it back into the main beam. The Fresnel lens (pronounced Fray-NELL) improved lamp efficiency four to five times over, and it came in seven sizes, which suited the board's needs.

At Assateague, the round platter on which two electric searchlights now revolve was fitted with a first-class Fresnel lens, the biggest made—more than six feet across and eight feet high, and weighing 12,800 pounds. All but invisible a few years before, Assateague Light could now be seen nineteen miles out to sea.

The lamps within the lenses—or, rather, the oil within the lamps—won the board's attention as well. At midcentury, most lights were using oil extracted from sperm whales, but overzealous whalers had made the animals hard to come by, and the price of their oil was climbing fast, from 55 cents a gallon in 1841 to $2.25 in 1855.

Following the example of England and France, the Lighthouse Board introduced colza oil, made from a wild cabbage, and found to its delight that it burned as well as whale oil. Unfortunately, this particular wild cabbage did not grow wild in the United States. Assateague spent about a dozen years burning lard oil and decades with kerosene before finally turning to electricity.

All of those advances, important though they were, paled next to the board's greatest contribution. "Only recollect every stormy night how many lives there are depending on your light," Winslow Lewis, a lighthouse wheel, had written to keepers in the early nineteenth century. "Think of this, and it is impossible that you can neglect them." His words were wishful thinking. A great many keepers were slackers, lackadaisical about hours, equipment, the public's trust. In a few egregious cases, keepers simply walked away from their lights for days on end.

The board, and the U.S. Lighthouse Service that succeeded it, insisted

on dedication and expertise, and it instilled a military efficiency and comportment into lightkeeping that redefined the profession. In a few short years, the American public's image of the keeper became that of a quiet, kindly hero, suffering solitude and extremes of weather for the general good, at times risking all to help strangers in peril.

I watch as dusk approaches, then edge my way down narrow steps to the watch room and step onto the balcony. It is bone-cracking cold outside, and though I can see that the air is calm near the ground—the trees clustered around the keeper's cottage are still—a gale is blasting the tower's crown.

Shivering, I turn back to the hatch, pausing to examine a small photoelectric cell mounted on the tower's brick. It's a plain, cheap-looking thing, linked by cable to a box of electronics up in the lantern. When the light fails, it sends a signal, and the box starts the lamps.

All so simple, so reliable. So sensible: A few gizmos do the work once performed by four men at this light station, save money in salaries and food and utilities. Eliminate the need to provide housing not only for keepers but also for their wives and children, many of whom worked as unofficial assistants.

But there's a downside to automation, I think as I undo the hatch and step back into the tower's warmth, and it's the very same stuff that's good about it. Lighthouses hold a special place in our imagination not just for their architecture, nor their settings, but also because they whisper with the lives that once filled them. Their romance isn't built of brick or stone or cast iron but rather the flesh and blood of their keepers, of adventures lived and yarns spun.

Take those keepers away, replace them with photoelectric cells and computers and automatic lamp changers, and you have yourself a more efficient lighthouse. It seems to me, though, as I climb back to the lantern and take my seat beside Assateague's big silver searchlights, that you've lost something, too.

IV

America's lighthouses include museums, private homes, and about 425 beacons still owned by the Coast Guard; the vast majority aren't open to the public. Yet people come by the thousands to stand at their feet, stare at their crowns, imagine themselves up with the lights. On North Carolina's Outer Banks, the government has spent millions of dollars to pick up the Cape

Hatteras Light and move it away from the encroaching sea, not because it's an essential aid to navigation but because it's an icon, an object of pilgrimage. Here at Assateague, Coast Guardsmen open the tower to tourists one weekend a month, and despite their not being allowed into the lantern—and, often, not on the balcony—folks line up to make the long climb.

Hatteras, Assateague, and other renowned lights emblazon picture books, posters, knickknacks, salt and pepper shakers. Place mats and doormats. Maps and stained-glass windows. Dish towels. Companies turn out pricey miniatures of some of the nation's more renowned lights, and collectors snap them up.

Further evidence of their allure lies in the story of Charles Hardenburg. He was a well-educated New Jersey man who, in 1910, at the age of thirty-five years, moved to Watts Island, an abandoned quarter-moon of soggy grassland in the Chesapeake Bay between Onancock and Tangier Island. His only company was a herd of goats and, about seven hundred yards offshore on tiny Little Watts Island, a keeper standing watch in a 48-foot lighthouse. Thirteen years into Hardenburg's stay, the feds decommissioned the Watts Island Light, and the hermit moved to the empty lighthouse compound.

Here's the telling part: In 1930, a New York newspaperman stumbled on Hardenburg and wrote a story about his simple, solitary life. And wouldn't you know it: Far from writing Hardenburg off as a kook, readers wished his life for themselves. He became an instant celebrity. Women besieged him with marriage proposals.

Hardenburg accepted one of them, and his new bride moved onto Little Watts. The couple passed three years with the lighthouse before they were chased to the mainland by the killer hurricane of 1933. Nothing could persuade Mrs. Hardenburg to return. Little Watts had a stronger pull on Charles: He went back alone, and lived beside the lighthouse for another three years.

Early in my stay, I spent a couple of hours walking the beach a mile east of the lighthouse, over sand driven flat and hard by the easterly wind, over deer and raccoon tracks, and a great bird's footprint that measured seven inches, heel to toe. Chest-high breakers thundered, hissed flat at my feet, but around me lay signs of much fouler weather: Even on the leeward side of the island's curving tail, horseshoe crabs a foot across were broken and strewn among clumps of dune grass.

I could almost imagine, in all the howling and crashing, the terror of blindness off this beach, of trying to steer a ship through the shoals invisible offshore while tensed every second for the jolt of hitting bottom. And I could almost imagine the relief that sailors must have felt when the Assateague Light began shining, and those sightless nights were ended.

Part of the lighthouse mystique no doubt relies on such scenes, real and imagined. As Chief Merritt told me: "There's something about Assateague, the way it is, the way it looks—especially if you go out there and you get into trouble and you look up and you see that light.

"I know I've been out there sailing before and been very, very happy to see that light come on and flashing."

The coast itself is part of a tower's appeal, of course. Lighthouses tend to enjoy dramatic settings, such as the tops of towering sea cliffs, or gull-shrouded offshore rocks, or lonely, spray-soaked headlands. Even without blessed topography they'd exert a pull, for the shore is always a place of beginnings and endings, of journeys completed, possibilities ahead; and its lights, likewise, are symbols of safe haven to some, the sea's wildness to others.

All of which might drive some of the emotional attachment people feel for what, architecturally speaking, are little more than fancy smokestacks, and what Chief Merritt and other Coast Guardsman will tell you are increasingly anachronistic tools for sailors.

I begin my last morning on the light's balcony to a line of pink on the horizon, and watch it widen like waking eyelids until the eastern sky is filled with light. Without drama, the lighthouse's beacon flicks off. The big searchlights stop rotating. Their electric beams die. I keep my sleeping bag snug around my head until morning surrounds me, then kick it off, scramble in the freezing wind for the hatch, fumble with its latches and lurch into the watch room.

A floor up, in the lantern, sunshine streaming through the floor-to-ceiling glass is already warming the air. A few panes are fogged with condensation. I pull on my boots. The lamps, their silver drums shining in the sunlight, tower above me, and I lean back, stare at them awhile, think of nothing. I listen to the wind breathing against the glass and feel the temperature slowly rise. Enjoy the peace of the place.

My sleeping bag is lying there. I stuff it into its nylon sack. Then, giving into temptation, I step through the hatch and back onto the balcony, and heave the four-pound bag over the rail. It tumbles, tumbles, seems to curve back toward the tower, takes a full three seconds to hit the ground.

It makes a surprisingly loud and deep thud. I head back inside and reluctantly dog down the hatch. After a final look around the lantern and watch room, I gather my gear and start down the stairs.

An hour later, after dropping off the keys and finding my way back to U.S. 13, I pull into a combination gas station–convenience store. It's busy. Ball-capped locals mumble among themselves at the counter. A harebrained disc jockey's screaming on the radio, then disco torch singing. Cars jounce in and out of the parking lot, each setting off a buzzer at the cash register. Standing in line, I realize that I already miss the lighthouse, and that what I miss about it isn't the simple goodness of its mission or its physical beauty or its symbolism.

What I miss is being able, for a few days, to lock myself in a high tower, stand at its top and behold a heavenly ground around me, and to share it with no one.

To retreat from the worries and irritations of life with neighbors and coworkers and other drivers. To escape other people's demands on my time. To pass hour on hour without small talk. Without having to be polite, or even civil. And to know I could enjoy that freedom to be selfish for as long as I wanted, because no one could reach me in that tower unless I wanted the company.

Maybe that was the most important thing, having that long helix of stairs between me and the ground. Maybe we cherish lighthouses and envy their keepers because we sometimes need those stairs as a buffer against the masses. Maybe, even, as a test of those few who would join us.

I stroll to the car and pull back onto the highway. The radio is busted. I drive in silence. I find I don't mind it.

At a Fork
in the Trail

Here she comes—an indistinct dot cresting the West Norfolk Bridge, a blue-spandex blur as she speeds down the near side. Look now: She's sharpened into a choreography of pumping legs and flashing spokes, hard skinny tires hissing on asphalt like fat in a hot skillet.

Seven minutes into a four-hour ride, Kristy Mantz glides westward at an unvarying 19 mph, the cadence of her pedaling as steady as a metronome, eyes focused on the road ahead, back bent and helmet tucked to cheat the breeze. A container truck rumbles past three feet from her left elbow, spewing grit and noise and diesel smoke. Mantz's pace doesn't waver. Cars veer into her path as she leans onto an exit ramp. She doesn't flinch.

Mantz is a mountain biker, the only nationally ranked female mountain biker in Virginia, but she lives in Portsmouth—hours from the nearest mountain—which forces her onto the road. She'll travel more than seventy miles of blacktop today, strengthening her already well-honed muscles, bolstering her endurance, seeking that coiled reserve that's un-

sprung only through sweat and pain and numbing dedication. A last, tiny store of power, of speed, to tap in a race.

Maybe it'll make the difference. Maybe she'll do well enough this season to climb even higher in the rankings than she already has. It's a long shot, but maybe she'll make enough money that "professional athlete" no longer translates to "flat broke."

Maybe.

Kristy Mantz is ranked the twenty-third-best female mountain biker in the United States. Last season alone, she climbed ten places in the standings, winning notice as an emerging force in a sport she's pursued for eight years.

Were she America's twenty-third-best golfer, Mantz would be rich. She'd earn big money by playing in tournaments, and perhaps even more by using a certain club or shoe, or for displaying a manufacturer's logo on her cap. The same would hold true if she played soccer or basketball. It would hold true if she bowled.

The twenty-third-best pro in those sports doesn't have to fret over how they'd scare up air fares and hotel money so they could reach races around the country. Mantz does. And now, as she crosses into Chesapeake, her tires a consistent one foot left of the fog line, her career approaches a turning point.

She is a rising star in a sport that has traditionally paid only a few dozen of its top athletes, and only a handful of its top women, a living wage. And which now may not even do that, for mountain bike racing is in dramatic decline: In the past few years, corporate sponsorship has dried up. Teams are folding or downsizing. Purse money has evaporated. Long-time team racers are suddenly without "rides" for the coming season, and are scrambling for slots that in the past would have gone to up-and-comers like Mantz.

She passes a guy cutting grass, steers around an inmate road crew, stands on her pedals to chug up an overpass. Chesapeake slides by. Ahead, on the left, looms a water tower advertising Suffolk.

Will she get the gear she needs? Or the ten thousand dollars the coming year's travel will cost, if she pinches every penny? She'll be thirty-three years old next month. When will she have struggled long enough? When does she give up?

An uphill climb, again out of her seat. Past an untidy verge of weeds and forest and over Interstate 664, then onto busy, high-speed U.S. 17. A chilly

wind blows. The sun climbs. Her shadow becomes a thin blob to her right.

This is the "long and slow" Thursday ride with which she breaks up the week's sprint sessions. She'll spend the morning and early afternoon in the saddle, take an all-too-short breather, then run for an hour. Yesterday she biked twice and swam. Tomorrow she'll swim and run. She burns so many calories that to maintain her weight—an all-muscle 134 pounds—she either uses dietary supplements or has to eat morning to night without stop.

The regimen steels her for contests in which she charges hell-for-leather along slick, corduroy paths studded with rocks, puddles, and roots, over and around boulders and logs, across streams and crumbling scree. She plunges downhill, brakeless, through potentially lethal forest, often shoulder-to-shoulder with other racers. She slogs through boggy patches on foot, her bike slung over a shoulder. Mud billows dense and heavy on her forks and brakes, and spatters off her tires and up her back to form a crusty stripe.

Her skill at this has brought rewards. In the 2003 season, she wore the logo of K2 Bicycles, and was supplied by the company with a fully loaded, aluminum-frame mountain bike. Cane Creek, a manufacturer of cutting-edge components, outfitted her with a selection of its wares. She was treated to jerseys and shorts produced by a sport-clothing company. A Chesapeake chiropractor realigned her spine without charge.

But that's as far as her sponsorship went. She received no endorsement money. No cash to defray race entry fees and travel expenses. And she was one of the lucky ones—many of her pro colleagues have no backing at all.

"I thought it was going to be easier to get sponsors, to get help," she'll tell you. "The people involved in all those mainstream sports, they make such huge sums of money that people in the States tend to think that all athletes make a lot of money. And unfortunately, that's not true."

Mantz was born Kristy Lanier in Manassas, where she played soccer and ran cross-country and earned admission to the University of Georgia. She bought her first mountain bike in Athens and took it with her when she transferred to the University of Hawaii to finish a degree in sculpture.

While working at a Honolulu bike shop, she met her husband-to-be, Chad, a navy diver pulling shore duty between stints on attack subs. They both got into off-road riding—everywhere they turned on lush, mountainous Oahu, a trail beckoned—and before long, Kristy tried racing.

She won her first race—won it so handily, in the "Beginner" class, that she decided to bump herself up not to the next class but the one above that, "Expert," just one rung below "Pro." It took her "three or four races," she recalls, "before I started winning every race I did."

Then came a big stage race, à la the Tour de France. Mantz won permission to run it as a Pro, and finished sixth against the toughest competition the island state could muster. With that, she submitted her resume to the National Off-Road Bicycle Association, the sport's governing body, seeking a permanent promotion.

In the meantime, Chad had been assigned to the attack sub San Francisco, which was headed to Hampton Roads to enter the yards. The couple married and moved to Portsmouth, where they bought a house in Port Norfolk and Kristy resumed racing.

"And then I was smacked in the face with reality—that just because my license says 'Pro' doesn't mean I was going to make any money or that I was all that fast," she says. "I got the smackdown when I got to the Mainland. I never came in at last place, but I was in the middle of the pack."

As her finishes improved in Virginia, then regional, races, she and Chad bought Port Norfolk's old Gleason Pharmacy, a sturdy commercial building with stamped tin ceilings and mosaic tile floors, built in 1906. It became Port Norfolk Bike. Kristy became a rolling testament to the new firm's expertise.

The traffic is fast and stupid as Mantz crosses the Mills Godwin Bridge on a shoulder littered with wire and glass and cigarette butts. She coasts down the bridge's hump, swigs from her water bottle, leans left across oncoming traffic to a narrow lane that meanders quietly past farm fields and deep front yards, a sand pit. She's been in the saddle for an hour, and has covered 18.9 miles.

She pedals past a Baptist church, a settlement of weedy yards and unloved houses, open cropland. In Chuckatuck, she turns onto two-lane VA 10. Semis hiss by so close she could touch their trailers with an extended left arm.

It didn't take Mantz long to learn the harsh calculus of her new career. Cycling is the third-biggest participatory sport in the country, behind walking and swimming, and mountain bikes account for more than half of the millions of two-wheelers sold each year. By all rights, mountain bike racing should enjoy mass appeal—certainly more than road racing,

which relies on skinny, severe machines that account for only 2 percent of domestic sales.

But, no. It has never achieved a broad following. Its stars have not become household names. And it has never been lucrative: Until 2002, NORBA's national championship paid a whopping five hundred dollars.

That year, after several big sponsors abandoned the sport, NORBA events stopped paying pro racers altogether. "So you have these elite, world-class athletes getting nothing for their efforts," Mantz says. "It's a pretty rough existence—very demanding, with very little monetary payoff."

The loss of prize money exacerbated an already troubling situation. The few American women who earn their keep solely from cycling enjoy not only salaries, but the best equipment money can buy, full technical support, year-round training—in other words, tremendous advantages over women with partial sponsorships, who must work part-time or scramble to raise cash.

"You'll be at a race," Chad Mantz says, "and the top five women will cross the finish line, and then you'll wait. Minutes will go by before that sixth racer crosses the line. And that's because that's where the money ends."

Which brings up a quandary. To maintain her national ranking, Mantz has to attend the big NORBA races; her place in the cycling food chain reflects her attendance, as well as her performance. Of the eight NORBA races scheduled for the coming season, only two are east of the Mississippi. Reaching the western six will take bundles of cash she'll not be able to recoup.

Mantz has therefore moonlighted in the popular Xterra series of off-road triathlons. Its races combine mountain biking, rough-water swimming, and trail running. They're well-organized and—no small matter—offer purses; the world championship pays twenty thousand dollars.

Trouble is, the Xterra games are scheduled on many of the same weekends as NORBA's events. Last year, the big Mount Snow, Vermont, mountain bike race took place on June 20, a Friday. The Richmond Xterra happened that Sunday. Mantz might have been able to drive from one to the next in time, but she'd have been exhausted, so she skipped Mount Snow.

"I was doing my best to round up some money," she says. "My national ranking took a hit because of that."

Mantz skims past horses, barking dogs, and a "Share the Road" sign, watches the wind whip paisleys of soil from a bare field. The past season ended in late October at the Nissan Xterra World Championship, which

pitted top-ranked athletes from the United States, Europe, and the Pacific. Among women, she finished ninth.

"I left with eight hundred dollars. I was still in the hole, but I won eight hundred bucks," she says. "You can actually come away with a little something from Xterra." A pause, and a sigh. "You kind of get tired of being poor all the time."

Barbed wire lines the road. She pedals past a small cemetery, a Gothic white-board Methodist church, the Orbit grocery. Cows stare. She is deep in Isle of Wight County now, more than thirty miles into her ride. Her velocity remains fixed. She has yet to stop. Her feet have not left her pedals.

So what will it be? Does she stick with NORBA, continue to suck it up and work to climb the standings—ultimately, to make a run at the national championship? Or does she go for Xterra, and rewards more tangible than bragging rights?

By mid-December most years, pro riders who are destined for a place with a team have already received the good news. Mantz has not, and it seems unlikely she will: The whole racing world is in retreat. "Rather than picking up new riders," she says, "they're just trying to find a way to help out the ones they already have."

If she stays true to cycling, of course, there's a chance she could earn one of the hallowed team spots. She might not, too: A close friend, Jeremiah Bishop of Harrisonburg—America's second-ranked male mountain biker, and a favorite for the U.S. Olympic team—has yet to land a ride for the coming year.

The road plunges into forest. In the gloom to Mantz's right and left, stumps rise ghostly gray from still black water. She's thought a lot about the triathlon in Maui, about how little separates ninth place from the podium. She could pose a serious threat next year, if she were to concentrate on Xterra, race NORBA when it fit her schedule.

She and Chad have prepared for either course, mailing her resume to bike and gear makers, hoping to get free product. They're starting a Web site, too—dirtbean.com, it'll be called—through which they hope to raise money for Mantz's travel, whether to Xterra or bike races.

Still, she'll very soon have to choose. If she bikes, she stays broke. If she goes to Xterra, she likely sees her hard-fought ranking suffer. What will it be?

The road offers little guidance: It is stripeless and black, indistinct, as it presses into the forest.

Mantz pedals on.

History Floats

Ahead and behind, the river purls empty in the yellow light of early morning. The *Pride of Campbell County* is alone, ghosting silently past elderberry blossoms nodding on the bank, over smallmouth bass and yard-long gar cruising in the shadows. The breeze dies suddenly. The leaves of drooping sycamores and maples fall silent. And that eerie, unmistakable hiss reaches the boat.

Around a bend on the seemingly languid James River, danger waits: a bank-to-bank nest of dark rocks—age-old rocks with green-slimed knuckles thrusting from the water, splitting the river's flow into dozens of foaming, fast-moving braids.

David Haney, the captain, glances over his shoulder from his station at the batteau's bow. "We'll have to take this from river left!" he barks over the deepening growl of the rapids. "I need poling on the right! Pole on the right!"

Behind him, his crew hoists poles of hand-trimmed poplar, plunges them into the quickening water, feels them bite into the pebbly bed two

feet below. The *Pride of Campbell County* yaws left, away from the bank and into midstream. And into the maw of Swift Island Falls.

It's an hour after sunup on a Tuesday in June, and Haney and crew are about to meet their first challenge of the day, one of scores they will encounter on their eight-day, 120-mile voyage from the Blue Ridge Mountains to the suburbs of Richmond. In a modern canoe or kayak, Swift Island Falls and the myriad other hazards that stud the James on its meandering course to the Chesapeake Bay would hardly quicken the pulse. But the *Pride of Campbell County* is no modern craft: It's a batteau, a reproduction of the flat-bottomed cargo boats that two centuries ago swarmed the James, carrying crops and raw materials from the mountainous west to the Tidewater. Its round-chine hull—forty feet long, eight feet wide, and pointed at both ends—is built of oak plank fastened with square-headed nails. It derives its power solely from the muscle of its crew. Its only steering is enormous sweep oars at bow and stern. Its only comforts: rough bunks shaded by a curving, Conestoga canopy of bentwood and canvas, exposed to slanting rain and patrolled by fist-sized wolf spiders.

And like the batteau of old, the *Pride of Campbell County,* with sixteen other such craft making the long journey, requires a fast-thinking skipper, a resolute crew, and a measure of luck to squeeze through the boulder fields, thump over the shoals, and blast down the chutes that the river puts in their way.

Up ahead, Swift Island looms off the right bank, low and woody. Now Haney can make out the rapids to its left, a confusion of humpbacked rocks, foam-flecked and glistening in the strengthening sunlight, the spaces between them narrow, the water rushing and shallow. "We need to go more left!" Haney calls. Forty feet back, wiry Glen Shrewsbury pulls hard on the stern sweep, and the boat's remaining crew, wives Barbara Haney and Brenda Shrewsbury, lean into their poles on the freighter's starboard side.

David Haney squints across the closing distance to the rapids' lip. The only opening—at least, what seems an opening from here—lies hard against the left bank. But getting there means getting the creaky, heavy craft across fifty yards of river, abreast of the current. And the James's pull grows stronger by the second.

Three seasons a year, forty-four-year-old David Haney works as a conductor on the CSX Railroad, eyeing the James from a track that hugs the river's north bank. Barbara Haney manages an after-school day-care program

in the couple's home in the Blue Ridge foothills southwest of Lynchburg. Glen Shrewsbury, sixty-one, is a machinist. His wife keeps their house in Forest, a speck on the map west of Lynchburg in sparsely settled Bedford County.

But each summer they ditch their modern lives, don the calf-length britches and muslin blouses of the late eighteenth century, and join the James River Batteau Festival, a tribute to Virginia's great river and the boatmen who braved it to open the West.

Every summer since 1985, the festival has replicated the journey once undertaken by thousands of boats between downtown Lynchburg and Maiden's Adventure Landing, about thirty miles above Richmond. Escorted by dozens of canoeists and a ragtag caravan of musicians, gypsy jewelers, and funnel-cake vendors, the waterborne parade has grown into one of central Virginia's most eagerly anticipated celebrations.

Latter-day batteaumen tie up at camps clotted with period tents and cook over open fires to a soundtrack of tin whistles, dulcimers, and bygone laments. On the water, the boats drift through time as they round the river's sluggish oxbows and gallop over its rapids. Once-bustling ports now lost to history's shadows slide by—Bent Creek, Columbia, Wingina. They pass Howardsville, where a single store remains of a vanished business district, and Warren, where no trace of a town survives and an old ferry lies weed-punched and half-buried in riverbank mud.

Stand on a batteau's prow on a misty early morning on these far-flung stretches of river, no power lines or houses or bridges in sight, no contrails overhead, and it's easy to imagine yourself in an age when the ungainly vessels were the backbone of Virginia commerce. Do it while the 3,500-pound boat groans over a falls, and you might wonder how any commerce happened at all.

Nineteenth-century travelogues are rife with warnings of rapids, hidden stumps, killer rocks on this river. The *Pride of Campbell County* is blundering against the current now, bound for such a hazard. "One narrow pass between two Islands very dangerous," surveyor Thomas Moore wrote of Swift Island Falls in 1818. "Many Boats have been wrecked against a single Tree."

The same report called Joshua Falls, just below Lynchburg and a high point of the festival's first day, "very hard for ascending Boats & one rock which might be easily removed dangerous in descending, on which several have been wrecked & some lives lost."

"Whenever you read about them, the references are not to 'boatmen,'

but to 'skilled boatmen,'" says William E. Trout of Richmond, a retired geneticist whose passion for James River history has made him Virginia's foremost expert on batteau and canal travel. "They had to be, to go down the river when it was running at any level and not get their cargoes wet or destroy their boats—or themselves."

Boatmen of old drowned in the freshets that swelled the placid James into a run-amok beast. They were dashed against rocks. Simply running aground presented the gruesome prospect of being crushed between boat and boulder. Even if they escaped injury, they faced constant threats to their boats and cargo. "A boat with the momentum of several tons of cargo hits a rock, and it goes 'crack,'" Trout says. "Its boards break, and it sinks."

True to its penchant for authenticity, the festival has had its share of disasters. In 1987, the *Maiden's Adventure II* snagged broadside on a rock, filled with water, and snapped in half. Eight years later, the *Fluvanna* caught on another submerged boulder, whipped sideways, took on water, and promptly splintered.

By its fourth morning, this edition of the festival has claimed no victims. It's been hard going, however: The James is low, sucked dry by drought, exposing rocks typically a couple of feet underwater. Two nights ago, one such rock snagged the *Lady's Slipper* and held it so fast that its all-female crew had to abandon ship. Throughout the third day boats had hung up so firmly, and so often, that multiple crews were required to lift them over the rapids. Several boats are now traveling together, the better to negotiate the hard spots.

David Haney pulls desperately on the bow sweep, peering downstream at the approaching rapids. The current is in charge. The rocks are close. The *Pride of Campbell County* won't make it to the left bank.

Then, dead ahead, what had appeared a solid knot of limestone reveals itself as a gantlet of rock around a narrow, deep-water chute. Very narrow. "Pull right!" Haney cries, as he begins bringing the bow around. "We're gonna take it straight ahead, Glen! We'll need to keep her straight!"

From the stern, Shrewsbury peers through the tunnel of canvas amidships and past Haney, assessing the hole. "That mess right there?" he hollers.

"It's the best there is," Haney shouts. "Nothin' but rock up here."

The bow swings lazily right as a bone-white boulder looms ahead. "More on the left!" the skipper barks, and at the stern his wife leans into her pole. The boat sidles ever so slightly, and the boulder slides past the port gunwale. Another rock, carved by the river into the scapula of some

great monster, erupts from the water to scrape along the starboard chine. The boat shakes itself free just as a third boulder materializes: a massive, smooth dome of algae-slick stone, its crown six inches below the water's surface and leaving no ripple. Invisible until this moment. Unavoidable.

Haney can only yelp "Hold on!" before the *Pride of Campbell County* drives straight over it. Rock grinds against oak plank. The boat shivers to a stop, its nose lifting from the water, timbers groaning. Its downstream end held fast, the batteau becomes a swinging gate in the current. In an instant it is pinned against a second rock, amidships.

Capricious though it is, the James holds a key place in American exploration, settlement, trade. No other topographical feature on the continent has witnessed so many critical turns in the nation's history. The first permanent English settlement took root on its bank, and not long after, the first factories, forts, and hospitals. It has run red with the blood spilled in three wars, in populist revolt, and in Indian raids along its length.

When early English settlers began to strike westward, they did so on the James. When Virginia's first eighteenth-century plantations sprouted on the frontier, they did so beside the river. And when the pioneers pushed farther, beyond the Blue Ridge, they found that the James offered an unbroken water route to the Appalachians. Not surprisingly, it became a corridor for travel in the other direction, too. Early in the eighteenth century, inland plantation owners faced the daunting prospect of delivering their crops to market in the Tidewater. The river at their feet offered the readiest solution.

Three hundred forty miles long, the James tumbles from a web of headwater streams high in the mountains of western Virginia, loops across the Great Valley, punches through the Blue Ridge in a steep-sided, twelve-mile gorge, then zigzags across the gently sloping Piedmont to the fall line at Richmond. By floating their crops downriver through the gorge, upland farmers could reach market on the Piedmont; by heading downriver from there, they could reach the capital in a fraction of the time it took to negotiate the steep, stumpy mud wallows that were the overland roads of the day. The river provided a direct link to overseas markets, as well. Just below Richmond lay Rocketts, where river cargo could be transferred to the sailing ships that plied the James's final one hundred miles, where the river becomes a wide, sluggish estuary of the Chesapeake.

Following the river on a map and doing it in person are two differ-

ent things, however. The flatboats and rafts then in fashion didn't stand a chance in the falls and rapids that cursed the route. Some farmers tried Indian dugouts. They were fast, but not big enough to carry much cargo. Then Robert Rose, a traveling parson and tobacco planter with a large spread near present-day Lynchburg, figured a way to lash two dugouts together and deck them with a wooden platform. This rude catamaran was stable, reasonably maneuverable, and big enough to carry several hogsheads of tobacco.

Before long, folks on the river were calling them tobacco canoes. Piedmont planters found they carried a load using a third of the men needed on a road journey. And they were cheap to use: In Richmond the platforms could be sold for lumber, and the dugouts paddled back upstream.

The parson's invention didn't stick. In 1771, Virginia was waylaid by a natural disaster that wouldn't be equaled for nearly two hundred years. That May, several days of torrential rain lashed the James's uplands and boosted the river's level by as much as sixteen inches per hour. By the time this bulge of water reached the falls at Richmond, it was a towering wall that smashed and swept away everything in its path. Cabins and farms vanished. Forests were felled. Islands were scoured. Dozens died. And the flood threatened to have a lasting effect on colonial commerce, for virtually all of the river's dugout canoes were swept away or reduced to matchsticks.

Along came Anthony and Benjamin Rucker, who settled north of Lynchburg, with a new craft—a double-ended, wood-planked freighter that crewmen pushed along by standing at the bow, jamming their poles into the riverbed, then leaning into the poles as they walked to the stern on planks fastened along the gunwales. The James River batteau was born. Within a few years the Ruckers had been copied hundreds of times, and the river was crowded with batteaux and their three-man crews shooting the rapids to Richmond.

To tobacco planters seeking self-sufficiency and low overhead, it made sense to use their own employees—in other words, slaves—to crew the boats. The batteau work force thus quickly became dominated by blacks. They were a hardy and proud lot, strong-muscled and steel-nerved, and they comprised one of the first black professional brotherhoods in America.

David Haney leaps into water surging cold and thigh-deep around the boulders at Swift Island Falls. The river is flowing hard against the starboard side. He walks along the port side, assessing the task ahead, as the rest of the crew scrambles off the stern.

It is a nasty hang-up: Freeing the *Pride of Campbell County* means pushing the boat against the current, away from the rock amidships, then backwards, upstream, off the boulder at the bow. And that is the easy part, because from there the crew will still have to negotiate the rapids that have landed them here in the first place. "We'll need everybody pushing on the left," Haney says. He returns to the bow as Barbara grabs a three-foot iron bar and wedges it between the port gunwale and the river bottom, and pries the boat away from the first rock. Glen and Brenda Shrewsbury lean into the batteau's side, grunting. The *Pride of Campbell County* moves perhaps six inches.

"Hold it there!" Haney yells, and puts his shoulder against the bow. His shove erases the progress at the stern: As soon as the boat shifts a foot back, its rear swings to port and the crew is helpless to stop it. "It's got us good," Glen mutters.

"It does," Haney agrees. "We've got to do it again. Let's push on the left. Really gotta push, now." The other three brace themselves against rocks and ridges on the slippery bottom, lower their heads, and strain against boat and river. It's at such moments that the festival's participants probably come closest to understanding the obstacles surmounted by the original batteau crews. And as bleak as the *Pride of Campbell County*'s situation appears on this Tuesday morning, it's such moments that keep boat crews coming back, year after year.

Unlike Civil War reenactors, many of whom can trace their lineage to the armies of North or South, few of today's boatmen have ancestors who poled the James; only a handful of blacks have joined boat crews over the years. The event's pull lies in its demand for old-fashioned problem solving, for meeting difficulties with muscle and mind, rather than technology. "Simplicity," David Haney explains. "It's taking away all the distractions, living simply."

The batteau dominated the river's cargo traffic for more than a half century, aided along the way by the construction of sluices that shot the boats around some of the tougher rapids. Many of the improvements survive today. Downriver, at the head of a stormy three-foot cascade between Scottsville and Bremo, is a dark slab of bedrock that bears the hand-chiseled inscription "1774." A few yards off, a rock-walled sluice still stands after more than 230 years.

Though ingenious, these primitive aids to navigation weren't enough to guarantee the safety of batteaux and the crews. After the Revolution the demand for smoother passage between Richmond and the hinterlands spurred the construction of a canal along the James's north bank. By 1840 it had reached Lynchburg. In 1851 it stretched to Buchanan, 197 miles from the capital.

The James River and Kanawha Canal was an audacious project, one of the most lavish public works in Virginia's long history. It crossed the mouths of creeks on aqueducts of hand-chiseled stone, bored past mountains, stair-stepped into the highlands in dozens of locks. Eventually, its planners hoped, it would connect with a canal system on West Virginia's Kanawha River, which feeds into the Ohio. Passengers and cargo would be able to board a canal boat in Richmond and cruise in comfort to the Mississippi.

But railroads were on the way, and though crews built locks, tunnels, and aqueducts farther upstream, the canal itself never made it past Buchanan. Partially ruined in the Civil War, the waterway was bought by the predecessor of CSX in 1880, and track was laid on its towpath.

Even before its own demise, the canal spelled the end of reliance on batteaux. By the time the railroad arrived, the old riverboats were rarities. By the early twentieth century, they'd disappeared so completely that no one could be sure how they'd been put together. They remained vanished, described only in the vaguest of ways, until 1983, when construction workers excavating the site of the James Center in downtown Richmond dug into the remains of the city's old canal turning basin. It had been filled and paved decades before, but still contained, in the mud that once formed its bed, a fleet of sunken canal boats and batteaux.

The following year a group of upriver history buffs used the unearthed boats as a model for their own batteau, the *Columbia,* and floated it to Richmond. Others followed suit, and the festival was born soon after.

For fifteen minutes the *Pride of Campbell County*'s crew has struggled to shove the boat off the rocks at Swift Island Falls. Now David Haney leaves the bow and wades back to the others. "We'll try it together back here," he says. "What we need to do is shove to the right, and push her backwards at the same time—and not let up until we're away from these rocks. We've just got to walk her upriver."

His crew, chests heaving, nods and seeks places along the port side. Calloused hands grip the boat's curved ribs and the rail around its gunwale. "One!" Haney yells. He leans forward. "Two!" He wedges a foot on the rocks behind him. "Three!" The four throw themselves against the boat, arms trembling, teeth bared, groaning. The batteau backs away from the rock at its center and swivels to starboard.

"Now, straight back!" Haney gasps, and they shift closer to the boat and push upstream. The *Pride of Campbell County* grinds against the rock at its bow. Its planks vibrate under the crew's hands. Then the boulder lets go, and the boat surges backward so quickly that Haney nearly pitches face-first into the river.

They heave the batteau twenty yards upstream, hold it fast while the captain eyes the rapids. To the left, he decides. They'll take it left, as originally planned, only they'll walk it—the water is shallow the width of the river, too shallow to accommodate a batteau and seven hundred pounds of crew. With a crewman at each corner they guide the boat through the rocks, until the river's bottom drops away and they've made it past Swift Island Falls. Haney leaps back aboard and runs the boat's length to the bow. His crew wriggles on, one at a time, and slumps to the deck, panting.

The sun has risen over the trees during the adventure, and the air now feels thick and creamy with heat. For a while they pay no mind to the world beyond the rails; they lie exhausted among the wolf spiders, unfazed by water that has seeped past the oakum that seals the hull to slosh brown and tepid at their feet. The *Pride of Campbell County* inches along, untended in the sluggish current.

Then the breeze lifts once more, cool and fresh across the bow. The dry leaves of the sycamores chatter. The canvas hooped over the boat's middle flutters and snaps. The batteau slows to a stop, hovers midstream. "A headwind," Haney announces. "Let's get to the right, try to get out of it."

His boatmen—his skilled boatmen—reach for their poles.

The Race Is Off

Ricky Rudd's in his F150 on a sun-dappled two-laner between Cornelius and Concord, North Carolina, aiming, as he is wont to do, to work past other drivers on suburban Charlotte's gummed-up roads.

His son, Landon, sits yawning beside him. "Dad, do we have my binder?" the fifth-grader asks.

"Yeah," Rudd replies. He tilts his head toward the back seat, to Landon's book bag and packed lunch. "It's there behind your pack."

Landon nods and settles into a sleepy stupor. Ahead, brake lights flash, and Rudd swings the truck right, onto a gravel lane that doglegs among hayfields and hardwoods. He knows pretty near every back way: Since the Norfolk native walked away from a long and distinguished career as one of the world's great race car drivers, most of Rudd's time behind the wheel has been on this daily round trip.

He has the lane to himself. In clean air, as a racer would put it, the air that hangs full and rich over open road. That keeps a car's wheels square on

the ground. Ask Rudd why he's left racing, why he won't be starting in the Daytona 500 for the first time in twenty-five years, and this idea of clean air is what it comes down to. You get crowded on a race track, and the air gets beaten, riled, thin. A motor can't catch its breath. A car might drift in the turns. And that's how life was getting, with the hurry, the crowds, the politics and crazy money, the never-ending push and pull of NASCAR's Nextel Cup Series. Rudd wanted time with Landon, and with his wife, Linda. Clean air.

The pickup crunches around a bend. Ahead a school bus is kicking up a white cloud, its lights flashing. It rumbles to a halt. Rudd sighs and stops his truck a good ways off.

"What are you doing?" Landon asks.

"Trying to stay out of the dust," he says.

Rudd has been racing so long that most NASCAR fans can't remember a contest he didn't start. He showed up to race in Riverside, California, on January 11, 1981, and didn't miss one of the 788 Winston Cup or Nextel Cup races that followed. They call him the "Iron Man" for that unbroken string, and well they should, because odds are, it'll never be matched.

Rudd showed up to win, too. He did it outright twenty-three times and came close hundreds of others. He finished in the top five in 194 races, in the top ten in 373, and consistently ended seasons in the hunt for stock-car racing's big championship—was among the ten top finishers nineteen times, to be exact, a feat topped by only Richard Petty and Dale Earnhardt.

He set the NASCAR record for consecutive seasons with a victory. He's raced a stock car more than a quarter-million laps, covering nearly 311,000 miles. He's been deemed one of the fifty greatest drivers of all time.

And now he's stopped.

"Over the years the travel routine, and the time away from home, started to take its toll," he says. "When you're racing, everything else in your life gets put on hold.

"I just felt like I needed a breather in my life."

Linda Rudd, whom Ricky started dating while both were tenth-graders at Chesapeake's Indian River High School, figures the time is right: "Landon is eleven years old," she says, "and in another three years he's not going to want to be doing things with Mom and Dad."

Rudd steers his pickup onto the school grounds, helps Landon into his

backpack, watches as he heads for class. "I've been getting a lot of phone calls," he says, back on the road. "A lot of opportunities, if I were to decide to take one. But I don't feel ready to make a decision.

"I recognize that if I sit out the full year, there might not be the phone calls coming in." His tone is matter-of-fact. He shrugs. "I'd go play with my go-karts, ride my dirt bike, and watch Landon grow up."

If it's true that Rudd has raced his last, we've seen the close of a career that could not be repeated. It began at the Daytona Motor Speedway, on the day he first sat in a race car. He was eighteen. He didn't understand the track's signal flags. The car handled like a dump truck.

Even so, he barely missed qualifying for the Daytona 500 that day in February 1975. Two weeks later, he showed up at Rockingham, North Carolina, and minus a lick of practice, not only qualified for the Carolina 500 but placed eleventh in the race. Two weeks after that, he ran tenth in the Southeastern 500 at Bristol.

As much as Rudd's later success, his $36 million in career winnings, his status as NASCAR's Cal Ripken, it's those early, lean days that set him apart from his sport's current stars—a clean-fingernail bunch, in large part, who've never known the panic of blowing their last engine, or the nervous exhaustion of pulling the race car on a flatbed trailer through the night, or what it's like to share a motel room with five, six, seven other people.

Rudd's in closer company with stock-car racing's old school, among drivers whose grit and courage grew the sport into a cultural tsunami, with days when Hampton Roads was a racing center.

When a salvage yard on North Military Highway was, in particular. For twenty years after World War II, Ingram Auto Parts was a meeting place for the heroes of the local dirt tracks—the old Chinese Corner oval at Virginia Beach Boulevard and Witchduck Road; Princess Anne Speedway, where Janaf Shopping Center now stands; and the Dog Track Speedway in Moyock, North Carolina. Ray Platte, Joe Jernigan, and Bill Champion, Norfolk drivers who figured in NASCAR's early days, all hung out at Ingram's. So did Paul Sawyer, who'd go on to open the race track in Richmond, and Joe Weatherly, a driver, promoter, and prankster destined to be Grand National champion—the equivalent of today's Nextel Cup winner—in 1962 and 1963.

The yard's owner, Robert Ingram, was a racer himself and tight with NASCAR founder Bill France. His payroll included a good many fellows

with a hand in stock cars. The Gee brothers, Walter and Vernon, did body work for Ingram and built race cars on the side; their brother Robert, who came around the yard, was to become NASCAR's preeminent sheet-metal man, and later on, his daughter would marry a Carolina driver named Dale Earnhardt. They'd have a son, Dale Jr., who would spend many of his boyhood summers in Norfolk.

Another Ingram employee was a scrappy former racer named Al Rudd Sr., who lived in Norfolk's Bayview neighborhood and had a gift for re-building wrecked cars.

"A body man and a half," another local car-builder, Dale Ore Sr., said of him. "The cars he built were better than some of them right off the assembly line, if possible."

Al Sr. and his wife, Margaret, had five children, and to make ends meet, he built and repaired cars at the house after hours. "He was a very hard-working fellow," recalls Ricky, who was born in Norfolk in 1956. "He'd get home from work, have supper, and then work until about 11 PM."

He did it well enough that by the early 1960s, the family lived in a big split-level in Chesapeake, on a shallow cul-de-sac near the Ford plant. In its two-car garage, Al Sr. cobbled together a miniature roadster for the kids. Every Sunday afternoon, "if it was cold, raining, snowing, whatever," Ricky would be in it. The asphalt circle out front was his first track.

Somewhere around the same time, this being when Ricky was about five, Al Sr. acquired a go-kart and took the family out to an unused stretch of concrete at Norfolk International Airport to run it. "I remember getting on that thing and taking off on it, and doing 60 or 70 mph," he says. "I'd zoom past them while they were all waving at me to stop. I kept on going. I'd go past them again, and they yelled at me to stop, and I didn't stop."

The stunt ended his trips to the airport, but it also offered a revelation. The kid was thrilled, not scared, by speed. A few years later, Al Sr. bought Ricky a racing go-kart of his own, and they started looking for a race.

They found one at a high-banked track beside Hampton's Langley Speedway. Not a kid's place: Most of the racers were shipyard workers, prone to high-speed dueling and trackside fistfights. "Tough bunch of men," Rudd says. "The place was nicknamed the 'Blood Bowl.'

"I couldn't imagine Landon going out there and doing it," he admits, "but I was always in control, and maybe my parents sensed that."

What everybody else sensed soon enough was that they were wit-

nessing something special. "The talent," Rudd calls it. Say you're tearing around a race track, there's a messy wreck dead ahead, and you have about a quarter second to avoid it. With the talent you understand what you see, pick it apart, weigh the variables—catalog the cars spinning every which way, the opening and closing escape routes—then respond. You do this as quickly as it takes most folks to scream.

It wasn't but a couple of years before Rudd graduated to longer road courses and faster, more sophisticated karts; he lay almost flat on his back and wide open to the wind in these machines, fuel tanks tight against his sides and steering wheel down by his belt buckle. They topped out near 100 mph.

The closest track, Virginia International Raceway, was in Danville; the rest were scattered far and wide. "When we raced in Atlanta," he says, "I remember getting home just in time to be dropped off at the front door of the school on Monday."

On most of the trips, it was Ricky, his dad, and his big brother, Al Jr., or "AJ"—a kid "who took stuff apart, put it back together, and made it better than it was." They made an exceptional team. The trophies piled high. At fourteen, in Indianapolis, Ricky won the national championship.

He took up motocross after that and proved almost as dominant on two wheels as he had on four. Still, he had no formal plan to make racing his career when he graduated from Indian River High in 1974. He went to work full-time for his dad, who had left Ingram's to open his own salvage yard in the Bowers Hill section of Chesapeake. Rudd drove around town delivering auto parts for $115 a week.

His racing days might have ended right there had it not been for AJ, who'd blossomed into a brilliant engine builder and was lending a hand to Bill Champion, the last of the old-time Norfolk drivers. The others had retired, or worse: Joe Weatherly had been killed in a race at Riverside, California. Joe Jernigan had died in a Richmond crash. Ray Platte met his end going into a turn at South Boston. And by 1975 Champion was close to used up. He talked about retiring, and AJ heard the talk.

He and his friend Cliff Champion, who was kin to the driver, told him about Ricky, convinced him the kid could drive a stock car. Bill Champion knew better than most that you reached the Grand National level after years of sliding around local tracks. Still, he went along with what, objectively speaking, was a fool idea. Not long after, "I'm sitting in the stock

car for the first time, trying to see if the seat fit," Rudd says. "It didn't even occur to me, 'You gotta get some training, get some experience.'"

Bear in mind that next to today's racing, this was the Dark Ages. Champion's '73 Ford incorporated a good many factory parts. No crew of technical specialists waited on the pit road, no truckload of spare engines. Champion's sponsor was Champion himself.

Nowadays, "stock car" is an oxymoron: No stock part, not a single one, resides within. Its frame is custom-built of square tubing. Its engine block is of an alloy unavailable to the public. The driver's seat is sculpted of carbon fiber or aluminum to match his every physical quirk, and curves around his ribs, shoulders, and head to hold him fast. The car's aluminum body is wind-tunnel-tested and tweaked to a degree befitting the space program.

But the tasks Rudd faced in the cockpit that day haven't changed much. He braked and worked the clutch with his left foot, gassed with the right. Drove with an eye almost constantly on the mirror. Thought ahead about when to take a curve high, when to go low, how to take advantage of slower cars, caution flags, pit stops. Did it all while enduring heat and noise that could cause a body permanent harm. And he did it far better than veterans expected. "At that time, 'young' in the garage area was thirty-two, thirty-five years old," Rudd says. "And here's this eighteen-year-old kid.

"I took a lot of jokes: 'Time for a pit stop, change the diaper.'"

He raced four times that first year. Broke his arm on his dirt bike, missed most of 1976. The following year, Al Sr. sponsored him, in a Chevy with "Al's Auto Parts" splashed down its side. The team could barely afford tires. The crew worked for free.

"We drove everywhere, even to California," Rudd says. "We'd get to a motel, and there'd be six or eight of us in a room, and I'm not talking about a big room. We'd flip coins to decide who slept on the box springs, who slept on the mattresses.

"My brother would take out the motor and bring it into the room to work on it."

At Pocono, the season's eighteenth race, the car blew its engine, and the Rudds had no backup. "Our tow truck was a one-ton pickup," Rudd says. "The only thing we could do is pull the good motor out of the truck. We machined it and had enough parts laying around that we got it ready for the car. We went and got a bigger engine out of the junk yard for the truck."

Rudd qualified at Talladega with the truck engine, then blew that.

Desperate, Al Sr. rented one from another team for $7,500. "That was a lot of money then," Rudd says. "My dad told me later he had no idea how he was going to pay for that motor."

Rudd finished fourth. His winnings: $7,500.

Much of the season went that way. One week, Robert Ingram passed the hat at all the local salvage yards so the Rudds could buy engine parts. Seems a fairy tale now. The Hendrick teams have upwards of three hundred employees. Roush Racing's people fly around in Boeing 727s. Some teams ship their cars to Europe for testing. Roger Penske's three Nextel Cup teams occupy eight acres of floor in a building the size of a shopping mall.

Makes it all the more unbelievable that Rudd posted ten top-ten finishes in that hardscrabble '77 season. He was named NASCAR's Rookie of the Year, too.

You'd expect that a sport's top newcomer would be a hot property, that sponsors and teams would be eager for his services. Wasn't the case.

Maybe it's because nobody knew what to make of a driver who so thoroughly broke the stock-car mold. "I came from the middle class," Rudd says now. "Didn't come from up north, but I was from the middle of the country. I was eighteen or nineteen, but looked thirteen."

Now all the sponsors want some young, photogenic guy at the wheel, but "at that point it was a good-ol'-boy sport," he says. "I was just sort of the oddball."

Maybe that helps explain why, even in years he's been a front-runner, the spotlight's been pointed elsewhere. Take 1991, when his duel with Dale Earnhardt for the Winston Cup championship went down to the wire. You'd have thought Earnhardt was alone on the track, for all the fuss he got.

Or maybe, as Rudd figures, the system favors drivers whose sponsors bring the most money to racing. "NASCAR needs a star," he says. "And their bottom line is, 'We gotta make money.'"

To be fair, Rudd may not have done himself many favors in the publicity department. He is an intensely private fellow. He'll tell you he's whipped, rather than energized, by large crowds. His TV presence is cordial but businesslike. He doesn't chew his vowels or lace his speech with aw-shucks, country-boy turns of phrase. He doesn't wear a Stetson, or pose as a badass, or claim a past running corn liquor across county lines.

About the only times he's made good copy have come when he's mad, as he was in 1986 when he claimed that Kyle Petty had tried to kill him at Martinsville, and he called Petty "a spoiled little brat" and suggested that "maybe he learned to drive from his daddy" and announced: "There's an idiot on the racetrack, an idiot named Kyle Petty."

Rare outbursts like that have earned him the nickname "the Rooster," as in bantam rooster—as in a creature that gets feisty when provoked. Rudd's never traded on that image, however. He has little stomach for publicity of any stripe.

"I still love driving race cars," he says. "But now in NASCAR, to make it, you have to be out there doing the marketing. Kyle Petty says it best: He says, 'I dreamed of being a race car driver. I didn't dream of being a PR guy.'"

Whatever the reasons, no one stepped forward to back him. He raced only part-time in 1978 and broke down more than he finished. He drove for a team out of Richmond the following year, and did well, too—but as Rudd tells it, the sponsor wanted a more traditionally southern driver. His 1980 season was split among several cars, several owners, and a stretch back at the salvage yard.

He and Linda were married by now, after years of dating, and were living in a brick rancher on Hawthorne Drive in Chesapeake. "The payment was $340 a month," Rudd says, "and I had no idea how I was going to make that payment."

Then came another break. Down in Charlotte, a legendary crew chief named Harry Hyde took a liking to the young driver and helped him get his car ready for a race there late in the season. Rudd finished a strong fourth. Next day came a call from DiGard Racing. Rudd finally had a ride.

So began his chain of consecutive starts. Beginning with the 1981 season opener, Rudd started every race, every year, through the end of the 2005 season, despite numerous dramas that threatened to interrupt it: mechanical troubles, Linda's pregnancy, Landon's birth. Al Sr.'s death.

Not least, there was his wreck at the 2004 Busch Clash, now called the Budweiser Shootout. Bumped coming off a turn, his Ford lifted into the air, barrel rolled, and crunched end over end. "I remember hearing the noise when I hit, and all the air came out of me," he says. "I don't remember the rest of it."

What he missed was flopping like a beached catfish after his seat snapped in half. Dirt and grass packed his eye sockets. Rescue crews had to pry him out.

Sure enough, he was back for the following week's Daytona 500—came in seventh—but that only tells the half of it: His face was so swollen that his eyes closed up in the turns during practice. "I saw some duct tape on a tool box," he said. "Proceeded to tape all that loose skin to my forehead. Put my helmet back on."

Remember that the next time you hear the "Iron Man" talk.

It took 161 races to get his first victory, at the same Riverside track where his dad's friend Weatherly died. After that the wins came steadily, at least one in each of the next sixteen years. He was knocked out of Victory Lane by mechanical failures too many times to count; Rudd's recollections are crowded with the phrase, "We were leading with x laps to go when the motor broke." Even so, he finished in the top ten in 43 percent of the races he started.

After DiGard, he raced in the Motorcraft Ford for Bud Moore, in Richard Childress's Piedmont Airlines Chevy, in the Quaker State Buick for Kenny Bernstein. In 1990 he signed with Rick Hendrick and the following year came within a whisper of winning the Winston Cup. In 1992, still with Hendrick, he won the International Race of Champions series, which pits the best drivers of stock-car and Indy racing.

His boldest feat came in 1994, when he left Hendrick to start his own team. For six seasons, he was his own boss, built his own cars, oversaw thirty to thirty-five employees, and drove a Ford plastered with the Tide detergent logo, among the most recognizable cars on the track.

Today, Rudd looks on those years as the best and most vexing of his career. Best, because for the first four he did well, with top-ten Winston Cup finishes in three and two wins in 1997. His biggest NASCAR victory came that year at Indianapolis, where he took the Brickyard 400. For an owner-driver to win one of the sport's most prestigious races was a rare event by then, and something that may never happen again.

There lay his frustrations, because big spenders already were remaking the sport. "It was apparent we were getting way behind the money curve," he says. "And a mistake we made was that out of loyalty to the sponsor, we didn't go around looking for any other sponsors."

In 1999, when Tide informed Rudd that it wouldn't be back the following season, he didn't win a race, and placed thirty-first in the cup standings. He was spent, besides: "I would go into the shop at 6 AM and leave at 11 every night," he says. "I aged a lot in those years."

Clean air is what he needed. He folded the team. He drove for Robert

Yates and later for the Wood Brothers, and at the end of the 2004 season knew he'd reached a crossroads. "I told him, 'You have to make the decision,'" Linda says. "'I'm tired . . . I'd like to have a normal, regular life. But you have to decide.'"

Rudd pulls the pickup into a strip mall and strolls into a coffee shop. He can show up at a public event—at an autograph session, say, like the one he did in Baltimore three days ago—and people will line up four wide by sixty yards deep to meet him, to tell him, "Ricky, you're a class act," or "This year just isn't going to be the same," or "Miss you on the track, buddy."

Most days it's a blessing, though, that he doesn't have the fame of a Dale Jr. or Jeff Gordon: This morning he orders coffee, sits down, and isn't bothered.

That suits him fine, and it's why he has no interest in covering NASCAR for TV. Beyond that, everything's negotiable. Maybe he's done with racing. Maybe he'll get bored and want to go back. Maybe, with Toyota joining the sport, there'll be some new role to play.

Maybe he and Linda will stay in Charlotte. Logistics forced their move there, and they're about to build a 7,000-square-foot house on a picturesque reservoir north of the city. Then again, maybe they'll move home. Rudd has his hand in real estate in Chesapeake, and three of his four siblings still live in the area.

This much he can say for certain: He's not at Daytona, not scrambling to ready a car for the 500, and it feels all right. He doesn't much miss it. He doesn't plan to go to the race or even to watch it on TV.

Linda will pick up Landon from school this afternoon, and she'll drive him to a piece of property they own, where Rudd will be waiting. He and his son will chase each other on dirt bikes.

Rudd walks out to his truck, starts it up. What happens beyond the evening doesn't worry him. He need not decide his future today, tomorrow, the next day. He coasts through the parking lot. Eases onto the road. Pokes along. In no hurry.

Tory Terrorist

The terrorists struck civilian targets, dissolved into the countryside, materialized elsewhere to visit fear, fire, and death on new victims. They relied on a network of associates to hide them from their American pursuers. The authorities, stymied by intelligence failures, seemed powerless to stop them.

Until, in a gambit to safeguard liberty, they denied it. They slammed a Draconian fist upon their foes: They put a price on the leader's head and declared his cohorts guilty without trial. The campaign succeeded, but Americans wondered: At what price is terror quelled?

They still wonder, more than 225 years later.

In a drama that seems all too familiar today, some of America's Founding Fathers beat back a daunting terrorist threat in 1778, earning censure for heavy-handedness in the process. But unlike those responsible for the attack on the Norfolk-based destroyer *Cole* and the carnage of September 2001, the terrorists of yore were a homegrown lot: They and their victims lived in what's now Virginia Beach and Chesapeake.

For three years, a small army of Tory marauders, loyal more to violence than the crown, robbed travelers on the region's lonely roads, torched homes and murdered their occupants, and earned such a reputation for mayhem that local militiamen refused to take them on.

Their leader was a man nearly lost to history. His name was Josiah Philips, and this little is known of him: He was an unlanded laborer who lived in the Lynnhaven Parish of old Princess Anne County, which took in the eastern half of modern Virginia Beach.

Period. No physical description survives of him, nor the particulars of his birth, his marital status, his schooling. One old account says he was black; most say nothing of his race, age, or exact address.

What's sure is that he remained loyal to the Motherland when the fledgling Virginia government took up arms against the English, and that he received a commission from the royal governor, Lord Dunmore, to fight on the king's behalf. He did it well. Before long, Dunmore was sent packing back to England, and Philips traded the political fight for flat-out crime.

He did that even better.

Rumors first reached Williamsburg that loyalists were raising hell in Princess Anne County in the summer of 1775. The news was no surprise to those leading what would soon be a War of Independence. The popular image of the Revolution holds that colonists were united in their opposition to the crown, but that was hardly the case. Before the Declaration of Independence, New London—today a suburb of Lynchburg—was among Virginia's principal towns. It had so large a Tory population that when the loyalists fled, its economy collapsed, and the town withered to nothing.

And in Princess Anne, the most Tory county in Virginia, many a first citizen was with the British. George Logan, who built Pleasant Hall—the grand house that once dominated Kemps Landing and still stands on Princess Anne Road—was one; he eventually fled to Scotland. John Saunders, who lived at Pembroke Manor, namesake of neighborhood and shopping mall, actually fought for the crown.

Philips was no doubt a player in the reports reaching the colonial capital, for it was at about the same time that Dunmore, who still enjoyed some control of the colony, commissioned him to enforce English rule in the Lynnhaven Parish, and Philips was nothing if not enthusiastic about

his assignment. But it wasn't until nearly two years later that he became a royal pain by name. In June 1777, Governor Patrick Henry received a letter from Colonel John Wilson, Norfolk County lieutenant, reporting that "sundry evil disposed persons, to the number of ten, or twelve, have conspired together, to foment a Dangerous Insurrection," and were "lurking in secret places threatening and doing actual mischief."

With Philips in the lead, the band would swoop down on the isolated farms of southern Princess Anne and Norfolk counties, and after committing various evils slip away in the cover of night to a hideout in the Great Dismal Swamp. Marshes, forests, and estuaries divided the gang's targets from their neighbors. The pickings were easy.

"Scarcely a night passed," William Wirt's 1817 biography of Patrick Henry relates, "without witnessing the shrieks of women and children, flying by the light of their own burning houses, from the assaults of these merciless wretches; and every day was marked by the desolation of some farm, by robberies on the highway, or the assassination of some individual, whose patriotism had incurred the displeasure of this fierce and bloody leader of banditti."

The governor issued a $150 reward for Philips and two of his fellow troublemakers, a goodly sum at the time, and later that year a free mulatto gave him up for the cash. Philips was captured.

He did not stay that way for long. Apparently even before the reward had been paid, Philips had busted out of the Princess Anne County Jail. On top of being a violent creep, now he was mad.

Philips ditched any pretense at a political agenda and embraced the role of menace to society. He put together a larger gang, fifty disaffected whites and runaway slaves. Protected by a network of friends, Tories, and relatives, they waged open war on Hampton Roads.

In the spring of 1778, Wilson tried to muster a militia to root out the miscreants. Men refusing to serve had to pay a fine; just about all the locals chose to cough up the money. "With such a set of men, it is impossible to render any service to country or county," Wilson complained in a May 20 letter to the governor. "A few days since, hearing of the ravages committed by Philips and his notorious gang, I ordered fifty men to be raised out of four companies, consisting of upwards of two hundred: of those only ten appeared."

Wilson wrote that he "compelled twenty others into duty," but that

one in four of the militiamen deserted that night, and that "such is their cowardly disposition, joined to their disaffection, that scarce a man without being forced, can be raised to go after the outlyers." There was more bad news: One of the militia's few stout souls, the unrelated Capt. Josiah Wilson, called on a neighboring house and was fired on by four of Philips's men, who were holed up inside. He died of his wounds.

Patrick Henry ordered the Nansemond Militia, in present-day Suffolk, to dispatch one hundred men to the scene of the bandits' vile deeds, and offered a reward of five hundred dollars "for apprehending Phillips the Ringleader dead or alive." The Suffolk men started deserting as soon as they started marching east. Colonel Wilson, the Norfolk County official, begged the governor to exile the locals sympathetic to Philips. Henry instead called up a company of Virginia's regular army, explaining to the General Assembly that "no effort to crush these desperadoes should be spared."

Legislators, keenly interested, came up with their own solution. Informed that Philips and company were "committing murders, burning houses, wasting farms, and doing other acts of enormity," they essentially declared Josiah Philips guilty of high crimes and authorized any and all Virginians to kill him.

So it was that Patrick Henry and Thomas Jefferson, who've been identified throughout American history as champions of human rights, were linked to a government act virtually without equal in its loathsomeness: a bill of attainder.

Such a bill was a legislative decree of guilt, without the fuss of trial, evidence, testimony or hearing, and prescribing a sentence on the unlucky accused. It was antithetical to everything American, a weapon of oppression so blunt and weighty that it was later outlawed not in the Bill of Rights, but in the Constitution's first Article.

Yet in an act that still has historians scratching their heads, Jefferson— *Jefferson!*—wrote the bill against Philips and shepherded it through both houses of the General Assembly. His handiwork, which became law on June 1, 1778, called on gang members to turn themselves in by month's end, lest they "suffer the pains of death, and incur all forfeitures, penalties, and disabilities, prescribed by the law, against those convicted and attainted of high treason."

Further, after July 1, it would be "lawful for any person, with or without orders, to pursue and slay the said Josiah Philips, and any others who

have been of his associates or confederates," provided the person slain was armed or on the run.

The gang didn't surrender, and the law caught up with it a man at a time. One likely member, a slave named Bob, was captured, tried in a Norfolk court that August, and executed. Another, an escaped slave named Will, was "hunted down like a mad dog," as one historian put it, and shot. Philips was captured before the July 1 deadline and, along with two accomplices, thrown back in the Princess Anne County Jail. Edmund Randolph, the state's attorney general, chose to follow regular court procedure in his prosecution, and later that month Philips appeared in the county court on charges that he had robbed one James Hargrove of twenty-eight felt hats, valued at twenty shillings each, and five pounds of twine.

The case was referred to the general court in Williamsburg, and Philips, along with several other suspected gang members, including those accused of Capt. Wilson's murder, was jailed there under a bolstered guard. At his October 20 trial, he argued that he was a British soldier, and no more than a prisoner of war. The court disagreed. Convicted, he was hanged in early December.

The danger extinguished, Philips was forgotten, and might have stayed that way if it weren't for a debate a decade later at Virginia's convention on the proposed federal Constitution. When Henry backed a bill of rights, Randolph blasted him as a hypocrite, and held up the Philips case as proof. For whatever reason—mind, memory, intent—Randolph spoke as if the bill of attainder had actually been carried out. "He was attainted very speedily and precipitately, without any proof better than vague reports," Randolph said. "Without being confronted with his accusers and witnesses, without the privilege of calling for evidence in his behalf, he was sentenced to death."

When Henry rose to answer the charge, he, too, seemed to forget that the bill was never consummated, devoting himself instead to defending the thinking behind it. Philips was "no Socrates," he thundered. "He committed the most cruel and shocking barbarities. He was an enemy to the human name. Those who declare war against the human race may be struck out of existence as soon as they are apprehended.

"He was not executed according to those beautiful legal ceremonies which are pointed out by the laws in criminal cases," he said. "The enormity of his crimes did not entitle him to it."

Nearly thirty years after, Jefferson remained mystified by the debate—

and an apologist for the bill. There are times, he argued, when such a mea-sure is appropriate. When events trump the regular machinery of justice. When a people must be empowered to gird themselves against terror.

"No doubt that these acts of attainder have been abused in England," he wrote in a letter, "as instruments of vengeance by a successful over a defeated party.

"But what institution is insusceptible of abuse in wicked hands?"

Out of Nowhere

I

Up at 5:30, Army Lieutenant Colonel Marilyn Wills grabbed a shower, got her two daughters out of bed, and jostled her husband, Kirk, for a place at the sink. She pulled on her uniform, packed lunches, hurried the girls to dress and brush their teeth. There wasn't time for her family's daily Bible verse that Tuesday, nor the prayer the four usually said together, nor even to see Portia and Percilla off to school; Wills doled out quick kisses instead, and was out of the house before the sun came up.

In the car she sang along to a gospel song on the CD player, and when it ended, she replayed it and sang it a second time, then a third. "Jesus, build a fence around me every day," she sang. "Lord, I'm asking you to protect me, all along the way." She rolled through the District, swung onto Interstate 395, and crossed the Potomac. On the river's Arlington bank she pulled onto a great lake of asphalt, found a parking space that corresponded with her place in the military food chain, grabbed her knapsack

Lieutenant Colonel Marilyn Wills. (Martin Smith-Rodden photo; used by permission)

and gym bag. She swiped her badge to enter the building, pulled off her army-issue beret, and ducked into a bathroom to check her hair.

As she did, John Yates was on his way into work, and feeling few worries. He was newly remarried, madly in love with his wife, happy. Nothing on the job pressed him. And it was a beautiful morning, a gorgeous morning, balmy and bright under a sky of unbroken blue.

At the same time, Lieutenant Kevin Shaeffer "slugged" to his navy job, catching a lift with a stranger so they could use Interstate 95's carpooling lanes through northern Virginia. Dropped off just outside, he crossed the enormous seat of American military power toward his office.

They were among thousands converging on the Pentagon. Men and women, soldiers and sailors, marines and airmen, civilians and visitors, they filled its parking lots, walked its 17½ miles of hallways, hurried to desks spread throughout 3.7 million square feet of office. They kept coming until twenty-three thousand of them were crowded under one roof.

That's how September 11, 2001, began.

At 9:43 that morning, a hijacked airliner would pancake onto the ground just outside, blow through the Pentagon's two-foot-thick shell, and slide deep into the offices of its first and second floors. But that calam-

ity was two and a half hours off, and inconceivable, when Marilyn Wills stepped into the bathroom. America was not at war. Few workplaces in the world felt as safe as the heavily built and guarded Pentagon. And it was a Tuesday, after all, the most innocuous, the most nondescript day of the workweek, a day given over to routine in offices throughout the country.

An army major was at the mirror, fretting: While changing into her uniform she'd discovered that she had no socks. Wills recalled that she had a spare pair stashed in a drawer. She walked to her second-floor office, a vast room of 130-odd desks ringed by cubicles, dropped off her bags, found the socks, and returned to the bathroom. "Oh girl," the major told her, "you're a lifesaver."

Back at her desk, Wills turned on her computer. She checked her phone messages, then her e-mail, then began to prepare for a twice-monthly meeting at which she'd be making a presentation.

After parking his truck, John Yates stopped at a Pentagon cafeteria for a guilty pleasure—an order of grits with brown sugar—then strode down the Fourth Corridor, one of ten wide halls radiating from the building's middle. The Pentagon is a mammoth doughnut, its five-acre hole encircled by five narrow, concentric rings of offices, labeled alphabetically; the A Ring is the innermost, the E Ring out along the perimeter. A right turn off the Fourth Corridor took Yates into a "cubicle farm" he shared with the men and women minding the army's intricate personnel policies. The second-floor space, just renovated, stretched from the E Ring all the way through the C.

He crossed the room to his desk, passing Marilyn Wills's cubicle on the way, and turned on his computer. It promised to be a busy but unremarkable day, like most. Yates was the security officer for the deputy chief of staff for personnel, and was charged, among other duties, with ensuring that his coworkers had the proper security clearances and kept them up to date. He'd had the job almost nonstop since 1988, when he was an army staff sergeant. After his retirement, he'd returned as a civilian to the same desk, same files, and same routine. Most of it was pleasant: Yates enjoyed conversation, and the job gave him a chance to chat; he liked to move around, too, and most days, the fifty-year-old Florida native covered four or five miles of hallway.

On occasion, of course, it wasn't so nice. Leave a classified document on the copier, and before long Yates's meaty, six-foot-two frame would loom overhead. "Here comes John," his coworkers would joke. "What did we do this time?" Some in the office had taken to calling him the Grim Reaper.

Yates checked his e-mail and went through his telephone messages. He rolled up his shirtsleeves. He pored over a set of briefing slides he'd made for his boss, on the lookout for errors. Busy but unremarkable. A typical Tuesday.

When Kevin Shaeffer had started working at the Pentagon he'd been on crutches, and for weeks after that he was "that young lieutenant with the cane"—not the sort of distinction that the handsome, athletic Naval Academy graduate enjoyed. Now, eighteen months after snapping his thigh bone in a motorcycle wreck, he was finally getting back to normal. His limp melted away a little more each day.

The twenty-nine-year-old lieutenant rode an escalator to the first floor and headed toward the building's outer edge on the Fourth Corridor. Halfway to the E Ring, the wall on his right was broken by a pair of heavy steel doors, seven feet tall. He swiped his ID badge through a card-reader beside them, punched a four-digit code into an adjacent keypad, and heard the electronic lock click open.

The doors were the only way in or out of the Navy Command Center, where sailors monitored world events around the clock, kept track of the navy's 317 ships, sifted through intelligence from the farthest-flung ports and sea lanes. He headed for the men's locker room, traded his shorts, polo shirt, and sandals for polyester khakis, then walked to his desk. Like the army office directly overhead, most of the Command Center was a single room, divided by shoulder-high partitions into four- and five-person cubicles. Shaeffer shared his, near the room's center, with three senior officers, his colleagues in "N513." They were the service's big thinkers, its egg-heads; in the 1990s, N513 had redesigned an armada built for Cold War showdowns into a smaller, smarter, more limber force geared to coastal combat, and Shaeffer helped blueprint the service's continuing evolution.

Shaeffer sat down at his desk and went through his messages. A few feet away, a rectangle of partitions cordoned the watch team, where large-screen televisions hung from the ceiling and sailors watched for breaking news. Nothing seemed to be going on.

His cubemates were seated around him, keyboards clacking, by the time he turned his attention to the *Early Bird,* the Pentagon's daily roundup of military-related stories from newspapers across the United States. He tried to read the handout front to back every morning.

But on this Tuesday, there wasn't much news in the *Early Bird,* and

what little there was failed to grab him. Around the world, it seemed, all was quiet.

Away in the northern Virginia suburbs, Sergeant Major Tony Rose let his toy poodles, Tippy and Butterscotch, into the yard. He was alone that morning, his wife visiting relatives in the Midwest, so he didn't linger; he jumped into the shower, then into uniform, then slugged into the office.

Rose was forty-six, a compact man of five foot six and 160 pounds, an army lifer from the blackwater swamps of coastal North Carolina. He had enlisted his first week out of high school, in June 1972, which made him a rarity—an active-duty soldier whose career dated to the fighting in Vietnam. Rose hadn't seen the war. He'd trained as a paratrooper but had broken his neck and back in an accident, so the army had moved him into supply work, and eventually career counseling. Now he was the service's top career counselor and its top retention NCO, tracking why his colleagues left the service and drumming up incentives for the good ones to stay.

He walked to his desk at the back of the big room and said hello to Master Sergeant John Frazier, with whom he shared a cubicle. They were among the lucky few on the personnel staff whose desks received any natural light; a few feet away, a row of windows overlooked a service road between the Pentagon's B and C rings.

Career counselors had to undergo schooling at a big conference each November, and that Tuesday Rose was preoccupied with the 2001 event; by day's end, he hoped to close a million-dollar deal with the headquarters hotel. He checked his e-mail and phone messages, then he and Frazier walked to the Pentagon's main cafeteria, notepads in hand, to drink coffee and chart out the day.

At 8:10, about the time they started back to the big room, American Airlines Flight 77 lifted off from a runway at Washington Dulles International Airport, bound for Los Angeles. It was a big machine, more than fifty yards long, its wings equal in area to the floor space of a three-bedroom suburban house. Empty, it weighed as much as a diesel locomotive.

In addition to the fuel in its belly, and the luggage and U.S. mail in its holds, the plane carried two pilots, four flight attendants, and fifty-three passengers. And five men planning mass murder.

Out in the field, lieutenant colonels like Marilyn Wills commanded the army's battalions. In the cubicle farm, a lieutenant colonel commanded

roughly forty-two square feet of carpet. Wills had spent nearly half of her life in uniform: The coming May, when she would be forty-one, she'd have twenty years in, the bulk of it in law enforcement. She'd risen through the officer ranks with military police units in Alabama, Louisiana, and at Hampton's Fort Monroe, on deployment in Honduras, commanding an MP company in Germany. She'd served as force protection officer for Bill Clinton's second inauguration, and as provost marshal at Fort Myer, the army post adjoining Arlington National Cemetery. She'd spent four years on the staff at West Point.

But no fieldwork adequately prepared an officer for duty at the Pentagon, where the hours were long, the workload heavy. Wills's job was especially frenetic in September, as the federal government's fiscal year neared its end: She was a congressional affairs contact officer, responsible for keeping the boss, Lieutenant General Timothy J. Maude, apprised of army business on Capitol Hill, and answering congressional queries about army personnel policy.

She shared the duty, and her cubicle, with a civilian, Marian Serva, who'd trained Wills when she arrived in 1999 and had since become her friend. Serva had a teenage daughter and knew the trials a mother faced in raising girls. That morning they chatted as the lieutenant colonel organized papers for her upcoming presentation. Across the room, John Yates printed the briefing slides off his computer, then photocopied the prints so that his boss could distribute them at the same meeting.

By that time, Colonel Phil McNair, usually the first into the office and the last to leave, had been working for nearly three hours. McNair was Lieutenant General Maude's executive officer, and as such, the personnel staff's hub; the forty-seven-year-old Texas native was responsible for farming out Maude's directives and keeping him up on news from around the office, the building, and the service. He also was a gatekeeper, his desk positioned at the general's door, across the E Ring corridor from the big room; no one saw Maude without seeing McNair first.

He'd arrived at the Pentagon at 5:30 AM, turned on the lights, flipped on the coffee machine, checked his e-mail and the general's calendar. He'd seen that the boss had a 9 AM meeting for eight planned for a small conference room in his suite. Only six chairs were positioned around the room's table, so McNair had dragged in another two and shoehorned them into the corners.

At 7:30 he'd crossed the E Ring corridor and stepped into another conference room—this one much larger, with a table that sat twenty—for his

weekly colonels' meeting, a forum for cross-pollination among the per-
sonnel staff's branches. Most officers in the room had far more experience
at the Pentagon: McNair had managed to avoid the building for all but the
last three months of a twenty-five-year career. He'd served instead on the
West Coast and in Korea and El Paso. He'd spent five and a half years in
Hawaii—his wife and two kids had liked that—and commanded a new
battalion of personnel specialists in Kentucky.

His arrival had coincided with the staff's move into its new space.
Four-fifths of the Pentagon was a dingy fossil of World War II–era plumb-
ing and wiring, asbestos-lined walls, cramped work spaces, worn furni-
ture. But as part of the building's first real makeover, one-fifth had been
stripped to its concrete bones and rebuilt, and it was in this "new wedge"
that McNair and company now worked.

When the agency had moved into the cubicle farm in late June, a lot
of its people had worried the new arrangement would be noisy, and that
so big a space would be impersonal, soulless; "Dilbertsville," some called
it. It had turned out to be remarkably quiet, its conversations muffled by
partitions, springy carpet, and a ceiling of acoustic tiles suspended eight
feet, four inches off the floor. And it was certainly safer than the rest of the
Pentagon: The wedge's skin of limestone, brick, and concrete had been re-
inforced with a lattice of steel, and girded with sheets of Kevlar, the woven
material from which bulletproof vests are made. The windows were steel-
framed, weighed close to a ton, and were said to be blast-proof.

The colonels' meeting broke up. Phil McNair returned to his office.
Major Kip Taylor, the general's military assistant, mentioned that he
planned to run some errands down on the Pentagon's concourse of shops
and snack bars. Hold on, McNair said. He had a pile of dirty shirts in the
bottom of his wall locker. Would the major mind dropping them by the
dry cleaner? No problem, Taylor replied. McNair grabbed a wad of light-
green shirts and handed them over. A visiting general dropped by. McNair
chatted with him for a few minutes, then hurried to answer some e-mail
before his next meeting.

Back across the E Ring, Marilyn Wills rehearsed her presentation as
Serva listened. When she finished, she asked whether she'd forgotten any-
thing. No, Serva assured her, I think you covered it all. Wills stacked the
papers she'd take with her, then phoned home to ensure that the kids were
off to school.

A floor below her, Kevin Shaeffer left an uneventful morning meeting
and sat back down at a desk decorated with pictures of his wife, Blanca.

They'd met at Annapolis, where she'd trailed him by a year, and it some-times seemed she had stepped into his life straight from a beer commer-cial. She was olive-skinned and brown-eyed, and adventurous, and crazy for motorcycles and golf. She was smarter than he was, too. While he'd zigzagged around the Pacific on cruisers and destroyers, Blanca had blazed through a navy master's program in engineering. They'd been married for almost six years.

As he trolled through his e-mail, Shaeffer noticed a buzz of voices out-side the cubicle, and heard the volume turned up on a television. He stood and peered over the partition around his desk to the watch section, whose sailors were scrambling to start VCRs, shouting times to each other, obvi-ously responding to crisis. On the big monitors over their heads were im-ages of the World Trade Center. Thick black smoke gushed from one of the towers.

It was 8:55 AM.

Wills stepped into the empty conference room, arranged her papers and calendar at her place at the table, and noticed the room was freezing. She strode back to her cubicle. "Quick meeting," Serva said.

"I wish," Wills replied. "It's freezing in there." She grabbed an army-issue black wool cardigan from the back of her chair.

At nine o'clock, when McNair and his assistant arrived for the meet-ing, ten people waited in the conference room, eight of them around the long table and another couple—guests from outside agencies—along the wall. Everyone stood. "Have a seat," the colonel told them. He took his place at the table's head and nodded to the major on his left; briefings typi-cally moved clockwise around the table.

Out in the big room, Serva turned on the small TV that she and Wills used to monitor action on Capitol Hill. Her neighbors, overhearing talk of a plane crash, began to wander over. Soon a half-dozen people were crowded around the set.

Downstairs, all thirty people in the Navy Command Center's main room were watching the monitors, and a small crowd had formed in the aisle outside Shaeffer's cubicle. A whispered question—Think it's an ac-cident?—came and went, came again. Surely it was possible, on a morning with unlimited visibility, to miss one skinny building in all that sky.

Then, on the screens, a dot appeared to the right of the towers. It crossed the sky over Manhattan, disappeared behind one of the buildings.

The picture bloomed orange. Everyone in the Command Center gasped as if punched in the stomach. Shaeffer looked at his watch. It was 9:03.

Betty Maxfield was headed into the big room upstairs right about then. She had heard that a plane had crashed into the World Trade Center, but assumed it was an accident and had put it out of her mind; her thoughts were on a new brochure she was putting together that profiled the army's ranks.

Maxfield was the service's demographer. From her office on the Pentagon's far side she tracked the effectiveness of army advertising, monitored soldiers' morale, consulted databases to answer questions from the brass: Are we promoting people according to any bias? Does pregnancy affect readiness? Are soldiers of all races, sexes, and faiths afforded equal access to training?

It was exciting work for a woman who saw patterns and trends where others saw ledger columns, the kind of work she'd found at the Peace Corps, the National Academy of Sciences, and the Defense Manpower Data Center before she'd joined the army staff. She was among the best-educated people in the new wedge that morning: She held a doctorate in educational statistics, which made the fifty-eight-year-old New Yorker "Doc Maxfield" to her colleagues.

She had two appointments in the cubicle farm. She first met with a lieutenant colonel about a detail of the army's recruiting policy, then made her way to Tracy Webb, who managed benefits for civilian personnel; Maxfield had recently returned from a leave to attend the National War College, and wanted to ensure that all her papers were in order. Webb's cubicle was within earshot of the people gathered around Marian Serva's TV. Even so, New York never came up. Their conversation revolved around Maxfield's personnel file.

And a scarf: Webb was an Avon representative, and Maxfield had ordered a scarf from her only to find, on receiving it, that it didn't appeal. Now Maxfield asked whether she could return it. She held her checkbook and a government-issue ballpoint pen at the ready, in case Webb said no.

"Absolutely," Webb told her.

In the conference room, Phil McNair heard from three officers on the table's left side, and a civilian who ducked out after his presentation. Next came McNair's assistant, who sat at the table's foot. The colonel turned to Wills. "Marilyn?"

About the same time, a sergeant called Tony Rose and John Frazier to an office off the big room, where some fifteen soldiers were gathered silently around a TV. Somebody walked over to John Yates's desk, too, told him, "Hey, John, you gotta see what's going on in New York." Yates

strolled the roughly forty-five feet to Serva's cubicle, and was astounded by the horror unfolding on the screen. After a few minutes he returned to his desk and called his wife, Ellen. She hadn't seen the New York attacks but knew of them. "Honey," she said, attempting a joke despite the quaver in her voice, "would you please, for the rest of the day, conduct business from under your desk?"

Yates chuckled. "Yeah, honey," he said, "I will." He hung up and walked back to Serva's cubicle. It was 9:35.

Kevin Shaeffer returned to his cubicle, where he and his three neighbors spent a few minutes discussing what they'd seen. They were all having trouble digesting it, were awed by its scale and violence. They wondered aloud how many people worked in those buildings, whether they were still straggling in when the planes hit. What time did New Yorkers turn up in their offices? What was it like inside those towers right now?

Shaeffer wished he could call Blanca. She worked down the Potomac in Dahlgren, at the Naval Surface Warfare Center, but that morning she was on the road, up in Massachusetts, and he didn't know how to reach her. He tried to return to work but couldn't keep his mind on it, and after a few minutes stood up at his desk. He could see one of the large-screen monitors, tuned to CNN, over the partitions. He couldn't look away.

This is an attack, he thought, feeling his anger build. An attack on American soil. He heard somebody outside the cubicle say: "This is war."

Upstairs, Betty Maxfield rose from her chair beside Tracy Webb's desk. "Well, see you later," she said. John Yates, numbed by the TV, turned to leave Marian Serva's cubicle. At the back of the big room, Tony Rose said to Master Sergeant Frazier, "John, you know, we need to be careful." In the conference room, Marilyn Wills, still in the midst of her presentation, glanced at her watch and thought: "I'm taking too long."

At that instant came a terrible sound.

II

That Tuesday had started, as most weekdays did, with Army Staff Sergeant Chris Braman rising long before his wife and three daughters, gulping down coffee and vitamins, and driving in from Springfield as the sun came up. He'd been the first person to arrive at the 45-seat restaurant that served the army's top brass. He'd loaded the coffeemaker, turned on the stoves, and waited for the cooks to arrive to precook the morning sides, start the soups, and cater a twice-weekly prayer breakfast.

The kitchen had needed a few last-minute ingredients for the day's

lunch, so once the breakfast was under way, Braman drove an army van to the commissary at nearby Fort Myer, singing along to a country station on the radio. He'd shopped for an hour, then pulled into the Pentagon's Remote Delivery Facility, where incoming packages are examined. There he'd transferred his groceries to a flatbed golf cart, driven them through a maze of hallways to a service elevator, and ridden it to the third floor.

As the time neared 9:30 AM, Braman had put away his purchases and left his receipt with an accountant. He'd poured himself a bowl of Shredded Wheat, made a peanut-butter-and-jelly sandwich, and carried his breakfast to his desk, which was wedged in a narrow room lined with fridges and food lockers. Now Braman ate in front of his computer, logging his purchases into the kitchen inventory between bites. He was joined by his boss, who was carrying his own bowl of cereal. While they talked, Braman noticed that there seemed to be a lot of people hurrying past the open door, but he didn't think much of it. The mess's steward, its top man, walked in. "Hey, Bud," he said, "did you hear what's going on in New York?"

No, Braman said. Look at the CNN Web site, the steward told him. The sergeant jumped onto the Internet and tried to call up the site, but after close to a minute it failed to load. Yeah, the steward said, mine's doing the same thing.

Just then the phone rang. It was Braman's wife, Samaria. "Do you know what's happened in New York?" she asked him. He detected a tremor in her voice.

"No, sweetheart," he replied. "What happened?"

Two airplanes hit the World Trade Center, she said. The kids had a videotape on; she'd only learned about the disaster when Braman's father had called a few minutes before. He'd told her that Chris could be hit next.

"Don't worry about this," Braman told her. "I love you. Don't worry."

As he hung up, the building jerked under his feet. Braman was pitched forward into a wooden liquor cabinet, and a moment later the lights went out and a sergeant burst from another office into the hall. "There's a bomb!" she screamed. "A bomb! Oh my God!" The floor rolled. To Braman, who grew up outside Los Angeles, it felt just like an earthquake.

One floor down and two hundred feet clockwise around the mammoth Pentagon doughnut, in the big room of cubicles, the moment felt significantly different. A Boeing 757–200 airliner, laden with jet fuel, throttle open wide, had torn into the new wedge.

Security officer John Yates was picked up and hurled thirty feet. Sergeant Major Tony Rose, punched into a ceiling column, watched as the glass in

the C Ring windows spidered into tiny cubes. The sound erupted a heart-beat later, a monstrous boom and crunch like a thousand file cabinets top-pling at once. To demographer Betty Maxfield, the room seemed to freeze, intact, for a moment, then in slow motion the computers clicked off and the lights failed and a fireball rolled through the cubicle farm like a wave, with bulbous head and tapered tail, and as it passed, everything around it burst into flames. Cabinets overturned, partitions exploded, ceiling tiles burned and danced and fell with their metal frames. The air boiled.

In the conference room, Colonel Phil McNair jumped to his feet, hol-lering, "What the hell was that?" His first thought was of a construction accident—a crane had fallen onto the building, a pipe had burst, some-thing had collapsed. The lights went out, and up near the ceiling at the room's far end, over Marilyn Wills's head, the ceiling tiles lifted and flames rippled out. Wills saw them, too. She curled into a ball in her chair.

Another floor down, in the Navy Command Center, Lieutenant Kevin Shaeffer was sprawled by the shock wave, then watched from the floor as a roiling, bright orange ball of fire shot toward him and everything—cu-bicles, desks, ceiling tiles, the building's concrete support columns—everything blew to pieces. Air turned to flame against his skin, his eyes, in his lungs.

The room went dark. Shaeffer, dazed, prone on the carpet, realized his back and head were on fire. He rolled to put himself out, then staggered to his feet. He ran a hand through his hair. His scalp felt wet. Around him, the Command Center was rubble. Fires burned here and there, and by their light he could see that the watch section had vanished. His own desk, five feet from where he'd been thrown, was gone, too, in its place a mountain of broken metal and masonry, ripped chunks of partition, smashed computer parts. Shaeffer scanned the room. Cubicles, all of the cubicles, were demolished. The ceiling had collapsed. Electrical wires dangled, sparking and hissing. Broken water pipes gushed. "This can't be happening," he said out loud.

He saw none of the twenty-nine others who'd been in the room. From the dark came groans and whimpers, the unconscious sounds of the dying, but those who made them were invisible. "Is anybody here?" Shaeffer hol-lered. "Can anyone hear me?"

No one answered. Thoughts collided in his head: He had to stay alive. He had to see Blanca again. And he had very little time—the air, already reeking of kerosene, was filling with a choking black smoke. He had to move. But where? When the power failed, would the electric locks on the

center's steel doors have frozen open, or shut? He might clamber over the mountains of wreckage blocking the doors only to find them impassible, and by then it might be too late to find another way out. Shaeffer instead set off in the dark toward the building's center, where there was no door at all.

John Yates came to his senses to find that his death was at hand. He could not breathe. He could not see. The room was ablaze around him. The metal furniture jumbled all about was hot enough to raise blisters. He heard screams. He wasn't sure that some weren't his.

His glasses remained on his face. They were smeared with something—unburned jet fuel, which Yates mistook for blood. He carefully took them off, folded them, and slipped them into his shirt pocket, then stumbled toward the big room's interior. In the second-floor conference room, Marilyn Wills found herself slumped beside a door that opened onto the E Ring corridor, the outermost of the Pentagon's five concentric hallways. She had no memory of crossing the room to reach it; she simply materialized there. The left side of her face felt burned. Her bangs were singed. The room, chilly just seconds before, was scorching, and the darkness was absolute. She could see nothing. Phil McNair, at the far end of the table, was trying to calm everyone over the screams of a secretary. "OK, people," the colonel was saying, "we gotta get out of here."

Wills groped for the doorknob, found it, gave it a turn, pulled. The door stayed put. "This won't open," she yelled. "We can't get out this way." She waited for a reply, but none came. In fact, she heard no sound at all. Eleven people had been in the room. Now she seemed to be by herself. She felt a panic rise until it buzzed in her ears. My God, she thought, I'm going to die in here.

It took a moment to force the fear back. No, she thought. You're not going to die. You're going to calm down. She took a deep breath. Smoke was filling the room. She crawled the length of the table, passed Colonel McNair's chair. She encountered no one, heard no one. The heat intensified as she neared the door to the big room. Wills started to tug off her sweater. She'd pulled an arm out when someone grabbed her back and latched onto her belt. "Who is that?" she cried.

Lois Stevens, a civilian who'd been sitting to her left at the meeting, spoke up. "Are you OK?" Wills asked her.

"I'm OK," Stevens said. She sounded remarkably calm.

"Hold onto me," Wills told her. Their faces were inches apart, but Wills could see nothing of her colleague. "OK," Stevens said, tightening her grip on the lieutenant colonel's belt, "I've got you."

Phil McNair was confident that whatever had happened, it had been very near the conference room, and that conditions would be better in the cubicle farm. He could hear others crawling toward the door with him. Get everyone out, he told himself, and they'll be OK.

Once over the threshold he realized he was mistaken. The larger room was black, the air incredibly hot, and smoke—greasy, opaque, laden with the odor of burning plastic and electrical wire—was quickly filling the space. He could hear screams, and fire crackling, and furniture crashing, and the ceiling's continued collapse, and layered atop these sounds were the whoops of the Pentagon's fire alarms, and a recorded voice on the public-address system, its tone eerily calm: "There is an emergency in the building. Please evacuate immediately. There is an emergency in the building. Please evacuate immediately."

Crawling, McNair turned toward the E Ring. The heat grew even fiercer, and as he neared the door to the corridor he saw bright orange through the crack along its bottom. He reversed course, yelling, "We've got to get out the other way."

The other way was via the door to the Fourth Corridor, on the far side of the cubicle farm. He and his people would have to cross it quickly, before the smoke dropped all the way to the floor, or fire devoured the room, or they were caught in a secondary explosion. The big room's partitions created a maze of blind alleys. McNair, like everyone else, was new to the place, and did not know it well. And like everyone else, he couldn't see a thing.

From the floor near his desk, Sergeant Major Tony Rose watched the ceiling's acoustic tiles ripped to powder, saw the metal grid that held them in place fall, the fluorescent lights flutter on their wires. Halfway across the cubicle farm the floor had split open and shoved upwards, and through this opening black smoke barreled in, climbed to the torn ceiling and shot toward the broken windows behind him.

Master Sergeant John Frazier had been blown under his desk by the concussion. Rose yelled at him to help clear the room. The building was laced with gas lines, electric cables, propane tanks. Another explosion seemed only a matter of time.

While Frazier led a file of visibly frightened coworkers to the Fourth Corridor, Rose met up with Lieutenant Colonel Victor M. Correa, a forty-four-year-old personnel analyst. They crawled the length of the aisle along the windows, pointing people they found toward the exit, then split up to explore the lanes that dissected the cube farm.

Wriggling low, staying beneath the smoke, the two checked passages and cubicles for the injured or lost, but found that the farther they pushed into the room's middle, the darker and hotter it got, the thicker the smoke became. Unable to get past the midpoint, they groped their way to the main Fourth Corridor exit.

The hall was filled with smoke, too, and over the whooping alarms Rose and Correa could hear cries for help from the direction of the E Ring. They found a janitor's closet, tore off their T-shirts, soaked them in the closet's sink, and tied them across their noses and mouths. Back in the corridor they crawled toward the voices, only to find their way blocked. The Pentagon's renovated hallways were equipped with metal curtains that sprang from panels hidden in the walls and unfolded along tracks in the ceiling. They were designed to contain smoke and heat, to keep damage from spreading. Unfortunately, like the flood-control doors on a sinking ship, they also pinched shut avenues of escape.

Now, as Rose and Correa crawled nearer the E Ring, a fire door accordioned out of the left wall before them. Correa wedged himself between the closing door and the right wall, and was able to stop its advance. Rose slipped through the gap.

In the first seconds after the fireball flashed past her, Betty Maxfield ran to the E Ring door, saw the glow beneath it, and retreated back to Tracy Webb's desk, just outside the conference room. She heard a male voice yelling that the air was easier to breathe near the floor, dropped to her knees, and froze there, unsure where to turn.

Maxfield was merely a visitor to this part of the Pentagon. She had no feel for its layout, knew of no exits other than that to the E Ring. She was, she realized, helplessly lost. The fire alarms whooped. "There is an emergency in the building," the recorded voice said. "Please evacuate immediately."

By this time, Marilyn Wills had crawled from the conference room, Lois Stevens clinging to her belt. She'd seen the fire's glow beneath the door to the E Ring hall, had turned away from it, and had run into someone in the dark—Major Regina M. Grant, who'd been with them at the meeting. They'd pushed into the cubicle farm to find a large form looming overhead. "Who is that?" Wills yelled.

"John Yates," the figure answered. He was standing upright in the smoke. "Get up," he said, "and come with me."

"No!" Wills screamed. "The smoke's too thick!" Yates strode off, Grant following at a crawl, Wills and Stevens trailing behind. The ceiling sprinklers kicked on, dousing their backs as they moved away from the conference room, and after a minute, they came upon Betty Maxfield, crouched low on the floor.

Maxfield thought she saw the dim shapes of people around her. As one crawled by, she grabbed an ankle—a man's ankle—and held on. It was McNair. He kept crawling, and Maxfield fell in behind him, and as she did, a third person grabbed her ankle, and a ragged daisy chain began snaking its way across the room. People at the head of the file made turns that took them, and those just behind, into dead-end cubicles instead of aisles, and as they regained their bearings someone else took over the lead. Invariably, those now at the front would make a wrong turn, and someone farther back in the line would take over the point, so that it was in a series of slow, frustrating jerks that the column leapfrogged toward the Fourth Corridor.

With each minute that passed, the smoke thickened, until every breath Wills took felt as if it were shredding her throat. She soaked her sweater under a sprinkler, pressed the wet wool into her mouth, sucked in air through the fabric. It was the first clean lungful she'd inhaled since the lights went out.

Soon Lois Stevens stopped. "Colonel Wills," she said, "I can't go on." Wills could make her out dimly in the dark, clawing at her throat. The colonel handed her the sweater, told her to breathe through it, then passed it to others in the line. "You have to keep going," she told Stevens. "Get on my back if you can't go any farther."

The caravan turned down a hallway that those in front thought led to the Fourth Corridor exit. Shouts soon came to those farther back: They couldn't get out that way. With that, Phil McNair decided he was probably going to die. Their escape routes were blocked. The smoke had dropped to within a foot of the floor, and the heat was getting fiercer, and if they didn't get away from both in the next few minutes, they'd be over-whelmed.

McNair had been an administrative officer for his entire army career, and while the job had seen him shipped to some hot spots, it always had been as part of the vast, rear-echelon infrastructure that supports every army deployment; the colonel had spent no time on the front lines. The

same was true for most of the officers in the big room that Tuesday: They were accountants, insurance specialists, logisticians, planners, managers of various stripe.

Still, they were army officers, trained in weapons and tactics and crisis management in addition to their specialties. And this, McNair thought, was a crummy way to die—on the floor of an office, among file cabinets. In paperwork.

Just past the fire door, Tony Rose found a couple of soldiers stumbling blindly in the smoke, screamed at them to get low, pointed them toward safety. Other voices reached him from deeper in the gloom. He crawled

Sergeant Major Tony Rose. (Martin Smith-Rodden photo; used by permission)

past another fire door, which for some reason had failed to deploy, and a little farther on found Tracy Webb standing over Major Regina Grant. Moments before, Grant had heard someone yelling at her to "Come toward the light," and had wound up here, separated from the daisy chain still crawling through the big room.

Someone came up behind Rose—he couldn't make out who it was in the smoke—and led the women out. He pushed on, hollering, "Is anyone here?" He could hear pieces of the Pentagon collapsing around him, and small explosions, yells and screams, and the alarm, that recording: "There is an emergency in the building. Please evacuate immediately." His own shouts were almost lost in the din.

Rose decided he could go no farther. He was flat on his stomach, his nose an inch from the floor. He couldn't breathe, even through his wet T-shirt. As he shouted and struggled to tune his ear to answers, the smoke suddenly darkened. It was getting thicker, Rose thought, then realized, no—a fire door was closing behind him.

A floor below, in the burning ruins of the Navy Command Center, Kevin Shaeffer clawed over tangles of smashed furniture and ceiling tile, broken glass and concrete, vowing silently to see his wife again, yelling at himself as he made for the room's rear: "Keep moving! Keep moving, Kevin!"

He knew he'd been at least singed by the explosion. His face and back hurt, and evidently he had cut his left hand, because he could feel blood running down his arm. He had little time to dwell on these injuries. Breathing was becoming ever more difficult; in addition to the smoke, the air was damp with vaporized jet fuel, unburned and caustic, and each breath he drew seared his lungs. And Shaeffer found his path all but blocked by a spastically jerking curtain of severed, but live, electrical cables. The sparking ends hung within a couple feet of the piled debris on which the lieutenant scrambled. Beside them, a thick tongue of water poured from a ruptured main.

On the Pentagon's third floor, a chef dashed into Staff Sergeant Chris Braman's office, eyes wide, asking: What do we do? Braman ran past the man into the kitchen, which still had lights, and shut off the stoves. The hall was crowded with people running and shouting and ordering evacuation. In the time it took Braman to lock the kitchen door, they were gone. He was alone.

He walked the empty halls and stairs and kicked open an emergency door on the Pentagon's northeast side. A crowd had gathered at the Remote Delivery Facility, where little more than an hour before he'd been unload-

ing groceries. All eyes seemed to be on something beyond his view, around the Pentagon's curving perimeter. Braman started toward the throng. On the way he encountered a Pentagon police officer trying to carry a wounded soldier and a baby. The cook took the baby, whose hair had been singed, and who didn't make a sound on the sixty-five-yard walk to a first-aid station.

It was there that Braman got his first glimpse of the new wedge's outer wall. Flames shot from the windows and a large, irregular hole in the limestone. Smoke erupted in plumes that folded over themselves, curled into tubes, swirled into dirty brown twisters. Braman handed off the baby and without thinking, ran for the breach.

As he neared it he saw four men half-walking, half-carrying an injured woman to an ambulance that had stopped on a nearby road. He recognized her as a finance officer who'd helped him with some papers during the summer. Her clothes had been blown off. She was a dark-complected black woman, but the back of her body, from head to calves, was a bright, wet pink.

The four dropped the woman off and headed back for others. Braman followed. They crossed a debris-littered helipad and a lawn charred and crunchy underfoot, passed a fire engine, minivan, and sports car veiled in flame. The hiss and rumble of the fire grew. He could hear metal bending, concrete splintering. Screams. Glancing to an upper floor, he saw a dead man in a window, still holding a coffee cup.

Staff Sergeant Braman was not a typical cook, in the army or out. He stood five foot nine, but had twenty-inch biceps, and at thirty-three, could crank out pushups until he lost count. He'd scored a perfect three hundred in his army physical fitness tests. The elite Rangers had stolen him from the kitchen of his regular army unit in 1996. They put him through jump school at Fort Benning, taught him combat search and rescue, made him a scuba diver. Before he was assigned to the Pentagon, in August 2000, he had spent an average of 218 nights a year away from home, often on missions so secret he couldn't tell his wife where he'd been.

Now he recognized where he was. The sounds, the smells, the sights, were those of a battle.

Braman reached inside his uniform, tore off his T-shirt, tied it around his face, and followed the others into the building.

III

Ten minutes after impact, a large section of the building was in shreds. Fires raged along the path the airliner had cored through the first floor.

Dozens of concrete columns had been vaporized, leaving the four floors above without support and doomed to collapse. The wreckage was strewn with the dead and dying.

In the Navy Command Center, Shaeffer bellied under a drapery of hanging wires, their popping and hissing loud in his ears. He was so confident he would be electrocuted that he was baffled when he realized he was past them. He lurched down a pile of wreckage and saw that the smoke before him seemed backlit, and that it brightened further as he passed through a hole in the Command Center's back wall, into a room he'd never seen before, filled with overturned desks and smashed computers. He climbed over the desks and through another hole, and into the golden sunshine of a clear September morning.

Shaeffer stood on a service road that circled the Pentagon between the B and C rings. A chunk of the 757's nose cone and front landing gear lay on the pavement a few feet away, resting against the B Ring wall. For a second it seemed he had left his body and was watching the scene from above: He saw himself stagger from the smoke and over the broken rock piled outside the opening, arms outstretched, eyes shut and mouth agape in pain and shock and horror. Just like that little girl in Vietnam, after the napalm attack, he thought. I look just like her.

A pair of navy men were the first to reach him. Yeoman Cean Whitmarsh was stunned that the lieutenant was still on his feet. His hair had been burned off. His polyester khakis were melted onto his skin. His flesh was charred black and bleeding and melted. And he was on fire: Flames licked up his left side. "I need help," Shaeffer cried. "Please help me. I'm hurt."

Whitmarsh tore off his own shirt and used it to smother the fire, and noticed something else: A two-foot piece of metal ceiling frame was wrapped around the lieutenant. One jagged end had been driven against his lower back; the rest of the rod curled across his back and over his right shoulder. It was too hot to touch.

He and an officer tried pulling it off, without success, then held Shaeffer down and pried it away with a penknife while Shaeffer cursed and struggled. His skin sloughed off in pieces bigger than playing cards.

On the second floor, Betty Maxfield, clutching the ankle of the man in front of her, her own leg held by someone behind, had dropped to her stomach, and still she couldn't get below the smoke, couldn't breathe.

Over the crashes of falling ductwork and ceiling tile, the crackle of fire, the whoop-whoop-whoop of the fire alarm, Maxfield heard a voice say, "We've got to try to get to the windows," and the caravan turned to the room's rear.

A row of windows there overlooked the service road. A rectangle of light appeared in the smoke, dim and indistinct. From ahead of Maxfield in the line, Army Colonel Phil McNair could see the silhouette of a man sitting on the sill; from behind, Lieutenant Colonel Marilyn Wills could make out the shadowy form of Specialist Michael W. Petrovich kicking at the rectangle's edges.

Petrovich had found a window torn from its moorings, and was trying to widen the gap between the frame and the building. Luckless, he jumped to the floor, grabbed a heavy computer printer, and tossed it at the glass. It bounced off, landing in Wills's lap. He retrieved it and threw it a second time. Again, it bounced.

We're not going to get out, Wills thought. We're going to die here. We've crawled clear across the room, through hell, and we're going to die anyway. She was a woman of strong Christian faith, but now felt anger well up, anger at God. You can't do this, she thought. No way. Come *on.*

McNair got to his feet and joined Petrovich on the sill, and together they kicked at the frame. Wills joined in, pushing. A gap of little more than a foot opened. Wills tapped Lois Stevens, who'd crossed the room holding onto her belt. You're first, she said.

"Stand up," Petrovich hollered. "Sit on the ledge. Do it quickly."

Stevens clambered onto the windowsill and dangled her legs outside. McNair and Petrovich held her hands as she slipped over the edge and through the opening. When she'd cleared the window frame, they let go. "Next!" Petrovich yelled. Betty Maxfield stepped onto a chair that had been shoved under the window, swung onto the sill, and squeezed outside. Smoke swirled around her. Through it, she could see that she was twenty feet off the road below, which was littered with broken concrete and other debris. It did not scare her in the least; she felt nothing but relief to have escaped the smoke. She let go, and was half-caught by soldiers and sailors on the ground. She was still wearing one-inch heels as she retreated to the B Ring. She still clutched her checkbook.

Up at the window, Petrovich yelled to McNair that he couldn't breathe. "OK, you go," the colonel told him, and with Wills's help, lowered the soldier over the side. Wills jumped onto the sill to take Petrovich's place, and helped a couple of others escape. Peering through the smoke for the next

in line, she was surprised to find no one there. Major Regina Grant, a link in the daisy chain for part of its crawl across the room, had broken away and found rescue in the Fourth Corridor, but Wills didn't know that.

"OK, Marilyn," McNair hollered, "you can go."

"Sir," Wills yelled back, "Regina was with us, and now I can't find her."

"What?" McNair said. They could barely see each other in the smoke. The alarms continued to whoop, the recorded message to intone: "There is an emergency in the building. Please evacuate immediately."

"Regina," Wills shouted. "She was here, and now she's gone." I'll have to tell Grant's husband, she thought. How can I do that? How *do* I do that? She was pondering this when McNair wordlessly turned back into the smoke. "Colonel McNair!" Wills screamed. "Don't go!"

Too late. He'd vanished. Long seconds passed, and Wills, shouting his name between coughs, wondered whether she'd lost him, too. Suddenly, he was back beside her. The smoke had dropped all the way to the floor. It was impenetrable. "Marilyn, it's no good," he said. "We have to get out of here."

"What about Marian?" she screamed. Marian Serva, her partner, the office's other congressional liaison. McNair could see that Wills was crying. "There's nothing we can do," he shouted.

"Let's try yelling together," she suggested, and they screamed a few times into the smoke. They got no response. No more yells drifted from the room's hot, dark center. No cries for help. "Now," the colonel told her. "It's time for you to go."

When she jumped, Navy Commander Craig Powell, a SEAL commando who'd just reported to the Pentagon the day before, was waiting. He caught her clean. Wills never even touched the ground.

John Yates had been part of the team planning the Pentagon's renovation for eight years. At times, the project had become all-consuming; he even dreamed about it once while vacationing in Aruba. He knew the floor plan of the made-over wedge, and the personnel space in particular, better than he knew his own house.

Now he crawled headfirst into a wall and knew that he had reached the hallway linking the big room to the Fourth Corridor. As he moved away from the cubicle farm he felt the cool water of sprinklers on his back, and could make out dim shapes in the lightening smoke. The door to the corridor had been blown off its hinges. He turned into the thoroughfare, col-

lapsed, lay on the floor for what might have been ten seconds, might have been several minutes. Then he stood up and walked down the corridor toward the building's middle.

Lieutenant Colonel Victor Correa appeared in the smoke. Are you all right? he asked. Yates replied that no, he wasn't. His body was smoking, and he radiated heat: Correa could feel it from three feet away.

Nearer the E Ring, Sergeant Major Tony Rose crawled past a closing fire door with so little time to spare that the metal barrier snagged his foot. He jerked it out of the way and crawled on to a second fire door, squeezing past just before it, too, locked shut.

An enclosed bridge carried the Fourth Corridor over the roadway between the B and C rings. Rose paused to look down on soldiers and sailors gathered around a pair of large holes in the C Ring wall. He saw his colleagues from the big room jumping from the window. He ran downstairs and joined McNair, who'd just escaped, outside one of the holes. Smoke billowed from the darkness, and from within it they heard pleas for help.

Rose started in, found his path blocked by debris, grabbed chunks of concrete and broken furniture and passed it to a man behind him, who passed it down a quickly forming line. A pile grew in the road. Some of the pieces were so hot that Rose needed to douse them with a fire extinguisher before he could touch them.

After a minute he saw a hand jutting from the wreckage, fingers splayed. He grabbed it, and the fingers closed tight around his. He dug out a sailor, the first of seven he and McNair and their compatriots rescued.

The fire in the Navy Command Center raced toward them. It got so hot in the hole that the man at the head of the line couldn't last more than a minute, would have to retreat to the roadway and roll around in puddles to cool his skin. The second in line would step forward, claw at the wreckage for a minute, retreat. The ceiling sagged at one point, and seemed sure to fall; Craig Powell, the big Navy SEAL who'd caught Marilyn Wills, held it up while the others crawled between his legs.

Not far away, Army Sergeant First Class Donald S. "Steve" Workman found Kevin Shaeffer sitting in the roadway, holding his arms straight out before him, his melted skin dangling like the fringe on a leather jacket. Shaeffer noticed his approach. "Please don't let me die," he cried. Workman commandeered a flatbed golf cart, lay Shaeffer on the back, and ordered the driver to take them to a clinic on the Pentagon's east side. Shaeffer could feel his adrenaline ebbing, and rising in its place came a pain so fierce his breath caught. He was hurt bad, he thought, really bad. Maybe

disfigured. "How's my face?" he asked Workman. "What's my face look like?"

"You're going to be OK," the sergeant replied, but he turned frantic when they found the clinic all but deserted. As they waited for help, Shaeffer's eyes turned glassy, and his speech slowed. He was slipping into shock. Workman elevated his feet and kept him talking. He asked about Shaeffer's wife. Blanca was out of town, Shaeffer told him, and recited her cell-phone number. The sergeant asked him what he liked to do. Golf, Shaeffer said. He loved to golf. Some days he and a friend would hit a course at 5:30 AM, try to get in nine holes before reporting to work.

Medics arrived to start an IV in Shaeffer's arm. The usual spots had been cooked, but when they worked up the nerve to try for a vein, they did it well, on the first stick. The medicine did nothing to dull the pain, however, and soon Shaeffer started screaming that he'd had enough of the place, that nobody was in charge, that for God's sake he needed a doctor.

Workman wheeled him outside as ambulances wailed their way to the building. A doctor intercepted them, telling Workman that no one could be loaded aboard without first reporting to a triage station. Forget it, the sergeant replied. The man's badly burned, anyone can see that. He needs to get to a hospital, and we're not waiting. So medics loaded Shaeffer aboard, Workman climbed in beside him, and a minute later they were speeding into the traffic-clogged streets around the Pentagon, horn blaring, jumping curbs, suddenly screeching to stops. They hit another vehicle. They didn't stop.

The doors popped open at Walter Reed Army Medical Center. Doctors cut off the melted remains of Shaeffer's khaki shirt, inserted a catheter. He overheard a nurse assessing his injuries. He had burns on about half of his body, and a fifty-fifty chance of survival. He grabbed her arm. "You don't understand," he croaked. "I made it. I'm alive."

They were working on his hands. He heard a doctor call for ring-cutters. Shaeffer stopped him, grabbed his wedding band with the charred, swollen fingers of his right hand, and ripped it off. He gripped his chunky Naval Academy ring with his equally wounded left hand and pulled it from his melted flesh. He gently placed both rings in the doctor's hand. "OK," he said, "do what you will." Then he passed out.

John Yates lay on his back in the Pentagon's center courtyard, staring at the sky. It was bright blue, an almost mockingly cheerful shade, except where

a heavy black smear drifted eastward from the fires burning in the new wedge. The sunshine was uncomfortably warm against his skin. He could see he was hurt. Burned skin hung off his hands. His left thumb looked as if it had exploded; the nail appeared to be barely attached to the digit's swollen tip. His skin was stark white; he'd later learn that bystanders wondered why he was wearing surgical gloves.

Just how badly he was injured began to sink in when he overheard a doctor speaking with the medic cutting his clothes away. "He's the first to go," the doctor said. "He needs to get out of here, now." Even so, Yates was calm. The courtyard's quiet was welcome respite from the insanity inside. When rescuers sat a woman he knew on the grass beside him, and she couldn't stop coughing, he leaned toward her and told her: "Hang in there. You'll be all right."

After a while, though, a Pentagon policeman ran into the courtyard. "We have to get these people out of here," he told the medics. "There's another plane headed this way." Yates had assumed a bomb had gone off near his office. Now he felt terror wash over him. He had been through hell. He'd been critically injured. Now he might have to do it again.

In the service road, Phil McNair and Tony Rose were still burrowing for survivors in the wreckage of the Navy Command Center when a police officer yelled into the hole. "You guys gotta get out of there," he told them. "Another one's inbound."

"Another what?" McNair asked, looking back at him. Police and firefighters were silhouetted in the cave's mouth. Glass rained on them from the upper floors, twinkling in the sunshine as it fell. The cop looked askance at him. "Another plane."

The diggers withdrew from the hole, fire following them out, McNair trying to process the information. A plane had hit the Pentagon? He stumbled over the broken concrete in the road, exhausted and confused, and decided he had better organize a retreat. "Let's go!" he shouted. "This way!" A cop stopped him. No, he said, that's not the way. He turned McNair around, and the colonel saw that everyone else was already running along the service road in the opposite direction. Dazed, he followed them into the B Ring, and kept walking until he stepped into the center courtyard.

It was eerily quiet. Among the trees was a tight cluster of people tending to a couple of the injured, and as he passed he heard somebody say to a man on the ground, "What's your name, sir?"

"John Yates," the man replied.

McNair immediately veered that way. The wounded man was shirtless, his skin blackened, his hair burned off, his scalp a patchwork of raw meat and soot. He looked nothing like the John Yates whom McNair knew, but the colonel bent down to offer a word of encouragement, made eye contact through his own smudged and scorched glasses, reached for the man's hand. Yates screamed as they touched.

McNair realized he was becoming more a hindrance than a help to anyone. He hurried across the courtyard, through the building, and wandered the perimeter until he could see the new wedge. Its limestone facade was charred. Black smoke spiraled skyward. Flames leaped from the E Ring windows, from the very suite where McNair worked.

His boss, Lieutenant General Maude, was in there somewhere. And Kip Taylor, who a little while before had agreed to haul McNair's dirty shirts to the cleaners. And other officers and secretaries whose desks had ringed his. They'd all been working a few feet from the point where the airliner's nose smacked into the building. They'd have had no chance. The same could be said, McNair realized, about a lot of people.

Outside the new wedge, Staff Sergeant Chris Braman and another rescuer, an army lieutenant colonel, clambered through a broken first-floor window and into the E Ring's fiery wreckage. Just inside, Braman saw a bright light, and turning, discovered that it was a man engulfed in flames. The man sprinted for an unbroken window, bounced off the glass, and flopped to the floor. Braman and the colonel pounced on him, smothered the fire with their bodies, then threw him to rescuers outside.

They struck toward the blackened hole where the plane had smashed through the Pentagon's outer wall. Braman's eyes stung, and even with his T-shirt lashed around his face, it hurt to breathe; he felt as if he had an advanced case of strep throat. After a minute the heat nearly overpowered them, and they retreated back out the window. People were jumping from offices on the second floor. The pair helped catch a few before the limestone around a first-floor window broke away, creating a door, and they started back in. A general in an unmussed uniform tried to stop them, but they pushed past the senior officer and into the smoke.

They could hear screams. "Follow my voice!" Braman shouted. "If you can hear me, follow my voice!" He tried to crouch below the smoke, but the way ahead remained aswirl in black, forcing him to shuffle, arms outstretched, groping.

Close by he heard choking, then the sound of someone clapping, and he lunged forward. His hand fell on an arm. Something about it felt loose

in his grip—whether it was melted skin or melted clothing, he couldn't tell—but he yanked the person close and ran out the makeshift door. It was a slender black woman, dark gray with ash. Her arms were curled into the "pugilistic position," as if she were shielding herself from blows, a common phenomenon among the victims of fire. Her hands appeared to be mummified. He ran her to medics. He was headed back in, perhaps one hundred yards from the building, when the place he'd just been disappeared: The Pentagon's new wedge collapsed, its upper four floors slumping into the gutted first.

That moment, thirty-five minutes after the crash, probably killed anyone still trapped inside, but Braman sought another way in. As he ran counterclockwise around the building, he passed a police officer escorting a civilian contractor covered in ash, shirt bloodied, left eye dangling from its socket. A little farther on he ran into the same general who'd earlier ordered rescuers away. This time he herded them into a crowd that was being pushed through a pedestrian tunnel under Interstate 395. Braman broke away and skirted the interstate to a secondary road, then followed it up the building's west side.

But by then, explosions were rocking the Pentagon, and rescuers were not allowed to get closer than two hundred yards. Braman and about a hundred others watched the new wedge burn from a highway underpass. The lawn was littered with twisted pieces of aluminum. He saw one chunk painted with the letter "A," another with a "C." It didn't occur to him what the letters signified until a man in the crowd stooped to pick up one of the smaller metal shards. He examined it for a moment, then announced: "This was a jet."

Chased from the C Ring, Tony Rose helped evacuate the wounded to the parking lot north of the Pentagon. With a second strike still a fear, he returned to the building to fetch first-aid supplies for the triage stations in the lot. He noticed the stations were without water, too, so he ran back inside with a fire ax, and broke open soda machines to get it.

After that, Rose helped organize forty people into teams for a last-gasp search for survivors. They tied shirts around their faces and reentered what remained of the new wedge, taking pains to split up; if a second plane hit, they reasoned, one team might need the other to pull it out.

Later still, Rose returned to the roadway between the B and C rings, where he presented himself to FBI agents. They asked him to help bag the body parts already scattered about, and which now washed from the Navy Command Center on the streams created by broken water mains. At one

point, Rose saw a severed foot and ankle lying beneath a piece of purple fabric. When he reached for the cloth to move it out of the way, he discovered that it contained a leg. So much water poured into the road that Rose and others positioned themselves in front of the storm drains, to keep body parts from sweeping away. He saw organs, in addition to limbs, and wondered whose they were.

Did they belong to victims on the ground? To one of the plane's six crew members, or fifty-three legitimate passengers? Or did they belong to the men who caused this carnage?

Those picking through the ruins could not tell.

<div align="center">IV</div>

At lunchtime, John Yates's wife, Ellen, got a telephone call at her office. She knew by then that the Pentagon had been hit, but not that Yates had been injured; like many Pentagon spouses, she had only a vague idea of where in the building he worked. The caller identified himself as a chaplain. "I want you to know that I've been praying with your husband," he said.

"Yes?"

"Yes," the man said. "I've prayed with John."

Ellen Yates felt a stab of fear. "Is he alive?"

"He's being taken care of," the man said.

"Is he hurt?"

"Well, yes, ma'am. He is."

"Where is he?"

They were putting him in an ambulance, the chaplain replied. "Someone will probably get ahold of you later," he added.

She hung up. John had a history of bad knees. Perhaps he'd simply blown one out. That hope lasted until the next call came, ninety minutes later, this one from an intensive-care nurse at Arlington Hospital who reported that John was undergoing treatment. "What's happened to him?" Ellen asked.

"We're doing an assessment now," the nurse told her.

"What are you assessing?" Ellen asked.

"Well," the nurse said, "he has burns."

Ellen Yates arrived at her husband's bedside to discover this to be an understatement. Yates had second- and third-degree burns over 38 percent of his body—on his face, his ears, his neck, on the top of his head, across his entire back, on parts of his buttocks and left leg. Second-degree burns

destroy cells not only in the outermost layer of the skin, but the deeper layer of flesh in which sweat glands, hair follicles and nerve endings reside. Third-degree burns penetrate to the fat and muscle beneath.

He had swollen to twice his normal size. His head, swaddled in bandage, was as big as a basketball. His lips were gargantuan. He spoke in an unpunctuated burst that lasted hours while his wife sat next to the bed, struggling to keep the fear she felt from showing on her face, staring at the misshapen creature before her, thinking: "Who are you?"

Elsewhere in the hospital, Navy Lieutenant Kevin Shaeffer suffered with third-degree burns on his hands and arms, and second- and third-degree burns on his face, head, and back. His injuries covered 42 percent of his body. His hair was burned off. His lungs had been seared by atomized jet fuel. That night, doctors sliced the scarred, inelastic skin of his arms, lest they rip open as he swelled.

Colonel Phil McNair was hospitalized until the poisonous carbon monoxide in his blood dissipated. It took seven hours. Betty Maxfield was driven to an urgent-care center, where she sat, her linen suit soaked and reeking of jet fuel, as young people paraded past her to donate their blood. Bandaged, her burns salved, she was sent home and sat in her robe as her husband returned calls from worried friends and relatives. She did not turn on the television; she simply sat.

As for Lieutenant Colonel Marilyn Wills, she collapsed in the Pentagon's center courtyard minutes after jumping from the second floor, her lungs clogged with soot. Once at the hospital, she used sign language to spell out "Call Kirk." Somebody handed her a pen. She wrote her husband's phone number on a paramedic's shirt, then blacked out.

As evening came, Sergeant Major Tony Rose, still collecting and bagging partial remains in a roadway between the Pentagon's B and C rings, was relieved by fresh troops and told to go home. He walked to a Red Cross tent in a parking lot alongside Interstate 395, picked up a bottle of water, and climbed up the highway's embankment to the southbound shoulder.

Rose was soot-covered and bleeding. Almost as soon as he hung out his thumb, a pickup truck veered off the road and stopped beside him. The driver asked if he needed to go to the hospital. No, Rose said, he just wanted to go home. The stranger took him to his door. The house was silent, neat, familiar but remote; it seemed odd that it should be as he'd left it, unchanged by so momentous a day. A neighbor had come by for Tippy and Butterscotch. After a while, another stopped in with food.

Rose could not look at it. The sergeant major instead turned his attention to the forty messages waiting on his answering machine, many from the families of men and women who worked with him. In most cases, he could say that he or others had seen a missing loved one alive and safe outside the Pentagon. But not all. Among the missing was Sergeant Major Larry Strickland, a popular noncommissioned officer who'd been preparing to retire. Rose was to emcee his going-away party and had planned to borrow some baby pictures on a visit to Strickland's wife, Debra, on September 13. Now Debra had called Rose looking for word of her husband's whereabouts. Rose called her back to say he had not seen him.

After several attempts Rose reached his wife, Beverly, who was visiting family. They cried. She wanted to come home, to grab the first flight back. No, he told her, you're not getting on an airplane. I'll drive to St. Louis to pick you up. At midnight he took a shower, and for the first time noticed his arms were blistered, the hair there singed. He found glass embedded in his chest and stomach, and tweezed it out. Some shards were more than an inch long.

Rose put a heating pad on his left knee and lay down. Sleep would not come. He got up, wrote a list of everything he had to do the following day, then went back to bed. He still could not sleep, so he lay on his back, the light on, staring at the ceiling.

That's how September 11, 2001, ended.

A day after the attack, Yates and Shaeffer were choppered to Washington Hospital Center, one of the nation's standout burn units. That Thursday, a phalanx of security men moved through the halls. Yates was intubated and unable to speak when President George W. Bush walked into his room. "We'll do everything we can," the president told him. "Don't you worry."

Shaeffer, barely conscious, was surrounded by Blanca, his mother, and his rescuer, Steve Workman, when the First Lady leaned in close to say he'd made the nation proud. The president moved up the other side of his bed. He hugged Blanca. Shaeffer tried to lift a bandaged arm. Workman saluted on his behalf.

Bush turned to leave. "If there's anything I can do for you," he told Blanca, "just let me know." Before he could stop himself, Workman blurted: "Well, actually, Mr. President, there is one thing." He recalled his conversation with Shaeffer in the Pentagon clinic shortly after the attack. "Kevin would like to play a round of golf with you, when he's able."

Bush looked surprised. "How good is he?" he asked.

"He's very good," Blanca replied.

"He'll have to give me a stroke," the president said.

"He can give you a stroke on every hole," Blanca told him.

"OK," Bush nodded, "we have a game. When Kevin's up to it, he's on."

Within a week the hospital staff had Shaeffer up and walking. The golf game, it seemed, was not far away. But in truth, the Pentagon attack did not end that week for Shaeffer, nor the week after, nor a month after that. The lieutenant was in grave condition, bandaged from head to waist, grotesquely swollen, his burned flesh weeping, a hole punched in his throat for a ventilator tube.

Four times a day the nurses changed his dressings. They'd unwrap each arm and hand, exposing the raw meat beneath the gauze, and scrub at it with coarse washcloths, then roll him over and do the same to his back, his head, his ears. Shaeffer screamed silently throughout. He was plunged into whirlpool baths and his dead flesh scraped away, in a procedure that left him physically and emotionally spent. He found no rest when he was returned to his room: His doctors strapped him into a bed that prevented fluid build-up in his lungs. It prevented sleep, as well, flipping him every few seconds so that one moment he faced the ceiling, the next the floor.

When he did manage to drift off, he dreamed of fire and heat and death in the dark, and jerked awake in terror. Before long even his conscious thoughts morphed into flashbacks. Exhausted, he asked Blanca— mouthing the words so that she could read his lips—to bring him picture books of forests, mountains, and ocean beaches. She did, holding them open over his face as he spun toward the ceiling.

The bed notwithstanding, infections sprouted in his arms and lungs, and ran riot through his body. His organs began to shut down. The oxygen levels in his blood plummeted. On October 4, Shaeffer's heart twice stopped beating. Doctors revived him with electric shocks but did not expect him to live through the night.

Naval officials urged Blanca to medically retire Shaeffer from the service, explaining that she'd receive greater benefits as the widow of a retiree. She signed the papers. As it happened, that night was his worst. When the infection in his arms continued to defy drugs, his doctors released maggots onto his decaying flesh to chew away the dead tissue, leaving the healthy, and as medieval as that sounds, it worked. They replaced his destroyed skin with grafts of synthetic material, or pigskin, or the skin from

cadavers. They opened him up to check for deeper damage, and cut out his inflamed gall bladder.

Shaeffer was in awful pain. He was scarred. He was stitched together like a quilt. But ever so slowly, his strength began to return.

On September 12, Phil McNair got up at his usual time and put on his uniform. His wife asked him what he thought he was doing. "I'm going to work," he told her. No, you're not, she said. McNair replied that yes, he was. He was his agency's executive officer. A great many people relied on him. He had to go.

Very well, she said, I'll go with you. And so she did: Nancy McNair stayed by his side throughout the day.

Tony Rose had ruptured the bursa sac in his left knee. His lung capacity was reduced by two liters. Still, on the morning of Friday, September 14, the sergeant major hobbled out to his car, drove to the Woodbridge commuter lot, picked up two carpoolers, and drove to work.

The personnel staff set up temporary offices in Alexandria, using borrowed phones and hand-me-down computers and folding banquet tables for desks. Civilian computer experts ventured back into the unstable ruins in search of the agency's network servers. Against all odds, they recovered them intact, enabling McNair's people to return to work far sooner, and far more completely, than anyone thought possible.

Weeks passed. Marilyn Wills, her conversation frequently interrupted by coughing fits, her arms stiff, her left shoulder frozen, resumed her duties. Betty Maxfield returned to her brochure project. Chris Braman went back to buying groceries.

John Yates underwent three surgeries. He was released from the hospital five weeks after the attack and moved into a hotel next door for a month of daily therapy. Some of his hardest days came after his physical pain began to taper. On October 11, the Pentagon held a memorial ceremony for those who had died in the attack. The Yateses watched in his hospital room as the names of the fallen scrolled across the TV screen. They saw the name of one of his coworkers. Then another. And another, and another, until he'd learned that twenty-four people from his office were among the Pentagon's 125 dead. Yates cried himself to sleep.

On an Indian summer afternoon later that month, Ellen and two of the couple's friends took Yates to the Pentagon. He had seen photographs and TV images of the building by then, knew that a piece of the new wedge

had collapsed. Seeing it in person awed him, just the same. Hundreds of people stood alongside Route 27, on the building's west side, staring at the damage. Bouquets of flowers and homemade memorials dotted the grass and fluttered in the breeze. Yates wandered away from the others, struggling to keep the day from rushing back. He started to sob. So many good people lost. So many friends.

Following the Pentagon attack, the survivors hungered for some explanation of why they lived when so many around them died. The only answer that seemed to suffice was the least satisfactory: chance. Dumb luck. A step taken here, a momentary pause there. How else could Yates explain how he, alone among the six people gathered in Marian Serva's cubicle, lived through the fireball? How to explain Shaeffer's survival, when the three men with whom he shared his cubicle perished? Or how an officer in the conference room lived, while the men sitting to either side died?

Army Lieutenant Colonel Brian Birdwell stepped into a hallway at the instant a fireball reached the same spot. A second later, and he might have escaped injury. When Birdwell passed out, he happened to fall under a sprinkler, which almost certainly saved his life. Happenstance. Fate. Divine intervention, maybe.

When a colonel plotted where his coworkers stood at the moment of impact, using a large schematic of the second floor drawn by the Pentagon's renovation team, he found fatalities bunched in Lieutenant General Maude's office suite, and in a section of the big room where the floor buckled. Outside those clusters, the dead were scattered without pattern; some people directly in the plane's path escaped, while others did not.

A few days after the attack, McNair visited the dry cleaner on the Pentagon concourse. He found his shirts waiting. Kip Taylor had delivered them, as promised. He'd returned to his office in time to die with his general. Had he procrastinated just a little, had he lingered on the concourse, had he stopped for a cup of coffee on the way back—the weeks after the attack were busy with such if-onlys. To a military culture steeped in personal responsibility, in action and consequence, in the notion that preparation prevents poor performance, chance—random, unavoidable—is a bewildering concept.

One sure thing that survivors took away from that Tuesday was the knowledge that many owed their lives to the actions of their fellow soldiers and sailors, some of whom were themselves wounded in the attack. On October 24, 2001, the army recognized the heroism displayed by its own in a ceremony at Fort Myer. Marilyn Wills, Phil McNair, Tony Rose,

and Chris Braman, the cook-turned-rescuer, each received the Soldier's Medal, the army's highest peacetime decoration for valor. They each received the Purple Heart, an acknowledgment of the injuries they'd suffered, as well. John Yates and Betty Maxfield were presented the Defense of Freedom Medal, the Purple Heart's civilian equivalent.

Steve Workman wasn't decorated until more than six months later, when Kevin Shaeffer was well enough to return to the Pentagon. The men stood together in the building's Hall of Heroes, surrounded by portraits of fighting men and women who had earned immortality in past moments of peril, Workman to receive the Soldier's Medal, Shaeffer the Purple Heart.

Shaeffer spends his days, these days, at home in Fredericksburg, putting himself back together. He has nerve damage across the right side of his body. His right elbow is partially frozen, making it difficult to use that arm to eat, comb his hair, brush his teeth. His right shoulder and chest muscles are withered. He has little feeling in his right hand. He suffers constant pain, which he rates four on a ten-point scale.

So the retired lieutenant lifts weights, and stretches, and carefully measures and records changes in his range of motion. He has overcome damage to his right leg that initially left his foot drooping. He has partially restored the muscle mass to his chest. He tries to stay positive. He is, he knows, enormously fortunate. Of the thirty people in the Navy Command Center's main room, he is the only one who lived.

Over weeks, over months, life back at the Pentagon resumed a routine. Crews tore away the building's shattered section, and in a few short months had patched the tear left by the crashing airliner. The facade's brighter limestone was the only outward hint of the disaster; inside, workers labored around-the-clock to finish new offices by the attack's anniversary. The personnel staff finished moving back into the building in late January, spread among borrowed rooms. It's now returning piecemeal to the new wedge, which again has been bolstered with coated windows and Kevlar-clad walls—improvements that the renovation people say prevented the plane from turning the building into shrapnel, and thus saved many lives.

New faces have joined the unit to replace the casualties of a year ago. Some men and women have rotated on to other army jobs. And on August 6, nearly eleven months after the attack, Colonel Phil McNair retired in a ceremony in the Hall of Heroes.

He had made many friends in his twenty-six years of active duty; some 150 people attended the ceremony. Among them was John Yates, clad in

Lieutenant Kevin Shaeffer, nearly a year after the attack. (Martin Smith-Rodden photo; used by permission)

a body stocking that protects his healing skin, a piece of one ear missing, his face and neck a stark white that will take years to return to its natural color. Yates stood in line with other well-wishers to speak with the man who'd reached for his hand in the center courtyard. He peeled off his protective glove so that he could feel McNair's hand when he shook it.

Afterward, about seventy-five people attended a luncheon in the Pentagon's third-floor executive mess, where Chris Braman works as the purchasing agent. It was a last gathering, of sorts, for many of those whose lives had braided that Tuesday.

As the group finished eating, the speeches began. A general had just launched into a monologue honoring McNair's long service when the lights in the room flickered. At almost the same instant a loud whoop-whoop-whoop filled the air and a recorded voice, eerily calm, came over the public-address system: "There is an emergency in the building. Please evacuate immediately."

Wills reflexively scanned the room and memorized the location of its windows. McNair thought: "Here we go again." For a moment everyone froze, unsure of what to do, wondering whether to take the alarm seriously.

A woman ran out of the room to check. The general held up a shadow box containing a flag that had flown over the Capitol and the decorations McNair had earned in uniform. "In case we can't come back," he said, "Phil, this is for you."

The woman reappeared. "I'm informed it's not a test," she announced. "Everyone needs to leave. Now."

The group filed into the center courtyard. It was quiet there, sunny and warm under a cloudless, bright blue sky. Workers in other parts of the building seemed unaware that anything was amiss: They strolled about the yard talking on cell phones, hurrying to and fro with papers, lost in routine.

After a few minutes the evacuees got the all-clear. They straggled back in.

The Pentagon got back to business.

Claimed
Only by
the Flood

They found the first of the nameless far downriver: a teenage boy, handsome, with high cheekbones and a wispy blond mustache and longish, light brown hair. He looked to be blue-eyed, but they couldn't be certain. Four days had passed since the flood. Four days of summer heat, and water, and flies.

A younger boy turned up a day later, not as far downstream. An old woman was next, then two little girls, then the truck driver. Searchers found the headless corpse on the twelfth day. They pulled a manicured young woman out of the mud five days after that. She still wore makeup.

All told, there were eight. In most respects, they were not unlike the dozens of others killed in Virginia's worst natural disaster, a thunderstorm that started late one August night in 1969 and that, by the time it ended a few hours later, had loosed a biblical deluge on rural Nelson County. When morning came, 125 people there had been carried away.

One thing distinguished these four children, three women, one man:

They were strangers—travelers, most likely, just passing through Nelson—and stayed that way. They bore no identification. No one from the county stepped forward to claim them. No one from outside came looking for them. They weren't missed, it seems, by anyone.

Which was all the more vexing for a detail that came to light in their autopsies.

The children shared the same last meal.

More than thirty-five years later, the eight still haunt the doctors who performed the autopsies in a tent out back of a local funeral home, as well as the lawmen who sowed descriptions of the bodies throughout the Mid-Atlantic. Nelson old-timers still shake their heads over them: How can it be, they wonder, that four children traveling together can die in a well-publicized disaster, and nobody asks after them?

For that matter, how can a trucker vanish along with his truck, without someone reporting them lost? How can an impeccably groomed woman in smart clothes vanish without notice? Theories abound, but real answers about them are as elusive today as they were in 1969.

All that can be figured with certainty is that of the eight, seven almost surely died in the Rockfish River, which begins as a trickle near the highland gap where Interstate 64 traverses the Blue Ridge, and travels southeast to empty into the James River at Howardsville, in Albemarle County. The exception most likely died in the James or the Tye River, which occupies a valley west of the Rockfish and is fed near its source by the famed Crabtree Falls.

Known, too, is that they fell victim to one of nature's great freak shows. Late on the night of August 19, the remnants of Hurricane Camille, which had lain waste to Mississippi's Gulf Coast two days before, grumbled eastward over the Blue Ridge. In terms of wind, the storm was spent, but it was heavy with water, and it was over Nelson County that it chose to lighten its load.

What followed was one of the heaviest rainfalls in recorded American history—at least twenty-eight inches during the night, most of it in less than five hours. That's a conservative figure: Most likely, thirty-one inches fell in parts of the county. Perhaps, in a few isolated spots, forty or more.

The rain turned hillsides to a gruel that swallowed up forests, fields, and houses. Tiny mountain streams ran a quarter mile wide and higher

than the trees. A Virginia State Police sergeant was present when the Rockfish blew through a steel and concrete bridge carrying U.S. 29, the main link between Charlottesville and Lynchburg. "Sergeant proceeded just south of the Woods Mill Bridge," the agency's report read, "at which time he saw two tractor and trailers which were parked in the right lane of Route 29, and a straight truck which was parked in the left lane of Route 29. Immediately following this observation, a wall of water washed the vehicles away."

The Tye underwent a similar transformation. "One eyewitness estimated that a surge of water 75 feet high entered the James River from the Tye," the state police reported. "This information is borne out by water markings on trees in the area."

By the following noon, the water had dropped, and casualties were mounting. Along Davis Creek, usually an inches-deep tributary of the Rockfish, fifty-two people were dead or missing. At Massies Mill, a village on the Tye, twenty-two were gone, along with nine in Tyro, others in Roseland and down by the James—and twenty-three people along U.S. 29, where a witness reported seeing the headlights of one car after another disappear off the washed-out bridge.

A search team found the first of the eight on August 24, clear across the county from that bridge at Woods Mill. Its members carried the boy into Lovingston, the Nelson County seat, and put him in a refrigerated trailer parked outside the Sheffield Funeral Home.

So many dead had been recovered that embalming them as they arrived was impossible; the trailer, donated by a frozen-food company in Crozet, enabled officials to store them until they were identified, at which time they'd be prepared for burial.

Identification was no simple matter, however. Most did not drown; they'd been beaten to death by mudslides, by tumbling trees and boulders, by blows from floating debris—telephone poles, fence posts and roof beams, truck tires and uprooted forest, furniture, dead livestock. They were broken, gouged, and stripped of even the rings on their fingers. They didn't look themselves.

So a team of local doctors, supervised by the state's deputy chief medical examiner, set up an outdoor laboratory a few yards from the trailer, and began conducting autopsies. "We weren't looking for cause of death,"

recalled Dr. Robert Raynor of Afton, one of the physicians. "We were just looking for everything we could to tell us something about that person.

"If we had a missing person who'd had a hysterectomy but the appendectomy hadn't been done, and we had a body the same way, and everything else fit, we were able to make an identification. If the appendectomy had been done, we knew it was someone else."

The boy wound up on the table within hours of his arrival. He was white, stood five foot eight, weighed 155 pounds. His hair was straight and parted on the left, his eyebrows a bit heavy. He bit his fingernails. He was circumcised. He had "no characteristic scars." Dr. George Criswell, a Lovingston dentist, examined his teeth. The youngster had amalgam fillings on three molars. His upper-left second bicuspid—two teeth behind his "eye" tooth—was rotated rearward, a trait that his own dentist likely would have remembered.

When the medical examiner, Dr. Walter Gable, opened him up, he found the boy was infested with roundworm, a parasite not uncommon in the rural poor. Among the worms were red beans and meat.

The second of the eight was recovered about ten miles below the Woods Mill Bridge. Gable's findings are preserved on a state-issued form, called a CME–1, with which Virginia's medical examiners summarize their work: "Young white male, 12–14 yrs. Long dark brown hair. 125–130 lbs., 62–64 inches. Very large spleen." His stomach contents: "Undigested red beans."

Four days passed before the third of the eight was recovered—and the one who didn't die in the Rockfish. She was a white woman of about seventy years. "Body No. 8," as she's still known, stood five foot two and had long white hair. She was toothless. Her appendix had been removed, and she'd undergone a hysterectomy that had included her cervix. She was wearing a blue shirt patterned with checks and dots, and blue-green denim bermuda shorts over pink underpants and a "net-like pink girdle." Beyond that, the official paperwork says little, except to note that her stomach contained a "large amount of mud."

Then again, by August 29 it was becoming difficult to glean many identifying characteristics from the remains. Of all of nature's systems, that for disposing of its fallen is among the most efficient: Within hours of death, an outdoor corpse becomes host to a legion of feasting insects and microbes, and within days, particularly in the humid heat of central Virginia,

this army can render a body unrecognizable to even those who knew it intimately in life.

Some were so far gone, so fast, that their sex couldn't be determined without an autopsy. The University of Virginia sent down a portable X-ray machine, with which Criswell made images of the victims' teeth. They were key to twenty-six identifications, which might have been impossible otherwise.

"I'd taken biology, and I knew maggots were the larval stage of the bluebottle fly," the dentist said, "but I'd never seen the way they did their business."

Said Raynor: "I couldn't eat white rice for months afterwards."

The little girls: Searchers found both on the twelfth afternoon. The first lay two miles above the Rockfish's confluence with the James. She was about ten and had long blond wavy hair. Her body bore no scars, but she did possess a dental imperfection that stood out—her upper-right second tooth, her lateral incisor, was hooked behind her right front tooth. The other girl was younger, six to eight by Gable's figuring, all of sixty pounds. She still had her first and second deciduous molars, or baby teeth.

Were they sisters? The state's paperwork noted their hair was "identical," that they'd eaten the same red beans, and that "the other physical characteristics are similar." They were miles apart, however: This girl had been swept out of the Rockfish and into the James and downstream past Scottsville. She'd hung up on an island in Fluvanna County.

Two more unknowns reached the trailer the following day, September 1. In the early afternoon, a search party found the remains of a middle-aged man in the Rockfish at Howardsville. He'd been a heavy, muscular fellow, just shy of six feet tall. Black hair and sideburns fringed what appeared to be a bald scalp. He had no scars to speak of, and his stomach contained a quarter pound of "pasty black material."

He was missing a couple of molars and had an amalgam filling in a lower bicuspid, but the doctors seized on another characteristic of his teeth: They were ground down and stained a deep brown. A tobacco chewer. County authorities figured him for a truck driver, perhaps one of those washed off U.S. 29 at Woods Mill.

Later in the day, a search team found another body in the Rockfish just a mile below the U.S. 29 bridge. "White, female, late 40s–early 50s," her CME-1 read. "150–160 lbs. Approx. 62 inches. Moderate length wavy

brown hair. Left breast larger than right." An understatement, Raynor re-called: One was three times the size of the other.

The document's brevity was explained by its last line: "No head."

The last of the eight was uncovered right at Woods Mill. It was late morn-ing on September 6, more than two weeks after the flood and long after anyone might have expected to recover fresh remains. But so they were, apparently preserved by their tomb of mud and debris. The corpse was that of a white woman in her late thirties. She measured five foot five and weighed 140 to 145 pounds. She had a deviated septum. She had varicose veins in her legs, a scar from a pilonidal cyst on her lower back, and what appeared to be a "large rounded area of scarring" in the muscles of her belly.

What impressed all who saw her, however, was her grooming: "She was in very good shape," recalled Harriet Gable, the pathologist's widow, now living in Jacksonville, North Carolina. "Her nails were done. She still had makeup. She was nicely dressed." Indeed, her legs and armpits were freshly shaved, her light-brown hair cut short, and she wore a stylish blue blouse and shorts set. She'd had a healthy last meal of green beans, corn, and to-matoes. "She was evidently quite well-endowed, financially," Criswell said. "If any of these people were going to be missed, it'd be her."

It didn't happen, which seemed to confirm a growing suspicion among county authorities: The eight had to be outsiders. On September 9, Gable and Criswell compiled dental charts on each. State police investigator R. David Jones reported that they mailed "hundreds of copies of this in-formation" along with the CME-1s "to all physicians and dentists within the commonwealth of Virginia and all surrounding states.

"The request was for these physicians to purge their files for any in-formation that might assist any identification of these bodies." Jones also "purged the complete known Missing Persons List at State Police Head-quarters, Richmond, Virginia." Neither effort yielded any leads.

The state police took the story to the public, too: "We put broadcast messages all up and down the East Coast, to TV and radio," trooper Ed Tinsley recalled last month, "broadcasting the fact that we had these eight bodies and giving a general description of them." That drew a flurry of responses, but "in each instance," Jones later reported, "it was determined that none of the bodies above mentioned were the friends or relatives of those making the inquiries."

Gable and his colleagues weren't out of ideas, however. On September 19, they cut the hands from the adults, packed them in brine, and shipped them to the FBI Laboratory's Latent Fingerpint Section, a standard practice when a body's condition precludes fingerprinting in the field. The prints matched none in the agency's renowned files. A week later, investigators photographed the faces of several corpses and made a composite drawing of at least one—the older teenage boy, the first found. The composite was distributed to the media. Again, the inquiry drew a blank.

With that, they'd exhausted the technology of the day. "It should be noted," Jones wrote, "that all members involved in the identification of the deceased were of the opinion that all the information that could be obtained from the bodies had either been removed, noted or photographed."

On October 2, 1969, investigators drove the eight to Richmond. The next day, all were cremated.

No names, all these years later. Theories, is all.

The first: The children were together, and were not traveling with any of the unidentified adults. Surely, the thinking goes, their chaperone would have eaten red beans. "We never found any adults that we could associate with them," said Bill Whitehead, the county's former sheriff.

The second: If the children had a guardian, he or she was not recovered. That wouldn't surprise, for of the 117 others thought to have perished in the disaster, 33 have never been found. Mountains moved in the rain and flooding. People were buried deep.

Third: The children were agricultural workers, traveling to or through Nelson between harvests. "What we think is, they belonged to a family of migrating workers, who move from place to place," Whitehead said, noting that the county produces a large apple crop. "They were coming up this way, probably, to go to work."

That might explain why no one came asking for them. "They were between jobs," Raynor mused, "and they weren't expected at any particular place, at any particular time."

Were they northbound? Southbound? No telling, and the same goes for so much about the others. Why did no company come looking for a vanished truck and driver? What happened to the trucks the state policeman saw washed off of U.S. 29? Were any of the adults traveling together? Mysteries.

And, perhaps, destined to remain that way. Criswell has kept the dental X-rays, but much else has been lost. In the years since Camille, other floods have swollen the Rockfish, the Tye, the James, surely carrying off any scant evidence that might have remained in the river beds—a license plate, an engine block, a wallet or purse. Floods have swamped Richmond, as well; a couple spilled into a basement where the chief medical examiner's files were kept, ruining them. Today, the office has nothing but the CME-1s.

As for the eight: Years later, their ashes were interred at Maury Cemetery in South Richmond.

Their grave is unmarked.

Notes on the Stories

"The Immortal Dismalites" was originally published under the same title in the *Virginian-Pilot* of April 13, 2003. It is reproduced here with minor modifications.

The story chronicles a near-death experience that had its beginnings about three years earlier, when Bill Trout—the dean of Virginia's historical canals and waterways, and a man who knows the state's rivers better than just about anyone—was kind enough to fact-check a couple of chapters from my first book, *Journey on the James* (Charlottesville: University of Virginia Press, 2001)—and as a postscript to this task, suggested: You know, now that you've canoed all of the James, maybe you should consider retracing William Byrd's famed Dividing Line expedition.

I was an ideal target for this pitch. The Dismal Swamp had always intrigued me; I'd canoed and mountain biked away a good many weekends there. I was likewise attracted to the concept of drawing a paycheck for a couple days spent traipsing through the woods.

I made a reconnaissance trip to the Dividing Line a week ahead of our hike, approaching the Line from the north. I was so cut to ribbons by *Smilax* that I ditched that route for the one the story describes, which promised—on paper, at least—far less bloodletting.

I think it worth noting that in the ten years prior to our ill-fated expedition, I ventured into the swamp by pedal or paddle at least a couple times a year. Three years have passed since our adventure, and I haven't been back since.

"The Unexpected Artist" was originally published as "Community Finally Embraces Writer . . . for His Paintings," in the *Pilot* of October 3, 1999.

I discovered Abbott on a visit to Gary McIntyre's Norfolk collectibles shop, long-since defunct, at which several of the artist's paintings were on sale. McIntyre's descriptions of Abbott convinced me he'd be a great story, and a few days later I visited the nursing home. I augmented my interview by reading his manuscripts, which friends at his boardinghouse made available to me.

Eugene Abbott died in 2000. The *Pilot* devoted an entire page to his passing, dominated by his self-portrait. I bought an Abbott painting from his estate. It depicts the superliner *United States* being menaced by what appears to be a World War II Japanese dive-bomber in New York harbor. It's titled *Corruption over America*. I'm not sure why.

"The Tangierman's Lament" originally appeared in the *Virginian-Pilot* as a two-part package under the titles "Losing Ground, Keeping Faith" (June 11, 2000) and "We're a Blessed People" (June 12, 2000). For this version, I've consolidated paragraphs and moved some of the copy breaks.

The photographs were taken by Ian Martin, my partner on the 1998 canoeing adventure that became *Journey on the James*. We spent the better part of six weeks on the island, during which winter passed into spring and each day brought a wholesale shift in the weather and sea conditions. Our darkest moment came when we arrived by ferry with a nor'easter and found the entire place under knee-deep water. By the time the stories ran, we could converse in Tangier's oddly cadenced vernacular.

It was well known that Tangiermen were all related, to some degree, but it wasn't until I happened on a diabetes study that had been conducted on the island—and which included the population's genealogy—that I decided on the Old Testament approach to introducing everyone.

"Tangierman," by the way, refers to any islander, male or female.

"Bang the Drum Loudly" was published under that title in the *Pilot* of February 4, 2001. It remains a favorite of mine, if only for the "eshing" line. I still can't believe I got away with that.

"When the Rain Came" was originally published as an eight-part serial in the *Pilot* editions of August 15–22, 1999. It was published simultaneously in the *Roanoke Times*. An abbreviated version appeared in chapter 12 of *Journey on the James*. The version here is minimally changed from the original.

Of all the stories I've written for newspapers, this one drew the greatest response: Readers of both papers called and wrote me by the hundreds. Survivors of the storm sent me their reminiscences and photographs—one man mailed in pictures of bodies he'd encountered along the Rockfish River.

All of this began accidentally: I'd never heard of Camille until six months before the series ran; in August 1969 I was a schoolboy in England, ignorant of the hurricane and its aftereffects. But in February 1999, as I sat with my next-door neighbor at the annual meeting of our co-op apartment building, she suggested I write an anniversary piece. As our conversation progressed, Anne Gowen, who'd spent some of her childhood outside of Lovingston, recalled seeing "missing" posters in a Nelson County general store. A lot of people, she said, had simply vanished in the rain.

The conversation led me to the newspaper's library, where I found clips on the flooding and realized I'd stumbled onto an amazing story.

Bill Whitehead died in 2005; Tommy Huffman did so in early 2006.

"Playing the Last Round" ran under the same title in the *Pilot* of January 1, 2003. It's been slightly reworded here to eliminate overly specific time elements.

Change has been the biggest issue on the Eastern Shore for years. The club's imminent demise gave me a great excuse to explore the subject without beating readers over the head with it.

"Where Is the Fabulous Dewey Diamond?" was published under that headline in the *Pilot* of March 6, 2005.

I went into this story with no plans to imitate nineteenth-century newspaper writing, but absorbed so much of it in my research that it lodged in my brain. The story was not only great fun, but a form of exorcism.

"In the Radiance of Master Charles" appeared under the same title in the *Pilot* of October 5, 2003. I've consolidated paragraphs in this version.

I'd heard of Charles for a dozen years, since before his promotion from Brother to Master, and had long been curious about him. I called Synchronicity expecting to be rebuffed; I was thrilled when I was invited to the Sanctuary.

I had a fine time, and liked everybody I met, but left confused about the master's past; fact and fiction were so blurred in past accounts of his life, and a firsthand rendition so adamantly refused, that I was hell-bent on digging until I turned up who he was.

Master Charles had given me a copy of his spiritual autobiography (inscribed, "To Earl—Sourcefully, Master Charles"), which contained studiously nondescript photos from his boyhood. But the football picture offered possibilities. I knew he'd spent time in Florida and had gone to Catholic school, and I was able to further narrow my research to the Palm Beach area, where in Charles's teens there was just one Catholic high school. Its football uniforms matched those in the picture, and one of the coaches from those days was still around.

"Ricochet" was published under the same title in the *Pilot* of November 13, 2005. It has undergone minimal change here.

The story grew out of a conversation with Earl Whitehurst, during which he intimated that the shooting might not have gone down exactly as officially described a half century before. Once I spoke with Reid Spencer, I realized that he, too, believed the official story to be flawed—but in ways unaddressed by Whitehurst's assertions.

What emerged was a story of layered uncertainty and divergent opinion. And when I thought my research into the case couldn't get more convoluted and weird, it did: At the end of my first meeting with Spencer, the retired judge announced that he was going to tell me something he hadn't previously shared. "I bank close by," he said, "and if I'm not mistaken, I still have the bullet from this case in my safe-deposit box there."

We met twenty minutes later in the lobby of a Norfolk public library branch. I used Spencer's Boy Scout pocket knife to unbend the staples sealing the envelope, and we removed the box and opened it right there. He left the bullet with me for several weeks, during which I had it analyzed by a forensics expert. The results were inconclusive.

Strickland initially agreed to meet with me, then called to cancel the

interview. When I sent him a certified letter again requesting a meeting, I received a reply from his lawyer.

"Meat" was published as "Go Fish!" in the *Pilot* editions of July 1, 1999. This version consolidates paragraphs.

Bob Selvaggi died in a motorcycle accident in 2005.

"Flush with Success" was originally published under the same title in the *Pilot* of February 18, 2001.

I'd admired the Love Doctor's rig in traffic years before, but for whatever reason, failed to recognize a story in the E. W. Brown corporate slogan. The company crossed my path a second time, in the form of Little Fat Buddy, as I drove to an assignment in North Carolina.

"A Song of Sorrow" appeared under that title in the *Pilot* of May 2, 2004.

I blundered upon a mention of the cyclone in a folk music Web site, while looking up the wreck of the Old 97. Never did do a story on the train crash, but I was thrilled to uncover this nugget of lost history.

"Love and Justice" was originally published as "Court Shows Dark Side of Valentine's Day" in the *Pilot* of February 15, 2000.

Valentine's Day is one of those obligatory story subjects that every reporter dreads, and here I got lucky: Norfolk's domestic relations court was in session that morning, and handling a crowded weekend docket. I've eliminated a sentence in this version.

"To the Lighthouse" was originally a four-part narrative in the *Pilot* editions of January 31 to February 3, 1999. It is substantially modified here. Most notably, I've eliminated photographer Ian Martin as a character—he accompanied me to Assateague but stayed in the keeper's cottage rather than the lighthouse, and on rereading the piece I judged him too peripheral to keep.

I had a great time on this assignment, which I remember as four days of forced quiet and meditation, and a chance to reread John Fowles's *The Magus*. The great challenge in writing the series was that the central character was a motionless, inanimate object—on its face, not the most dynamic of subjects. Luckily, its past was colorful enough to drive things along.

"At a Fork in the Trail" was originally published in the *Pilot* of December 13, 2003. The Mantzes have since moved to West Virginia. At last word, Kristy was still competing.

"History Floats" originally appeared in *Chesapeake Bay* magazine's June 2000 edition under the headline "Bateau Royale." I've changed it here to correct the magazine's spelling of "batteau," which might be bad French but is correct Virginian.

Much of this story appeared, in somewhat altered form, in *Journey on the James.*

"The Race Is Off" went by that title in the *Pilot* of February 19, 2006.

I'd shaken Rudd's hand some seventeen years before I called him for this story. My dad was Quaker State's vice president for marketing in the late eighties, and as such oversaw the company's racing program. Rudd drove the No. 26 Quaker State Buick for team owner Kenny Bernstein at the time.

Being a local boy, Rudd always had the attention of the *Pilot*'s sports staff, but I'd long been mystified by his failure to achieve national stardom—he was, after all, a perennial contender, photogenic, and well-spoken, much more so than some of the bigger names on the NASCAR circuit.

Reporting this story cleared up the mystery. Rudd and I spoke for eleven hours by phone before I flew to Charlotte to spend a Monday afternoon and Tuesday morning with him. He wasn't exactly a reluctant subject, but it was plain that he wasn't a wildly enthused one, either.

"Tory Terrorist" was originally published under the same title in the *Pilot* of June 30, 2002.

I thought maybe I'd simply missed a well-known story when I came upon the outlaw's name. Then I tried to dig up something on his exploits, and learned I was mistaken.

"Out of Nowhere" first appeared as a four-part serial in *Virginian-Pilot* editions of September 7–10, 2002.

The previous spring, I was talking by phone with a friend and Pentagon source, Army Lt. Col. Franklin Childress, who worked for the deputy chief of staff for personnel and whose desk, until September 11, had been a few feet from Marian Serva's; had he been in the office when the plane

hit, he'd almost surely have been killed or gravely injured. Childress mentioned that he had been frustrated in his dealings with the press after the attack, as had his coworkers. Reporters repeatedly asked the survivors how they felt about what had happened, he said, but no one had thought to ask: What happened? What did you go through that day? The people in his office were eager to talk about it, he said, but it seemed that no one wanted to listen.

Well, I told him, I'll sure listen. Let's do a story.

In late June I drove to Arlington and met about a dozen people in the office. I interviewed all several times by phone after our introductions, and from that pool chose the characters for the story. Key to the narrative's success was my acquisition of a floor plan of the army's "cubicle farm," originally drawn for the new wedge's renovation and annotated to show the location of everyone in the office at the moment the plane hit.

"Claimed Only by the Flood" was originally published in the *Pilot* of March 19, 2005.

Bill Whitehead mentioned the unnamed eight to me in 1999, when I interviewed him for "When the Rain Came," but that story didn't give me much room to address the subject; it earned a sentence fragment.

It stayed with me, though. Five years later, I revisited the case in hopes that the state had retained tissue samples in its archives, which might be subjected to mitochondrial DNA analysis. There were no such samples, nor much of anything else.

Acknowledgments

All but one of the stories in this collection were originally published in the *Virginian-Pilot* of Norfolk, my professional home since 1987. They thus owe much to the dozens of smart, funny people with whom I'm lucky to collaborate every day.

In particular, I'm indebted to my colleagues on the paper's Narrative Team: Diane Tennant, Lon Wagner, Denise Watson-Batts, and Lane DeGregory have been my first readers, brainstorming partners, and patient listeners, and had a hand, direct or otherwise, in everything here.

An even bigger player was Maria Carrillo, our editor for seven of the team's nine years and a font of encouragement, skill, and patience. Maria invested herself in every story I wrote, helping me think through questions of structure or tone, to pare and polish my writing, and shepherding the results through the editing process and into the paper. These are her stories as much as mine.

Others at the paper deserve my thanks: Kay Tucker Addis, who cre-

ated the Narrative Team, was editor when most of these pieces first saw print and was our staunch champion; Denis Finley, Kay's successor, who understands that you get out of reporting only as much as you put into it; Dennis Hartig, our former managing editor, who after thirty years of daily journalism remains wildly excited to step into the newsroom, and spreads that glee around; and Fred Kirsch, a great role model not only in his writing, which is superb, but his humanity, which is boundless.

Ian "Hammer" Martin was my coconspirator on several stories in the collection, drank a lot of beer with me, and lent his beautiful pictures with enthusiasm. Martin Smith-Rodden kindly contributed photos, as well.

Patient family and friends have put up with me while I've chased these stories, among them Robin Russ; Laura LaFay; Mark Mobley, who does a dead-on imitation of Al Green imitating Billie Holiday singing a Joni Mitchell song; Jamie and Rhett Walton; Richard C. Bayer; Mr. Charles Wickers; and Joe "He Gets All the Facts In" Jackson.

Special thanks go to my parents; my compadre, mentor, and Scrabble nemesis, Mike D'Orso; my big-brained and beautiful daughter, Saylor; and the smart, compassionate, and utterly gorgeous Amy Walton, who has inspired me to no end.

My agent, David Black, looks out for me with the sharpest eye around. Finally, the good people at the University of Virginia Press again have been a pleasure to work with. Boyd Zenner, in particular.